HAMLET *Do you see nothing there?*

QUEEN *Nothing at all, yet all that is I see.*

The Transfiguration
of the Commonplace

A Philosophy of Art

Arthur C. Danto

Harvard University Press
Cambridge, Massachusetts
1981

For Dick and Peggy Kuhns

Library of Congress Cataloging in Publication Data

Danto, Arthur Coleman, 1924–
 The transfiguration of the commonplace.

 Includes index.
 1. Aesthetics. 2. Art—Philosophy.
I. Title.
BH39.D36 700′.1 80-18700
ISBN 0-674-90345-5

Preface

A character in Muriel Spark's novel, *The Prime of Miss Jean Brodie*—Sister Helena of the Transfiguration, who once was Sandy Stranger, a Glasgow teenager, disciple, and rogue—is described as having written a book called *The Transfiguration of the Commonplace.* Hers was a title I admired and coveted, resolving to take it for my own should I ever write a book it might suit. As it happened, the events in the artworld which provoked the philosophical reflections in this book were in fact just that: transfigurations of the commonplace, banalities made art. When it seemed I might then have use for the title, I wrote Muriel Spark of the takeover, curious also to know what might have been the content of Sister Helena's book, which is not made manifest in the novel. Fictional dragons have only the biology their creators choose to give them in the works in which they appear, so Wagner's silence on the matter leaves logically unanswerable questions about Fafnir's metabolism and his(?) mode of reproduction. Similarly, works that appear in works of fiction have an indeterminate content, and authors are usually clever enough not to try to write the Great Novels, or whatever, with which their authors are fictionally credited. Still, it seemed to me that Spark might have views on what the book would have been about had she chosen to make it about something, and she replied, to my delight, that it would have been about art, as she herself practiced it. The practice, I suppose, consisted in transforming commonplace young women into creatures of fiction, radiant in mystery: a kind of literary caravaggism. Upon reflection, I have done something more amazing if less impressive: I have made fiction into reality, for what was once a fictional title is now a real one. A lesson may be learned from this curious feat, given the aspiration of artists from platonic times to the present of redeeming art for reality. The possibilities of success are exceedingly limited, are limited perhaps to such things as titles, and it is interesting to consider how little has been achieved in actualizing the dream of centuries. Still, it is nice to have a title which overcomes limits it is the task of the book it denotes to establish, in case someone should think that titles are only what works are called.

So much for the title. As to the artistic episodes it seemed to describe so admirably, I suppose one must look first to Duchamp, for it would

have been he, as a matter of art-historical precedent, who first performed the subtle miracle of transforming, into works of art, objects from the *Lebenswelt* of commonplace existence: a grooming comb, a bottle rack, a bicycle wheel, a urinal. It is (just) possible to appreciate his acts as setting these unedifying objects at a certain aesthetic distance, rendering them as improbable candidates for aesthetic delectation: practical demonstrations that beauty of a sort can be found in the least likely places. Even the familiar porcelain receptacle may be perceived as "white and glistering," to use Saint Luke's language in narrating the original transfiguration. One *can* see Duchamp in those terms, but then his would be but a laboratory comment on a theory as old at least as Saint Augustine, and itself perhaps the aesthetic transform of an essentially Christian teaching that the least of us—perhaps especially the least of us—is luminous in holy grace. But this reduction of Duchamp's act to a performative homiletic in demo-Christian aesthetics obscures its profound philosophical originality, and in any case such an interpretation leaves quite in darkness the question of how such objects get to be works of art, since all that would have been shown is that they have an unanticipated aesthetic dimension. So a fresh start was required, in which the transfigured objects were so sunk in banality that their potentiality for aesthetic contemplation remained beneath scrutiny even after metamorphosis. This way the question of what made them artworks could be broached without bringing aesthetic considerations in at all. This I believe to have been the contribution of the Pop artist Andy Warhol.

I recall the philosophical intoxication that survived the aesthetic repugnance of his exhibition in 1964, at what was then the Stable Gallery on East 74th Street, where facsimiles of Brillo cartons were piled one upon the other, as though the gallery had been pressed into service as a warehouse for surplus scouring pads. (There was also a room with facsimiles of Kellogg's cartons, which failed, in contrast with the charismatic Brillo boxes, to excite the imagination.) Some irrelevant negative mutterings aside, "Brillo Box" was instantly accepted as art; but the question became aggravated of why Warhol's Brillo boxes *were* works of art while their commonplace counterparts, in the back rooms of supermarkets throughout Christendom, were not. Of course there were manifest differences: Warhol's were made of plywood and the others of cardboard. But even if things were reversed, matters would have remained philosophically unaltered, leaving it then an option that really *no* material differences need distinguish the artwork from the

real thing. Warhol in fact exercised the option with his celebrated Campbell Soup cans, which were simply taken from the shelves of outlets where the rest of us buy our soups. But even were he laboriously to have fashioned them by hand, in a singular exercise of the tinsmith's art—hand-made cans so faultlessly fashioned as to be indistinguishable from the manufactured article—he would not have advanced them one degree in the category of art they already occupied. Peter, John, and James saw Jesus transfigured before them: "His face did shine as the sun, and his raiment was white as the light." It is possible that the work of art was the one that glowed, but incandescence could not be the sort of differentia a definition of art would look for, unless as a metaphor: which luminosity may well be in the Matthew Gospel itself. Whatever the difference, it could not consist in what the artwork and the indistinguishable real thing had in common—which could be everything that was material and open to immediate comparative observations. Since any definition of art must compass the Brillo boxes, it is plain that no such definition can be based upon an examination of artworks. It was this insight that equipped me with the method I use in my book, in which I pursue that elusive definition.

So elusive has the definition been that the almost laughable inapplicability of philosophical definitions of art to art itself has been explained, by the few who perceived the inapplicability as a *problem*, as stemming from the indefinability of art. Such was the Wittgensteinian dissolution of the question, though of course for reasons too complex to discuss in a preface. The Warhol boxes, however, make even this alleged indefinability a problem, since they so totally resemble what by common consent are *not* art works and so, ironically, make the question of definition urgent. My own view is that the inevitable emptiness of the traditional definitions of art lay in the fact that each of them rested on features the Warhol boxes render irrelevant to any such definition; so revolutions of the artworld would leave the well-intentioned definition without any purchase on the brave new artworks. Any definition that is going to stand up has accordingly to indemnify itself against such revolutions, and I should like to believe that with the Brillo boxes the possibilities are effectively closed and that the history of art has come, in a way, to an end. It has not *stopped* but ended, in the sense that it has passed over into a kind of consciousness of itself and become, again in a way, its own philosophy: a state of affairs predicted in Hegel's philosophy of history. By this I mean, in part, that it really required the internal development of the artworld to become sufficiently concrete for the philosophy of art itself to become a serious

possibility. Suddenly in the advanced art of the nineteen-sixties and seventies, art and philosophy were ready for one another. Suddenly, indeed, they needed one another to tell themselves apart.

The problems this book addresses came forward most vividly in what might be called painting-and-sculpture. And so a good many of my examples are drawn from that genre of art. Nevertheless, they can be made to arise transgenerically, in all the branches of art: in literature and architecture, in music and dance. So I shall from time to time draw illustrations from these as well. More important, if anything I write fails to apply throughout the world of art, I shall consider that a refutation: for this aims at being an analytical philosophy of *art*, even if it may also be read as a sustained philosophical reflection on the painting-and-sculpture of the present time.

My philosophical responses to the Brillo boxes were delivered in an invited paper to the American Philosophical Association in 1965. Its title was "The Artworld," and I had the morbid satisfaction of not having it understood at all. So it might have slumbered in a back number of the sepulchral *Journal of Philosophy* were it not discovered by two enterprising philosophers, Richard Sclafani and George Dickie, who gave it a modest fame. I am very grateful to them, and additionally grateful to those who have erected something called the Institutional Theory of Art on the analyses of "The Artworld," even if the theory itself is quite alien to anything I believe: one's children do not always quite come out as intended. I nevertheless, in classical oedipal fashion, must do battle with my offspring, for I do not believe that the philosophy of art should yield herself to him I am said to have fathered.

New York and Brookhaven A.C.D.

Acknowledgments

In addition to "The Artworld," various papers of mine prefigured the shapes of certain arguments and analyses of this book. I cite "Artworks and Real Things," *Theoria*, 29 (1973); "The Transfiguration of the Commonplace" and "An Answer or Two for Sparshott," *The Journal of Aesthetics and Art Criticism*, 1974 and 1976 respectively; and "Pictorial Representation and Works of Art," in C. F. Nodine and D. F. Fisher, eds., *Perception and Pictorial Representation* (Praeger, 1979). I am grateful to the editors and publishers of these for permission to incorporate materials, examples, and in certain cases prose from these earlier reflections.

I could not begin to thank individually all those artists, art historians, and philosophers from whom I learned something I might never have hit upon myself. But foremost among those I must mention is the late Rudolph Wittkower, whose *Architectural Principles in the Age of Humanism* wiped the scales from my eyes and made it possible for me to philosophize about art. Rudy was in addition a great man, one of the rare scholars not in any degree infantilized by his calling, and his life was an exemplification of moral grace. There is no one I feel I owe as much. But here, in no particular order, are those whose contribution to my mind I am conscious of: the art historians Leo Steinberg, Meyer Shapiro, Albert Elsen, the late Otto Brendel, Howard Hibbard, Theodore Reff, Linda Nochlin, and H. W. Janson; the artists Arakawa, Madeline Gins, Newton and Helen Harrison, André Racz, Joseph Beuys, Jeffrey Lohn, Pat Adams, Louis Finkelstein, and Barbara Westman Danto; and the philosophers Richard Wollheim, Nelson Goodman, Stanley Cavell, Richard Kuhns, Hide Ishiguru, George Dickie, Josef Stern, Ted Cohen, David Carrier, and Ti-Grace Atkinson.

The National Endowment for the Humanities made it possible for me to present a large portion of this when a work in progress to a number of gifted philosophers at a summer institute it sponsored at Columbia University in 1976. Other opportunities were given by Yale University; by the Annenberg School of the University of Pennsylvania, through five lectures arranged by Barbara Herrnstein Smith—from whom I have learned a great deal in beneficial argument and discussion; and as Ida Beam Visiting Professor at the University of Iowa, where I spent a

week at the invitation of Paul Hernadi and the Department of Comparative Literature.

Joyce Backman, my editor at Harvard University Press, caught the cadence of my writing and my thought, and helped give it a kind of clarity from within. I am certain the book would have been even clearer had I heeded her more often.

The last portion of the book was written in the late summer of 1978, after the death of my first wife, Shirley Rovetch Danto. Only a year later, discovering how moved I was by my own descriptions of artists' portraits of their wives—Cezanne, Monet, Rembrandt—did it become clear to me what these examples meant, and that I had written a philosophical memorial to her and to that marriage.

Contents

1 Works of Art and Mere Real Things *1*

2 Content and Causation *33*

3 Philosophy and Art *54*

4 Aesthetics and the Work of Art *90*

5 Interpretation and Identification *115*

6 Works of Art and Mere Representations *136*

7 Metaphor, Expression, and Style *165*

Index *209*

Works of Art and Mere Real Things

1 Let us consider a painting once described by the Danish wit, Sören Kierkegaard. It was a painting of the Israelites crossing the Red Sea. Looking at it, one would have seen something very different from what a painting with that subject would have led one to expect, were one to imagine, for example, what an artist like Poussin or Altdoerfer would have painted: troops of people, in various postures of panic, bearing the burdens of their dislocated lives, and in the distance the horsed might of the Egyptian forces bearing down. Here, instead, was a square of red paint, the artist explaining that "The Israelites had already crossed over, and the Egyptians were drowned." Kierkegaard comments that the result of his life is like that painting. All the spiritual turmoil, the father cursing God on the heath, the rupture with Regina Olsen, the inner search for Christian meaning, the sustained polemics of an agonized soul, meld in the end, as in the echoes of the Marabar Caves, into "a mood, a single color."

So next to Kierkegaard's described painting let us place another, exactly like it, this one, let us suppose, by a Danish portraitist who, with immense psychological penetration, has produced a work called "Kierkegaard's Mood." And let us, in this vein, imagine a whole set of red rectangles, one next to the other. Beside these two, and resembling each as much as they resemble one another (exactly), we shall place "Red Square," a clever bit of Moscow landscape. Our next work is a minimalist exemplar of geometrical art which, as it happens, has the same title, "Red Square." Now comes "Nirvana." It is a metaphysical painting based on the artist's knowledge that the Nirvanic and Samsara orders are identical, and that the Samsara world is fondly called the Red Dust by its deprecators. Now we must have a still-life executed by an embittered disciple of Matisse, called "Red Table Cloth"; we may allow the paint to be somewhat more thinly applied in this case. Our next object is not really an artwork, merely a canvas grounded in red lead, upon which, had he lived to execute it, Giorgione would have painted his unrealized masterwork "Conversazione Sacra." It is a red surface which, though hardly an artwork, is not without art-historical interest, since Giorgione himself laid the ground on it. Finally, I shall place a surface painted, though not *grounded*, in red lead: a mere arti-

fact I exhibit as something whose philosophical interest consists solely in the fact that it is not a work of art, and that its only art-historical interest is the fact that we are considering it at all: it is just a thing, with paint upon it.

This completes my exhibition. The catalogue for it, which is in full color, would be monotonous, since everything illustrated looks the same as everything else, even though the reproductions are of paintings that belong to such diverse genres as historical painting, psychological portraiture, landscape, geometrical abstraction, religious art, and still-life. It also contains pictures of something from the workshop of Giorgione, as well as of something that is a mere thing, with no pretense whatsoever to the exalted status of art.

It is what he terms the "rank injustice" in according the classy term *work of art* to most of the displayed items in my exhibit, while withholding it from an object that resembles them in every visible particular, which outrages a visitor, a sullen young artist with egalitarian attitudes, whom I shall call J. Seething with a kind of political rage, J paints up a work that resembles my mere rectangle of red paint and, insisting that his is a work of art, demands that I include it in my show, which I am happy enough to do. It is not one of J's major efforts, but I hang it nevertheless. It is, I tell him, rather empty, as indeed it is, compared with the narrative richness of "The Israelites Crossing the Red Sea" or the impressive depth of "Nirvana," not to mention "The Legend of the True Cross" by Piero della Francesca or Giorgione's "La Tempesta." Much the same epithet would characterize another of J's works, what he regards as a piece of sculpture and which consists, as I recall it, in a box of undistinguished carpentry, coated with beige latex paint applied casually with a roller. Yet the painting is not empty in anything like the way that mere expanse of red-painted canvas is, which is not even empty as a blank page might be, for it is not plain that it awaits an inscription, any more than a wall of mine might were I to paint *it* red. Nor is his sculpture empty in the way a crate would be, after its cargo is taken out or unloaded. For "empty" as applied to his works represents an aesthetic judgment and a critical appraisal, and presupposes that what it applies to is an artwork already, however inscrutable may be the differences between it and mere objects that are logically unsusceptible to such predications as a class. His works are literally empty, as are the works in the rest of my show: but literalness is not what I have in mind in saying, in effect, that J's achievements lack richness.

I ask J what is the title of his new work, and predictably he tells me that "Untitled" will serve as well as anything. This *is* a title of sorts rather than a mere statement of fact, as it sometimes is when an artist

neglects to give his work a title or if we happen not to know what title he gave it or would have given it. I may observe that the mere thing in whose political cause J created his work also lacks a title, but this is by dint of an ontological classification: mere things are unentitled to titles. A title is more than a name; frequently it is a direction for interpretation or reading, which may not always be helpful, as when someone perversely gives the title "The Annunciation" to a painting of some apples. J is somewhat less fantastic than this: his title is directive in at least the sense that the thing to which it is given is meant not to be interpreted. So predictably too, when I ask J what his work is about, I am told that it is about nothing. I am certain this is not a description of its content (chapter two of *Being and Nothingness* is *about* nothing, *about* absence). For that matter, "Nirvana" may be said to be about nothing in the sense that nothing is what it is about, a picture of the void. His work, J points out, is void of picture, less a case of the mimesis of vacuity than the vacuity of mimesis: so he repeats, about nothing. But neither, I point out, is that red expanse in defense of which he painted "Untitled" about anything, but *that* is because it is a thing, and things, as a class, lack aboutness just because they are things. "Untitled," by contrast, is an artwork, and artworks are, as the description of my exhibition shows, typically about something. So the absence of content appears to be something rather willed in J's instance.

Meanwhile, I can only observe that though he has produced a (pretty minimal) artwork, not to be told by naked inspection from a bare red expanse of paint, he has not yet made an artwork out of that bare red expanse. It remains what it always was, a stranger to the community of artworks, even though that community contains so many members indiscernible from it. So it was a nice but pointless gesture on J's part: he has augmented my little collection of artworks while leaving unbreached the boundaries between them and the world of just things. This puzzles J as it puzzles me. It cannot be simply because J is an artist, for not everything touched by an artist turns to art. Witness Giorgione's primed canvas, supposing the paint to have been laid on by him: a fence painted by J is only a painted fence. This leaves then only the option, now realized by J, of *declaring* that contested red expanse a work of art. Why not? Duchamp declared a snowshovel to be one, and it was one; a bottlerack to be one, and it was one. I allow that J has much the same right, whereupon he declares the red expanse a work of art, carrying it triumphantly across the boundary as if he had rescued something rare. Now everything in my collection is a work of art, but nothing has been clarified as to what has been achieved. The nature of the boundary is philosophically dark, despite the success of J's raid.

It is a striking fact that an arrayed example of the sort just constructed, consisting of indiscernible counterparts that may have radically distinct ontological affiliations, may be constructed elsewhere if not everywhere else in philosophy. In the sequel, I shall be as much interested in the principle that allows such examples to be generated as I shall be in the actual examples I will develop. Here, however, it may be useful to cite just one analogous array, if only as a prophylactic against supposing that we are dealing with structures peculiar to the philosophy of art. Here then is one from the philosophy of action, which I enlist *not* to imply that the philosophy of art is satellite to the philosophy of action, but that parallel structures are discernible in both and, indeed, in every sphere of philosophical analysis. In previous writings I have exploited structural parities between the theory of action and the theory of knowledge, without ever having been tempted to proclaim an identity between cognition and performance. In any case, if I may quote myself, here is an example with which I begin *Analytical Philosophy of Action:*

In the middle band of six tableaux, on the North wall of the Arena Chapel in Padua, Giotto has narrated in six episodes the missionary period in the life of Christ. In each panel, the dominating Christ-figure is shown with a raised arm. This invariant disposition of his arm notwithstanding, a different kind of action is performed by means of it from scene to scene, and we must read the identity of the action from the context of its execution. Disputing with the elders, the raised arm is admonitory, not to say dogmatic; at the wedding feast at Cana, it is the raised arm of the prestidigitator who has caused water to become wine; at the baptism it is raised in a sign of acceptance; it *commands* Lazarus; it *blesses* the people at the Jerusalem gate; it *expels* the lenders at the Temple. Since the raised arm is invariantly present, these performative differences must be explained through variations in context, and while it may be true that context alone will not constitute the differences and that we must invoke Christ's intentions and purposes, still, we cannot overestimate the extent to which context penetrates purpose. (Cambridge University Press, 1973, p. ix)

Now in the field of action theory, it has proved instructive to ask, in the manner of Wittgenstein, *what* it is that is left over when, from the fact that you raise your arm, you subtract the fact that your arm goes up. I am convinced that Wittgenstein's favored answer to this para-arithmetic query is "zero," that my raising my arm and my arm going up are identical. As G. E. Anscombe says in *Intention:* "I *do* what *happens.*" Aside from other difficulties, it is hard to see how this radical answer might survive the above example, inasmuch as the raised arm not only underdetermines the differences between blessing and admonition but

also between an action of some sort, on the one hand, and on the other a mere reflex, a tic or spasm, where the arm rises, as it were, without being raised by its owner, in contrast with a basic action of the sort I am supposing Christ is represented to perform. The difference between a basic action and a mere bodily movement is paralleled in many ways by the differences between an artwork and a mere thing, and the subtractionistic query may be matched with another one here, which asks what is left over when we subtract the red square of canvas from "Red Square." And though it is tempting to say, in a Wittgensteinian echo, that nothing is left over, that "Red Square" *just is* that red square of canvas, or, more portentously and more generally, that the artwork just is the material from which it is made, it is difficult to see how this creditable theory can survive an example in which something like a red square of canvas underdetermines the differences between "The Israelites Crossing the Red Sea" and "Kierkegaard's Mood," as well as the philosophically deeper differences between either of them and that red square which was not an artwork but a mere thing—at least until redeemed by J.

Wittgenstein's followers realized, in the sphere of action, that something after all was left over. This yielded a formula that an action would be a movement of the body plus x, which, by parity of structure, would then yield a formula that a work of art is a material object plus y; and the problem in either domain is to solve in some philosophically respectable way for x and y respectively. An early Wittgensteinian solution was this: an action is a bodily movement that is covered by a rule. The solution in question of course left unresolved a distinction between those bodily movements that were sufficiently voluntary for the agents in question to have internalized and to have conformed to a rule—as in signaling, to take a convenient and persuasive example—and those bodily movements that, though outwardly indiscernible from these, are involuntary, as tics and spasms are. Granted that these don't fall under rules because they are not actions, it follows that being an action is a condition for falling under an appropriate rule—and hence falling under a rule cannot explain a distinction it after all presupposes. And, I think, parallel perplexities remain in the parallel theory of art according to which a material object (or artifact) is said to be an artwork when so regarded from the institutional framework of the *artworld.* For the Institutional Theory of Art leaves unexplained, even if it can account for why such a work as Duchamp's *Fountain* might have been elevated from a mere thing to an artwork, why that particular urinal should have sustained so impressive a promotion, while other urinals, like it in every obvious respect, should remain in an ontologically degraded category.

It leaves us still with objects otherwise indiscernible, one of which is an artwork and one of which is not.

The Wittgensteinian impulse in the philosophy of action was polemically clear enough. It sought to escape, by collapsing actions onto bodily movements, the dualistic contaminations of traditional theories of action according to which a bodily movement is an action when caused by some interior, which is to say mental event, like a volition or a reason—and a mere bodily movement when it lacks a mental cause. Decryers of the Internal World, conflationists of mentalism with dualism, the Wittgensteinians fled to the externalities of institutional life rather than admit the compromising internalities of mental life, when they recognized that radical identification was spongy. That, however, is an issue for a different book. Here, I think, it will suffice only to indicate that theories of what makes the difference between artworks and mere things have at times prevailed which may appear as philosophically unacceptable as mentalism did to the Wittgensteinians—theories to which the Institutional Theory itself, whatever the motivation of its main adherents, is an obvious hardnecked antidote.

This is one such theory, cited merely because it fits so symmetrically with the theories of action the Wittgensteinians repudiated: an artwork is an object correctly called an expression because it is caused by a feeling or an emotion on the part of its maker, and which it in fact *expresses*. An action and an artwork then would be differentiated by their respective orders of mental causes, and by the further differences between conforming to an intention and expressing a feeling. The theory has difficulties, of course, in differentiating artworks from paradigm cases of things which express feelings but are not artworks—tears and cries and grimaces, for instance—and inasmuch as the mere internal occurrence of a feeling cannot discriminate artworks from sobs, it can be appreciated that an external mark will be sought. But, as our red squares show, there cannot be an external mark either. Since differentiating features seem to be neither internal nor external, it is easy to sympathize with the initial Wittgensteinian response that art must be indefinable and (a later, more considered response) that a definition might be finessed out of institutional factors. But at least we have been able to see that nothing in which indiscernibilities consist can be the basis of a good theory of art—or a good philosophical theory of anything whatever. The consequences of this perhaps prematurely enunciated insight will be met and dealt with as our argument evolves.

L et us consider a somewhat richer specimen of J's oeuvre: last year, inspired by some rather famous theories of art advanced by Plato and by Shakespeare, J exhibited a mirror. The artworld was ready for an event of this order, and the question of whether it was an artwork was never provoked, though the question of what enabled the mirror to be one is not without a certain philosophical interest. Strikingly, though a natural metaphor for the theory that art is imitation, this mirror perverts the theory by not being itself an imitation of anything: it is, J insists, with characteristic churlishness, just a mirror—a *commonplace* mirror. J could have hung a row of mirrors around the walls of the gallery and called the work *Galerie des glaces*, an arch imitation of the celebrated room at Versailles. But though an imitation in the sense that it happens to use mirrors to imitate mirrors, the fact that there are mirrors in subject and work alike seems incidental to the fact of imitation: in the appropriate sense, a row of broomsticks placed upright at regular intervals about the room could imitate—or "mirror"—the peristyle at Karnac: no need for columns at all. In that case, something could imitate without being a mirror, inversely to J's work, which happens to be a mirror without being an imitation. So the theories that inspired J are repudiated by the work that was supposed to illustrate them.

I am the last one in the world to refuse to honor "Mirror" as an artwork, my concern being only to investigate how it acquired this status. One thing, however, is plain, which is that though a mirror can be an artwork, its being one, in this instance, has evidently very little to do with its being a mirror, and the theory that "art is a mirror held up to nature" is curiously irrelevant to the status of this mirror as an artwork, since its *being* a mirror seems so little relevant to its status. J could have exhibited a breadbasket instead, for all that the theory helps, and the question why this breadbasket is a work of art and the one on my breakfast table is not, may be precisely matched by the question of why his mirror is an artwork and the one in the purse of Frayda Feldman— she whose gallery is fortunate enough to be the showplace for J's work—is not one. The richness of "Mirror" lay in the fact that we believed it connected with a theory which it apparently has nothing to do with, and this work seems, in consequence, little different in kind from the two expanses of red paint J managed to get classed as artworks.

I am not trying to defend myself against J: I just want to know wherein lies the logic of such feats. It would be laughable were J to try to get me to accept a breadbasket as a mirror. Why then is he so easily able to get me to accept a mirror as an artwork? What kind of predicate anyway *is* "an artwork"? Perhaps we should go back to a more tractable class of artworks, the very ones J's theory invoked, things that

are artworks because they are mirrors, rather than artworks in spite of being mirrors, as J's appears to be. For that theory too maintained a distinction between artworks and mere things, and may help us accordingly in understanding a boundary that our examples cross without erasing.

Whether or not they reflect their own considered theories, Plato and Shakespeare advanced, through the voices of Socrates and Hamlet, the theory that art is a mirror of reality. From this common metaphor, however, they drew conflicting assessments of the cognitive and, I suppose, the ontological status of art. We cannot easily tell, of course, if Socrates is being characteristically ironical, invoking mirrors as a sly counterinstance to rebut a theory that mirrors illustrate, since he must have recognized as well as the next man that mirror images of real things are not artworks as such. The theory would have been that art is an imitation of reality, and imitation itself was characterized merely in terms of duplicating an antecedent reality; if nothing more were asked of an artwork than this, there would be no criterion for distinguishing mirror images, which by common consent are not always artworks, from more routine instances of mimesis; and a further condition must be sought. At best we would have a necessary condition for arthood. And Socrates may have been suggesting that if exact mimesis is, after all, the dominating aim of artists, as it appeared increasingly and, to his mind, dangerously to have been becoming in the artworld of his time, then, if that is all that is wanted—an exact copy—we may achieve this far more simply than the current methods of artistic education permitted, by the mere device of holding up a mirror to the world: "You would soon enough make the sun and the heavens, and the earth and yourself, and other animals and plants, and all the other things of which we were just now speaking, in the mirror." This may have been just the same sort of effort at defeating a definition that prompted Diogenes to offer a plucked chicken as a counterinstance to the definition of a man as a featherless biped, and, as an act of artistic criticism, it foreshadowed a parallel move of Picasso's, who once pasted the label from a bottle of Suze onto a drawing of a bottle, implying that there was little point in approximating to a reality by arduous academic exercise when we could just coopt fragments of reality and incorporate them in our works, immediately achieving what the best academic hand could only aspire to. Who needs, and what can be the point and purpose of having, duplicates of a reality we already have before us? Who needs detached images of the sun, the stars, and the rest, when we

can see these things already, and since nothing appears in the mirror which is not already there in the world to be seen without it? What end could be achieved by detaching appearances from the world and representing them in a reflecting surface—this escaped Socrates' comprehension. And if all that mimesis entailed was an idle duplication of looks, his puzzlement about the status of art as so characterized was perfectly justified.

But even mirrors, whatever relationship there may be between them and mimeses as a class, have some remarkable cognitive properties to which Socrates was curiously insensitive, since there are things we may see in them we cannot see without them, namely ourselves. And fixing upon this asymmetry of mirror images, Hamlet made a far deeper use of the metaphor: mirrors and then, by generalization, artworks, rather than giving us back what we already can know without benefit of them, serve instead as instruments of self-revelation. This implies a complex epistemology worth dwelling upon for a moment.

Consider, to begin with, Narcissus, with whom Leon Battista Alberti believed, upon whatever authority, that the ancients believed the practice of artistic representation began. If so, Socrates reflected the ideas of his time. Though it is true that Narcissus fell in love with himself, he did not at first know that it was himself with whom he had fallen in love. What he first fell in love with was his own image, thrown back at him from the smooth surface of a crystal spring—a natural mirror—which he initially believed to be a marvelous, attractive boy looking up at him out of the depths. It would be fascinating to speculate how he came to infer that it was his own image, and hence himself, that was so obsessively attractive: it would have been possible, after all, to construe the looking-glass world as an alternative impenetrable reality into which we could *only* see (like the world of moving pictures), in which case the failure to consummate love, of which Narcissus died, would have been explained by him with reference to something other than our own anatomical limitations. As it was, he died of self-knowledge, just as Tiresias predicted he would, an object lesson in epistemological suicide to be taken seriously by those who suppose "know thyself," Socrates' celebrated cognitive imperative, can be pursued with impunity. Socrates would have scorned such a consideration, saying that it is but an instance of the infatuation with appearances of just the sort his aversion to mirror images—and mimeses generally—was intended to impugn: Narcissus' self-cathexis, if anything, would be an object lesson of *that* (though it is curious that Narcissus did not fall in love with the sound of his own voice, that having been the sorry infatuation of Echo).

This, however, may merely reflect a shallow comprehension of the

structure of self-knowledge, if we may apply a certain analysis of this structure derived from the theories of Sartre on the subject. Sartre distinguishes the sort of immediate and direct knowledge one has (or is philosophically alleged to have) of one's own conscious states, from the sort of knowledge one has of objects, of which one may indeed be conscious without these being states of consciousness: one is conscious of them as objects, as the things of one's world, without being conscious of oneself as an object or, consequently, as a thing in the world. A consciousness that is conscious of itself (there is for Sartre no other sort) he designates a For-itself (*Pour-soi*), an entity immediately conscious of itself as a self, and immediately conscious of its not being one of the objects it is conscious of. Nothing in the internal structure of the *Pour-soi*, so characterized, would enable it so much as to conceive of itself as an object, since it belongs to a radically different ontological order than mere objects do. Thus far, the *Pour-soi* resembles a Berkeleyan *spirit*, and objects resemble Berkeleyan *things*. It comes as an unforseeable metaphysical surprise, accordingly, that the *Pour-soi* realizes that it has another mode of being altogether, that *it* is an object for others, that it has an existence For-others (*Pour-autrui*), and so participates in the degraded mode of being of the things it has always distinguished itself from: it comes to the recognition that it has, as it were, an outside and an inside, whereas the experience of itself as *Pour-soi* would have led to neither conclusion: it would have been metaphysically sideless.

Sartre illustrates this vividly with the character of a voyeur, who is initially merely a gaze, so to speak, feasting itself on forbidden sights through a keyhole, when suddenly it hears approaching footsteps and recognizes that it itself is seen, that it, suddenly, has an external identity, that of a voyeur, in the eyes of an Other. Moral consideration to the side, the philosophical structure of the discovery is impressive: I come to know that I am an object simultaneously with coming to know that another is a subject: that *those* eyes are not just pretty bits of color, but are *looking* at *me*: I discover that I have an outside in a way logically inseparable from my discovery that others have an inside. It is a complex recognition, all the more so, I suppose, in the case of Narcissus who, for the first time in the mirror of the stream in Thespia, sees what others saw, his own face and form, by which time what he had seen was what he was in love with. Since the gaze in which he was trapped into objecthood was his own gaze, given back to him through the mediation of a reflecting surface, he was servant to his own master and no doubt died in what Sartre speaks of as a "futile passion," which is to become a self-conscious thing whose outside and inside are one.

Whatever the case, it is the function of the mirror as a mode of self-

recognition that Hamlet certainly has in mind when, through the *Death of Gonzago* he seeks to catch the conscience of the King. Claudius' recognitions are even more complex than Narcissus', since he is perhaps the only member of the audience who realizes that the play *is* a mirror, replicating specific historical occurrences that are his own acts. So he knows that his actions are objects in the consciousness of an Other—Hamlet himself—and at the critical moment perceives that Hamlet knows that Claudius knows that Hamlet knows the shameful truths. This is a marvelous coentrapment of consciousnesses, but for just this reason it is difficult to generalize it into a good theory even of mimetic art. Hamlet's image of a play as a mirror is apt in context, since it is intended to present to the King a reflection of his full moral stature. But then the King stands to the play in a very different relationship from that in which sundry members of the audience do, who may see it as an imitation of an action if they have read Aristotle, or may see it as having generalized reference to the mobility of feminine affection and the deviousness of political usurpation, or may merely accept it as a distraction for the courtiers. Of course any of us might see himself reflected in a work of art, and so discover something *about* himself, though only in a stretched sense was that archaic torso of Apollo, of which Rilke wrote so stunningly, the mirror image of the poet who resolved to change his life on the basis of it: I suppose he saw his softness reflected in the statue's strength: for "da ist kein Steele,/die dich nicht sieht." And a wanton may see her degradation in a painting of the Virgin. Still, we do not need art for this order of self-consciousness, as Sartre's own analyses show. Shallow or not, then, it is the duplicative function of mirrors, hence of artworks, as imitations to which we must return. It would, to be sure, have required an immense metaphysical adjustment for Plato to have accommodated how we appear into the structure of what we are, and in any case it is striking that both Plato and Shakespeare (in his final statement) should put art, appearances, mirror images, and dreams on the lowest ontological rung: "an insubstantial pageant fading."

Plato did not precisely propose that art was mimesis, but that mimetic art was pernicious, though in a way difficult to grasp without at the same time grasping the complex metaphysical structures that compose the core of Platonic theory. To begin with, art of this sort stands at a certain invidious remove from reality, by which Plato meant primarily the reality of what he termed *forms*. Only forms are ultimately real, since impervious to alteration: *things* may come and go, but the forms these things exemplify do not come or go—they gain and

lose exemplifications, to be sure, but they themselves exist indepen-
dently of these. Thus the form of the Bed must be distinguished from
the particular beds, wrought by carpenters, which participate in this
common form: these owe their bedness, as it were, to this participation,
and are less real than the forms they exemplify. Imitations of beds do
not even exemplify bedness: they merely appear to do so and, as ap-
pearances of appearances, are two degrees removed from reality and
can claim in consequence only the most inferior ontological status. But
because the productions of artists charm the souls of art lovers with
what are little better than shadows of shadows, they divert attention
not merely away from the world of common things but from the deeper
realm of forms through which the world of common things alone is in-
telligible. As philosophy has precisely the aim of drawing attention to
this higher reality, and art the consequence of drawing it away, art and
philosophy are antithetical, which then constitutes a second indictment
of art when one realizes the importance, moral as well as intellectual,
assigned to philosophy by Plato. Finally, speaking as a precocious
therapist as well as a true philistine, Plato insinuates that mimetic art is
a sort of perversion—a substitute, deflected, compensatory activity, en-
gaged in by those who are impotent to *be* what as a *pis aller* they
merely imitate. And who, Plato asks, would choose the appearance of
the thing over the thing itself; who would settle for a picture of some-
one he could have, as it were, in the flesh; or would pretend to be some-
thing in preference to being the thing as such? Those who can, *do*, we
might interpret him as having maintained; those who can't, *imitate.*

It is possible to read the entire history of subsequent art as a response
to this triple indictment, to imagine that artists have been bent upon
some kind of ontological promotion, which means, of course, overcom-
ing the distance between art and reality, and moving up a notch in the
scale of being. The American artist Rauschenberg once said, "Painting
relates to both art and life (I try to work in that gap between the two)."
Perhaps it is not altogether an accident that Rauschenberg should once
have exhibited a bed, as though, like philosophy according to White-
head, art were but a collection of footnotes to Plato: a bed, to be sure,
which nobody could sleep in, since it was attached upright to a wall
and smeared with paint. A somewhat closer approximation to what a
carpenter might have turned out was made at about the same time by
Claes Oldenberg—a hideous plastic confection on which it would have
been a horror to sleep, but not bad for an artist if the gap between him
and the carpenter is as vast as Plato supposed it was. It would remain
for our artist J to have gone the full distance, and to have exhibited his
own bed as a work of art, without having to give it that bit of vestigial

paint Rauschenberg superstitiously dripped over *his* bed, perhaps to make it plain that it was still an artwork. J says his bed is not an imitation of anything: it is a bed. No doubt it was made by a carpenter, but though the carpenter made the bed, J made the artwork, and inasmuch as beds exactly like it are beds but not artworks, standing abreast of the carpenter could not in any case be considered a philosophical success, whatever success J's *Bed* may be supposed to have as an artwork.

Perhaps then we should reconsider the history of art: if there still *is* a gap, and if, moreover, closing it after the manner of J merely opens up another gap between his artworks and the real things that exactly resemble them, the gap itself may be more interesting than what happens to lie on either side of it. Suppose that we look at the gap between imitations and reality to see what sort of gap it is, and then endeavor to discover what it might have in common with the gap between art and life which contemporary artists seem so bent on exploiting; and then perhaps we can get a better understanding of art and of reality *at once.* So let us return to the most elementary consideration of art as imitation, as a duplication of an ulterior reality, standing to it even in the way a mirror image stands to a thing reflected, abstracted from Shakespearean complications due to consciousness and Platonic considerations having to do with metaphysics. My motive for scrutinizing this ancient theory is that the gap between imitation and reality may be a more perspicuous way of appreciating the gap between art and life. It would be an impressive strategy if both turned out to exemplify the same sort of gap.

It is widely appreciated that resemblance, even exact resemblance between pairs of things, does not make one an imitation of the other: all the exemplars in my exhibition of red expanses are required, by the logic of the principle they were regimented to exemplify, to resemble one another; but each, so far as I have described them, is independent of the other, and none imitates any other (though I could add a painting of the mere red square, exactly like its subject, which it imitates perfectly, or add some copies of the acknowledged artworks in the original example). Similarly, J's bed resembles any old bed, but is an imitation of none: it is, he patiently explains, really just a bed, not an imitation of one, say of the sort Van Gogh depicted in one of his roomscapes. Imitations contrast with reality, but I am hardly in position to use in the analysis of imitation one of the terms it is my object to clarify. Still "that it is not real" must evidently contribute to the pleasure men derive, according to a stunning piece of psychology by Aristotle, from

imitative representations. "The sight of certain things gives us pain," Aristotle writes in the *Poetics*, "but we enjoy looking at the most exact imitations of them, whether the forms of animals which we greatly despise or of corpses."

The knowledge that it is an imitation must then be presupposed by the pleasure in question, or, correlatively, the knowledge that it is not real. So the pleasure in question has a certain cognitive dimension, not unlike a great many even of the most intense pleasures. Part of sexual pleasure, surely, is the belief that one is having it with the right partner or at least the right sort of partner, and it is not clear that the pleasure would survive recognition that the beliefs taken for true are false. Similarly, I should think, there are beliefs presupposed by the pleasure one derives from eating certain things, namely that they *are* the sorts of things one believes one is eating: the food may turn to ashes in one's mouth the moment one discovers the belief to be false, say that it is pork if one is an Orthodox Jew, or beef, if one is a practicing Hindu, or human if one is like most of us (however good we might in fact taste). It is not required that we should be able to taste the difference for there to be a difference, since the pleasure in eating is commonly more complex, at least in humans, than the pleasures in tasting and, as Goodman has pointed out in a parallel case, knowledge that it *is* different may in the end make a difference in the way something tastes. Or, to the degree that it does not, the difference between the two may after all not be something one sufficiently cares about for the relevant beliefs to figure in the background of one's pleasure.

To be sure, beef is not imitation pork—nor are males imitation females, to revert to the sexual case in which one believes oneself involved with one sort of partner when in fact it is of another sort altogether—and in these cases it is merely that the beliefs are false, and of taking something for something else. I am not sure that what divides the imitation from the real is anything like what divides male from female or pork from beef, in part because I am not certain what sort of differentiating property *reality itself* will turn out to be. But it is striking that the source of pleasure, in the case of imitations, must be understood as other than real, whatever this is to mean, and the concept is accordingly presupposed available to whomever takes pleasure of this order. Possibly children take less pleasure in imitations than adults do, because they have not yet developed a sense of reality—or acquired the concept of reality—and though imitations may indeed give them pleasure, this will not be because they are imitations, as Aristotle's observation requires. You may give considerable pleasure to a gullible person by imitating that person's long-lost son, by pretending to be that son—

but the person's pleasure could hardly be supposed to survive the discovery that you are an imitation son; and the parent's pleasure, accordingly, would be just the inverse of the pleasure Aristotle describes, where you must know that it *is* an imitation and where its being an imitation is part of the explanation of your taking pleasure in it. Thus a person may take pleasure in what he believes is an imitation of his son, which would be a deeply transformed pleasure upon the discovery—the "recognition" as Aristotle would term it—that what one took to be an imitation was one's real son after all. The pleasures taken in imitations are, accordingly, something of the same order as the pleasures one takes in fantasies, where it is plain to the fantasist that it is a fantasy he is enjoying and that he is not deceived into believing that it is the real thing. Fantasists sometimes become haunted by guilt, thinking that if their fantasies are morbid or sadistic, then *they* must be that, whereas in truth most fantasists would be horrified at the correspondent realities, as we are by what Aristotle speaks of as the animals we most despise, whose effigies please us the more exact they are. There is no inference that "deep down" we really love those animals. Part of the pleasure surely is due to the knowledge that it *is not really happening*, and not because we learn from the imitation, as Aristotle goes on to say, seeming to give an explanation but actually changing the subject.

This sort of pleasure, then, is available only to those who have a concept of reality which contrasts with fantasy—or imitation—and who realize that it would be a different sort of pleasure altogether were we to try to realize our fantasies. Or if there is no difference in the pleasures, the first cannot be explained as pleasure taken from fantasies, since the difference between fantasy and fact evidently makes no difference at the hedonic level: it is a fantasy that causes the pleasure, but not because it is a fantasy. So knowledge about the explanation of the pleasure, as well as a knowledge of the identity of the source of the pleasure, must be presupposed as well. And neither of these is available if the concept of the difference between reality and fantasy—or imitation—is either not yet formed, as in the case of a child, or is inoperative, as in the case of a madman, according to a criterion of Plato, who proposes that the madman really lives the pleasures most of us only dream. We are dealing with a different sort of false belief, then, than the belief that something is beef when it is really pork, and learning the difference between appearance and reality seems to be learning of a different and somehow more philosophical order than learning the difference between pork and beef, or between male and female; and we ought to make some provisional effort to clarify it, all the more so if it resembles learning the difference between an artwork and a real thing. In any

case the art lover is not like Plato's cavedweller, who cannot mark a difference between reality and appearance: the art lover's pleasure is exactly based upon a difference he is logically required to be able to mark.

L et us return to Narcissus, who falls in love with what he believes he sees in the water: a comely boy. It would at that point have been possible for Narcissus to believe that there are two orders of boys, those who live in water and those who, like himself, live in the air. On the basis of such a belief, he might generate a complex anthropology for waterpeople, discovering by sustained observation that they have forms and ways remarkably counterpart to our own, though curiously aniso-tropic and insusceptible to wounds: spears driven through waterboys draw no blood. And they are to Narcissus maddeningly unembraceable. However it is that Narcissus may have hit upon the idea of a reflection, it immeasurably simplified anthropology, physiology, and hydrology at small cost to optics. Reflection-boys, he proposes, are not boys but only simulacrums of boys, and Narcissus spontaneously has discovered a predicate ("reflection-") which, when attached to a noun, fails to yield the sorts of inferences that predicates normally attached to nouns yield—fat boys are boys, lean boys are boys, but reflection-boys are not boys. The world containing as it does large classes of such counterparts, sooner or later each of us must master a certain number of such predi-cates. Thus a child reports to his mother that there was a cat in his room during the night and that it wanted to eat him. His mother, surprisingly enough considering her usual protectiveness, does not go on a cat hunt, but instructs the boy in the concept of a dream: a dream-cat is not a cat.

It is difficult not to admire the extreme theoretical effort which must have gone into the invention of such predicates. There are tribes of people whose members believe that the experiences had in dreaming really occurred, explaining away the obvious incoherences this way: during sleep you leave your body for a time, occupying another, in which you have *in fact* the experiences *we* would say were not had but dreamt. The distortions widely appreciated as characteristic of dreams are explained—fortunately—as due to the rigors of bodily interchange. I say "fortunately" because the alternative possibility would remain of referring the distortions to the *world,* and believing then that reality is immensely more intricate than life in our own humdrum bodies would lead us to suppose, full of mad metamorphoses and transmogrifications, and in which what we merely wish for can be fulfilled in the flesh. Ac-counting for distortions as they do, by contrast, enables these tribes to

have a better chance at projecting a plausible science than would be possible if they had to integrate what they dream with what they routinely observe: there hardly could be any laws of nature for them. "Is a dream," like "is a reflection" or "is an echo," serves as a shock absorber to the system of beliefs that conservatively defines a world, extruding into a quite different ontological space entities which, if admitted into the world, would immensely complicate that system. To be sure, even when we are equipped with such concepts, it is not always easy to apply them in specific instances, particularly when the instances so resemble what would be their counterparts in the real world that nothing internal to the first would enable one to classify it properly.

Such would have been the case, for instance, with those poor voyagers caused to believe by Prospero's magic that there was a fire on their ship and a storm at sea: such disasters after all do occur, and it would have been virtual insanity in the midst of the turbulence experienced to propose that it was hallucination. In fact, when Prospero claims to have brought it about by magic, it was more plausible to regard *him* as mad, and it is the epistemic function of the rather vapid allegory in Act IV of *The Tempest* to demonstrate to Ferdinand that he, Prospero, indeed has such powers: "I must / Bestow upon the eyes of this young couple / Some vanity of mine art." For how otherwise would one believe him, without sacrificing one's own confidence in distinguishing fact from fancy? The shipwreck, then, has no more ontological weight than "the baseless fabric of this vision," and all the beliefs based upon countenancing its reality must be revised and the true history of recent events recovered from the counterfactual history erected upon illusion. Think how hard it would be to explain the intact ship, once encountered, if one continued to believe in the fire at sea and the shipwreck. And though the case is complicated by the concept of magic—itself nearly of the same logical order as "dream" and "reflection"—there is enough strength in the issue to have given rise to the entire problem of skepticism in philosophy. For the predicates of concern to us, entailing that the thing to which they apply is a *false* thing—in the sense that a false friend is not a friend or a false pregnancy not a pregnancy—leave it an open possibility that we may, since to outward appearances a false x sufficiently resembles an x to be taken for x, take a false x for an x, as Descartes supposed we might always take a dream world to be the real world; and inasmuch as an imitation x is also a false x, mimetic art, in Plato's suspicious mind, presented the permanent possibility of illusion. Beliefs about false things are not, of course, necessarily false beliefs, and we might note, since it is an ambiguity to which we shall have occasion to return, that a false belief *is* a belief, as a false sentence *is* a sentence.

In any case, and questions of illusion to one side, it would have been this stigma of descriptive falsity which must have concerned Plato in connection with mimetic works of art, though it evidently did not occur to him that the concept of a work of art serves pretty much the same function of extruding the objects it applies to from the real, no matter whether, in addition, the object in question happens to be an imitation, almost as if it had not occurred to Plato that there are other ways than being imitations through which things might be disqualified as unreal.

Consider the role of such an expression as "I did not mean it" applied to an action. It serves precisely to withdraw the action in question from the framework of assessments and responses that an outwardly similar action would be subject to if meant. So with "It was only a joke" or "It was just a game" or "It was only in play" or, finally, "It is an artwork." But what then are we to say of J's bed which, though an artwork, exactly resembles an ordinary bed because it is one? J tells us to go ahead, lie down on it, it is perfectly all right to do so, etc. Gingerly we comply: gingerly, because we are pretty sure of what to do with beds, radically unsure about what to do with artworks that happen to be beds. For with ordinary beds such reassurances would be *puzzling*. Whatever the case, there are close conceptual ties between games, magic, dreams, and art, all of which fall outside the world and stand at just the same kind of distance from it which we are trying to analyze. To be sure, one will have gone only a certain way in the understanding of imitation in characterizing it this way, for in addition to being a false thing, imitations have a more important function of *representing* real ones. But the concept of representation itself has an ambiguity it would be well to canvass before proceeding further.

The two senses of representation I wish particularly to mark emerge in Nietzsche's discussion of the birth of tragedy out of what he speculated were first and originally Dionysian rites. It may be allowed that the identification of something as religious excludes it from at least the routine realities—holy water is not just water, however, indiscernible a sample of it may be from commonplace water—and there is accordingly some logical parallel to be drawn between the boundary of some sacred precinct (the Grove of Dionysus, say) and the precinct within which what happens is officially to be classed as art. I shall return to the parallels directly, but for the moment let us just consider Nietzsche's theory. We must first recall that the Dionysian rites were orgiastic occasions, the celebrants working themselves up,

through intoxication and sexual games, to a state of frenzy largely asso-
ciated with Dionysus. "In nearly every case," Nietzsche writes in *The
Birth of Tragedy*, "these festivals centered in extravagant sexual licen-
tiousness . . . the most horrible savage instincts were released, including
even that horrible mixture of sensuality and cruelty which has always
seemed to me to be the real *witches brew.*" The effort, in brief, was to
stun the rational faculties and the moral inhibitions, to break down the
boundaries between selves, until, at the climactic moment, the god
himself made himself present to his celebrants. Each time he was be-
lieved literally to be present, and this is the first sense of representation:
re-presentation. However, and over whatever interval of time it took
place, this ritual was replaced by its own symbolic enactment, which
was tragic drama. The celebrants—who came in time to be the cho-
rus—did not so much engage in the rites as imitate the dancing, and so
on, as a kind of ballet. As before, at the climax of the ritual, not so much
Dionysus himself as someone representing him made an appearance,
and indeed it is Nietzsche's thought that the tragic hero was an evolu-
tion out of this early surrogate epiphany. This is the second sense of
representation, then: a representation is something that stands in the
place of something else, as our representatives in Congress stand proxy
for ourselves.

The difference, of course, is immense between the mystical appear-
ance to a kind of group-soul of a genuine god and the symbolic repre-
sentation to what in effect is a kind of audience of someone merely imi-
tating the god in question. But my interests are less historical, or even
religio-psychological, than they are conceptual, and what impresses me
is this, that the two senses of representation correspond quite closely to
two senses of *appearance,* according to the *first* of which the thing itself
appears, say as when the Evening Star appears in the sky, and appears
in such a way that it would be ridiculous to say it is "only the appear-
ance" of the Evening Star and not the Evening Star itself; and accord-
ing to the *second* of which we indeed contrast appearance with reality,
with Plato perhaps, and say what you took to be the Sun was "only an
appearance," perhaps a solar effigy, a bit of bright light. Dionysus is
believed to have appeared to the celebrants in the *first* sense of appear-
ance, and if any of them believed it was "only an appearance" they
would feel that the ritual had not worked. Dionysus appears in the *sec-
ond* sense of the term in the tragic enactments in which the rituals are
put at a certain distance in the hellenic transfiguration. If someone be-
lieved it *was* a god appearing, he would be told that it was only an ap-
pearance (and not the real thing): and if the first person were right, the

second one would have to feel that some wild violation of theatrical propriety had occurred, gods themselves having no business in the theater.

I think this ambiguity runs very deep indeed, and that it is not confined to the example from which we have derived it. Surely something like the first sense of representation or appearance must have been widely connected with the concept of art, and perhaps accounts for the magicality often associated with art. The artist had the power of making a given reality present again in an alien medium, a god or a king in stone: the crucifixion in an effigy true believers would have regarded as the event itself, made miraculously present again, as though it had a complex historical identity and could happen—the same event—at various times and places, roughly perhaps in the way in which the god Krishna was believed capable of simultaneously making love to countless cowgirls in the familiar legend. How, save against the background of some such belief, are we to account for the urgency of iconoclasm or the interdiction against graven images? (Plato supposed the forms were present in their appearances, so the latter had at least a degraded degree of reality; and then he *contrasted* appearances with reality, exploiting, as it were, both sides of the ambiguity.) In any case, when something stops being a re-presentation of the crucifixion, but merely stands as what we might term a crucifixion-representation—a mere picture—the congregation that addresses it has become an audience rather than coparticipants in a piece of mystical history, and the walls of the church are half-transformed into the walls of a gallery, close architectural kin to the walls of the theater, which were architectural transforms, if Nietzsche is right, out of the boundaries of the sacred precincts.

The extremely ancient theory that a representation embodies what, on a more modern theory, it merely stands for, is perhaps grammatically evidenced by the fact that we continue to speak of the *content* of a story—or of a picture—so that something is a picture of Marx or the story of O in a way that is grammatically of a piece with something's being a bottle of beer or a kettle of fish, where the "of" marks what grammarians speak of as a deep prepositional phrase. It might appear, thus, that the two are of different forms through the fact that the one— say the story of O—admits a genitive form (O's story) whereas nothing counts as the beer's bottle (you drink a bottle of beer but you don't drink the bottle). But this, I think, is illusory. For "O's story" is ambiguous: it can indeed be that tale *sadique* concerned with the sexual degradation of that young woman. But it could just be one of those stories O tells: just as "picture of the Duke of Wellington" could indeed be that

portrait of the Iron Duke by Goya, but it could also be any picture in the Duke's collection, perhaps that very picture, in which case it would be the Duke's picture of the Duke, where "of the Duke" is a predicate that identifies which among the Duke's paintings we are referring to: what Goodman would use hyphens for to form the predicate "Duke-of-Wellington-picture."

If it is possible to speculate that mimetic representations evolved out of what were earlier believed to have been representations in that earlier sense, namely re-presentations of the thing itself, then, to the extent that it was possible to believe, in that earlier case, that one was in the presence of the thing itself, it was possible to misbelieve, in connection with mimetic representations, that one was in the presence of the thing itself, assuming (doubtless contrary to historical fact) the two representations to resemble one another and hence, in the latter case, to resemble what would have been taken as the real thing. For nothing in the appearance need have undergone a change, only one's conception of the relationship in which the appearances stood to the reality: in the one case the relation was that of identity—in seeing the appearance one *was* seeing the thing—and in the other the relation was that of designation, a gap having opened up, so to speak, between the reality and its representations, comparable to, if not indeed the same as the gap that is perceived to separate language from reality when the former is understood in its representational, or descriptive, capacity.

Though I shall return and return to this dual conception of representation, for the moment it is primarily the mimetic form that concerns me. As soon as it is appreciated that something is a representation which, by prevailing criteria of similarity, must be supposed sufficiently resemblant to reality to be considered mimetic of it, the possibility opens up that mistakes of a special order are possible: one can mistake a reality for its own imitation or, more likely one can mistake an imitation for its designated reality, and hence take toward what is presented the attitudes and expectations appropriate only to its counterpart on a different ontological plane. So artists committed to the program of mimesis must take precautions of a special sort in order to abort these inverse errors. And this must be one of the functions of the theater where what is witnessed on the stage is put at a distance, and is excluded by convention from the framework of beliefs the precisely resemblant thing would fall under were it taken for real.

A estheticians have thought to find some utility in the concept of *psychic distance*, a special insulation that a transformation

of attitude puts between us and the object of our attentions, and which is meant to contrast with what is designated the *practical* attitude. The basis for the distinction is to be found in Kant's *Critique of Judgment*, where it sounds, and perhaps is meant to sound, as if there are two distinct attitudes that can be taken toward any object whatsoever, so that the difference in the end between art and reality is less a difference in kinds of things than in kinds of attitudes, and hence not a matter of what we relate to but how we relate to it. There is clearly something to be said for this view when the objects in question are not to begin with works of art, but are just things that have a role to play in the network of expediencies that define the practical world. It is always possible to suspend practicality, to stand back and assume a detached view of the object, see its shapes and colors, enjoy and admire it for what it is, subtracting all considerations of utility. But since it *is* an attitude of contemplative detachment that may be adopted toward just anything, however unlikely (and think of the way tools fall out of the *Zeugganzes* of practical labor and become elevated into objects of aesthetic contemplation), it is possible to see the whole world across aesthetic distance, as a spectacle, a comedy, or whatever. But *for just this reason* we cannot explicate the connection between artworks and reality on the basis of this distinction, which is at right angles to it.

My own view incidentally is that there would be cases in which it would be wrong or inhuman to take an aesthetic attitude, to put at psychical distance certain realities—to see a riot, for instance, in which police are clubbing demonstrators, as a kind of ballet, or to see the bombs exploding like mystical chrysanthemums from the plane they have been dropped from. The question instead must arise as to what one should *do*. For parallel reasons, I think, there are things it would be almost immoral to represent in art, precisely because they are then put at a distance which is exactly wrong from a moral perspective. Tom Stoppard once said that if you see an injustice taking place outside your window, the least useful thing you can do is to write a play about it. I would go further, suggesting that there is something wrong in writing plays about that sort of injustice in which we have an obligation to intervene, since it puts the audience at just the sort of distance the concept of psychic distance means to describe: something like this has been offered as a criticism of the photographs of Diane Arbus. This, to be sure, is to admit that there is something to the notion of psychic distance, save that it will not help us with framing the distinction we want, though perhaps it might be suggested that an artwork is an object toward which only an aesthetic and never a practical attitude is appropriate. But this is at odds with the fact that art has often had useful roles

to play as art, didactic, edificational, purgative, or whatever, and the theory thus presupposes a degree of detachment available only in special periods of art history. It certainly was no aim of the art of the high Baroque to be perceived disinterestedly: its aim was to change men's souls. For this reason, then, I rather applaud the polemic of George Dickie, who contests what he speaks of as "the myth of psychic distance" and says that what prevents us from attempting to intervene in actions we see on a stage is not due to some mysterious sort of attitude, but to the fact that we know how to look at a play: we have mastered the conventions of the theater. For knowing that it is taking place *in* a theater is enough to assure us that "it is not really happening."

The conventional perimeters of the theater serve, then, a function whose analogue might be that of quotation marks, where these serve to dislocate whatever is contained within them from ordinary conversational discourse, neutralizing the contents with regard to the attitudes that would be appropriate to the same sentence were it asserted, for example, rather than merely mentioned. And the quoter has no responsibility for the words he speaks or writes—they are not his words in the act of quotation (though he may of course quote himself, which is a different order of linguistic act from repeating his words). Indeed, parallel features may be found throughout the domain of art: picture frames or display cases, like stages, are sufficient to inform the person privy to the conventions they imply, that he is not to respond to what they mark off as though it were real; and artists will exploit them to just that end and violate them only when it is their intention to cause illusions or to create a sense of continuity between art and life, as in the case of the painting of the entombment of Saint Petrinella by Guercino, where the lower edge of the painting is coincident with the actual edge of the tomb of Saint Petrinella herself, above which the painting was originally displayed.

No doubt the concept of mimesis shades off into the project of creating illusions, and it is the danger of this possibility which figures in part in Plato's anxiety about mimetic art; but mimesis itself, providing that the conventions of dislocation are clear to the audience, in fact inhibits just those beliefs that would be activated without those conventions. But then it is precisely the confidence that the conventions are understood which enables the mimetic artist to carry mimesis to its extreme point, to make whatever is to appear within the relevant brackets as much like what would be encountered in reality as he can manage. And his major problem might be phrased thus: to make whatever is so bracketed sufficiently like reality that spontaneous identification of what is being imitated is assured, the brackets themselves guaranteeing

that no one will take the result for reality itself. Of course, it is always possible for the project to misfire: we can imagine one actor really stabbing another, and when the other actors take their bow, the corpse may remain supine on the proscenium, blood pooling around him, the audience applauding innocently, thinking this a striking conceit and an excercise of realism, a device for extending the illusion past the curtain fall in a way more or less of a piece with Guercino's conceit in the painting just described. The brackets are very powerful inhibitors of belief.

This sort of perversion apart, though, it is safe to say that the greater the degree of realism intended, the greater the need for external indicators that it is art and not reality, these becoming decreasingly necessary as the work itself is decreasingly realistic. Recall the celebrated broadcast of Orson Welles in the 1930s, when the radio audience genuinely believed the earth was being invaded by Martians, there being no easy way for anyone listening to know that it was simulation and not fact (on television he could have had a message printed at the bottom of the screen, but nothing like this was possible in radio broadcasting, for we cannot hear two things at once in a way in which we can see two things at once). When one takes theater into the streets, one has to count on making it very plain indeed that these are actors playing roles, not real people doing real things: hence the need for such devices as masks, special costumes, makeup, characteristic intonations, and the like. In realistic plays, realistic costumes enhance the artistic illusion, but in street plays they would confuse attitudes on the part of spectators, who are uncertain whether they are witnesses or audiences. Much the same considerations point to the importance of uniforms or special items of clothing. A doctor I know jogs to his train every morning and, because he wears ordinary clothes and carries a medical bag, is invariably offered rides; this would not occur were he in jogger's garb—joggers themselves not running to anything, merely running—but then the medical bag would have controverted the clothing. If a man stands in the middle of 114th Street and makes elephant cries or barks stunningly like a dog, he would be considered mad, whereas on the stage nothing of the sort would be believed about him, for we would know that he is imitating animals and not believing that he is one, or whatever we suppose him to believe about himself when he barks on 114th Street. So I do not think we can exaggerate the philosophical role of these nonmimetic features of art (to use Meyer Shapiro's expression) in view of the fact that it is they which make mimetic art a possibility.

L et us now, continuing to think in terms of Nietzsche's historical speculation regarding theatrical history, suppose that by the time of Euripides, who was the villain in Nietzsche's account, charged with having destroyed tragedy through reason, the conventions of the theater were sufficiently internalized by the Athenian audiences that he could embark on a program of purgation, eliminating from his dramas anything whose counterpart was not to be found in life. "Nothing was beautiful which was not rational" Nietzsche supposes him to have believed, executing in his dramatic works a program of rationality Nietzsche associates with Socrates. Thus, if he does not quite eliminate the chorus, he renders it pretty vestigial, inasmuch as choruses would be mimetically unconvincing, none of us in actual life enacting our destinies in the presence of a nosy anonymous set of kibbitzers. Of course the chorus has a cognitive function in the tragedies: it was part of its function to know what the hero was thinking, for example, and through the chorus this information was transmitted to the audience, who then could better understand what was going on. This informative function was crucial, the question only being how to perform it through more "natural" avenues, and it would be this that is the role of the confidant—the lieutenant or the personal maid—to whom the hero and heroine can in a wholly credible way reveal their innermost fears and ambitions. For similar reasons, the heroes and heroines had to be cut down to size, made more like you and me, so that we could without special effort assimilate their conduct to the beliefs and practices through which we rationalize one another's behavior, and assign them motives we could similarly internalize and recognize as counterparted in our own lives. The old heroes were too cosmic, their motives too exalted, too remote from any that might enter into the practical syllogisms ordinary persons can internalize. So they were replaced with types we can understand: housewives, jealous husbands, difficult adolescents, and the like, and the dramatis personae of intelligible tragedies are accordingly banalized. This is what Nietzsche speaks of as Aesthetic Socratism. Of course, these ordinary persons are thrust by Euripedes into the most unordinary situations, which almost test the limits of moral reason. But there is little doubt that a certain mysteriousness is sacrificed and, with this, something essential to art, in Nietzsche's view, is expunged in the interests of rationality—a mysteriousness he supposed in his own time to be reintroduced into art through the mythic content of Wagnerian opera; it is not art unless it defies rational explanation, and unless its meaning somehow escapes us.

So in the end Euripides achieved an artistic surface comprehensible in terms of the categories of ordinary life. Then indeed art is imitation

in the sense that it resembles what is possible, but though this may indeed be Socratism in a sense, it immediately encounters the problem posed by Socrates in Book Ten of the *Republic*: what is the point of having in art something which so resembles life that no difference between art and life can be marked in terms of internal content? What is the need or good of a duplication of what we already have? Who requires a world just like this world, Nelson Goodman asks centuries later, adding in his characteristically snappy way that "one of the damned things is enough." A map, it may be said, is a kind of duplicate by means of which we can find our way about a certain reality but, as Lewis Carroll made plain, a map cannot be a duplicate of the country, or to the degree that we are lost in the one we are lost in the other. Moreover, the idea here is that life itself is supposed to be something like a map for art, since it is by reference to life that we find our way through what is set up as an imitation of life. So the cognitive defense the analogy to maps might offer is gone forfeit in the case of such art. And immediately a counterprogram suggests itself: if art is to have any function at all, it must be exercised through what it does *not* have in common with life, and this function can hardly be discharged by the Euripidean program. Only to the degree that it is discontinuous is it art at all, this countertheory holds. So under pressure of Socrates' question, mimetic art fails when it succeeds, when it gets to be like life. But then, to the degree that it is to succeed in whatever function it is to discharge, it cannot be through mimesis. This we may speak of as the Euripidean dilemma.

We are familiar enough with attempts to slip the dilemma, which suppose art to consist in the discrepancies between reality and its imitative replications. Euripides, it is argued, went in exactly the wrong direction and paid the price by producing something otiose and parasitic, like an echo or a shadow. Let us instead make objects which are insistently art by virtue of the fact that, lacking counterparts in reality, no one can make the sort of mistake that is possible so long as imitation prevails as an artistic program. The pleasure we take in imitations is, as noted, dependent upon the knowledge that it is an imitation and not the real thing. We take a (minor) pleasure in the crowcalls made by a man imitating crows which we do not ordinarily take in crowcalls themselves, not even when one crow repeats the same calls made by another. It is essential that the man not be inept: he must make crowcalls close enough to the original that they can be mistaken for such by, say, an overhearing crow, for otherwise his ineptitude blocks by distorting the (minor) artistic signals intended for our delectation. And it is essential that we know enough about crowcalls to know what these are

imitations *of*; otherwise, as Aristotle suggests, the pleasure is due not to the imitation but to something else—in this instance perhaps to sheer raucousness—in which case the pleasure in question could be indifferently had whether the noises were made by crows or by men imitating them or even by men so stricken in the pharynx that their only vocal utterances are tragically indiscernible from what crows make in the common course of nature.

So there are varieties of mistakes possible in the case of imitation which are not possible if the object in question is a product of the counter-Euripidean program just sketched. We may suppose, if it is successful, that there is nothing in reality to mistake the artwork for, or for which the artwork itself can be mistaken; and it may *be* this order of artwork that Plato himself would have endorsed, being rather more a mystic in any case than his hero. Thus the disfigurements banished in the name of Aesthetic Socratism are one by one reintroduced, this time by an artistic decision: one *cultivates* a self-conscious woodenness, a deliberate archaism, an operatic falseness and falsetto so marked and underscored that it cannot be taken as our intention to subject our audience to the danger of illusion (unless they should happen to live in worlds so different from our own that in being discontinuous with our own we have created something continuous with theirs). But to an audience from the artist's own world it must be clear that the artist is not a failed imitator, like the inept crow simulator, and that his aims lie elsewhere. Think for a moment of an inept magician, who inadvertently reveals the false bottom in his boxes and the cards up his sleeve, and who fails in consequence to bring off the benevolent deceits which are what magic shows are made for. But contrast this with a man who deliberately shows what is up his sleeve and makes plain the phoniness of his boxes. Then he raises his art to a new level, which now may be puzzling because it is discrepant with the banal conventions of prestidigitation: wherever (if anywhere) illusion is to be located here, it will not be at the customary place between hand and eye. And so it is with this counter-Euripidean art, of which, if Nietzsche is right, Wagner is an example, with an already initial advantage in the fact that he used opera, the least probable of the arts save for such communities as those in which members communicate normally by singing and perhaps resort to talking for entertainment, so that our plays, even such ruthlessly realistic ones as Euripides', would be as abstract to them as operas are to us. In any case, the essence of art, on this new theory, lies in precisely what cannot be understood through simple extensions of the same principles that serve us in daily life. Inevitably, then, art is going to be mysterious: and, as before, it is in the expurgation of mystery in the name of

reason that Euripides was claimed to have engineered the demise of tragedy.

There can be no doubt that this is a serious theory, and that a great deal of extremely interesting and in some instances strikingly great art can be enfranchised by means of it. But it is not without its difficulties when we approach it somewhat philosophically and put out of consideration the fact that it is, to begin with, somewhat parasitic upon and hence conceptually interlocked with the theory it rejects, namely mimetic theory itself. Moreover, reintroduction of earlier conventions cannot be done with the expectation that they will mean the same to a present audience as they meant to an earlier one, for it will not merely be drama which will have changed in the interval but society itself; so a contemporary audience will of necessity stand in a very different relation to the reactivated conventions than did that audience for which they were indeed conventions, and spontaneously accepted as part of theatrical—or artistic—experience generally.

These are important points, but not the ones that concern me. My concerns are these: (1) What is to distinguish an object that happens to be discontinuous with reality as thus far defined by an audience from just a new piece of reality? And is every new piece of reality—a new species, say, or a new invention—to be considered a contribution to *art*? (2) What about J's objects, such as his plain old bed, similar to all the beds his contemporaries sleep in (no fancy surrealistic embellishments, no superogatory paint, just plain bedness)? So that with these there is nothing to distinguish them, no discontinuity whatever between them, as beds at least: for though J's bed may be a novel work of art, its novelty does not consist in its discontinuity with reality since none can be marked, and hence the novelty cannot be located where *this* theory seeks to locate it. (3) Finally the conventions of theatricality supposed constant, it must now seem that *anything* which appears within the brackets they provide, whether or not it imitates reality, whether it is continuous with or discontinuous with life, merely in consequence of occurring within brackets, is art. But then being a work of art must seem to have as little to do with any intrinsic features of the object so classed as with the conventions through which it first gets to be a work of art. Then the program of mimesis and the program of countermimesis projected by Nietzsche are each of them irrelevant to the *essence* of art. This appears to leave us only with the institutional framework: just as someone is a husband by virtue of satisfying certain institutionally defined conditions, though he may outwardly appear no different

from any other man, so something is an artwork if *it* satisfies certain in-
stitutionally defined conditions, though outwardly it may appear no dif-
ferent from an object that is not an artwork, as in the case of J's bed. But
this puts us back where we started, and clarity on the nature of the
boundary evades us still.

\textbf{B}efore commenting on this, however, it is worth drama-
tizing the dilemmas that occur within the brackets of convention as art-
ists struggle with reality. The Euripidean dilemma was that, once one
has completed the mimetic program, one has produced something so
like what is to be encountered in reality that, being just like reality, the
question arises as to what makes it art. The effort to escape this di-
lemma, by exaggerating non mimetic elements purged in the name of
the program, results in something so unlike reality that the question just
raised is stunned. But another, of virtually the same force, remains:
what, given that at the extreme we have something discontinuous with
reality, remains to distinguish this as art—and not just another piece of
reality, supposing that we want to say that not just every novel thing is
ipso facto an artwork and we want, after all, to suppose that reality can
be enriched without this having to be through art?

Consider, for example, the very first canopener ever made, designed
by that benefactor who made preserved food a practical possibility as a
handy gadget within the economic reach of every household and whose
use did not tax the manual dexterity of the average housewife: nothing
like it had been seen before, a model of utility and economy, to which
the inventor thoughtfully added the now familiar corkscrew. An ar-
cheologist of the future, unearthing one of these, might wonder
whether it is not a votive object executed in base metal, but I am less
interested in this possibility than that the canopener enriches reality by
being a novel form which nevertheless is by common consent not a
work of art. Now we may suppose that at just the very moment that its
inventor deposits it in the world with a cry of Eureka! an artist, quite
independently, has produced a work of art that exactly resembles it,
shape for shape. Here is a critic's glowing assessment of this work,
which I translate from the *Chronique des beaux arts:*

The single starkness of its short, ugly, bladelike and surprisingly ominous ex-
tremity embodies an aggressive masculinity, all the more pronounced by its
formal and symbolic contrast with the frivolous diminishing helix, which
swings freely but upon a fixed enslaving axis, and represents pure unavailing
femininity. These two motifs are symbiotically sustained in a single powerful

composition, no less universal and hopeful for all its miniature size and commonplace material. Had it been of a preciousness commensurate with its size, like a piece of orfevrerie, it would have lost scope, for the message concerns male and female as common denominator of the human condition. And had it been huge (and one must admit its essential monumentality) it would have exaggerated through heroization the cosmic banality of its theme. No, size and substance together reinforce image and import: a masterpiece of condensation, a major statement by J, from whose teeming genius so many remarkable works have sprung, a fitting member in that select circle of instant and insistent chef d'oeuvres defined by Donatello's *St. George* and Brancusi's *Mlle. Pogany.*

As an artwork, of course, the object so magnificently received must as a matter of course have whatever properties are thought by theorists of art to characterize artworks as a class: Purposiveness without Specific Purpose, for example, or Significant Form. To be sure, it is an object that could be used as a canopener by a philistine, but the question is how it could be possible that this object should possess such qualities while another, exactly congruent with it—the true first canopener—should not? It would be astonishing that two things be of exactly the same shape, size, and substance, and yet one possess and the other lack Significant Form! True, either object can be set at an aesthetic distance and held up for aesthetic appreciation: but, predictably, the distinction we are after is orthogonal to the revelations available through aesthetic distance, relative to which the distinction between artworks and mere things is inscrutable. So none of these theories will help much in drawing the line, any more than will the historical fact of mere novelty, since either object is discontinuous with whatever was before it. And the irrelevance of novelty so construed may be underscored by supposing the historical order somewhat different. Imagine the first canopener to have entered the world several months before its exalted counterpart, which we may as well title *La condition humaine*, though J, true to type, detests that sort of blague and has only scorn for the critic of the *Chronique*, on the basis of whose tribute he nevertheless sells the thing to the Frankfurter Kunsthalle for upward of a million marks.

So it is as though the Euripidean dilemma arises in a different form at the opposite end of the spectrum from that at which it was originally provoked. Given that revolutions in art tend to be characterized by swings in either direction as defined by this spectrum—from extreme realism to extreme realism—the dilemma seems to be inescapable no matter *what* direction we move in. And perhaps the dilemma is going to be forever inescapable so long as we attempt to define art in terms of features that either compare or contrast with features of the real world.

But *then*, it might be said, it must be *fatally inescapable*, since what else save comparative or contrastive features *can there be* upon which to erect a theory of art? That is the form I want the question to take: for then, like all serious philosophical questions, it looks like the sort of puzzle whose solution is to be found only by moving, as it were, onto another plane from that in which the facts seem to be deployed in a way fiendishly resistant to a solution, and perceiving them from a direction indefinable in terms of that plane. So far all we have are the "conventions," within the space defined by which this dialectical comedy has been allowed to play itself out. This suggests the natural next answer, that the difference between art and reality *is* just a matter of those conventions, and that whatever convention allows to be an artwork is an artwork.

There is an element of truth in this theory, but at the same time it seems to me shallow: "is a work of art," as evidenced by J's egalitarian reaction at the beginning of this discussion, is an honorific predicate. And honors do indeed seem very much to be matters of convention. But there are honors which are *earned*, and the question is what entitles something to this honor: is there not something which must first be present before the honor relevantly descends? And what about *defeating* conditions? Are there not at least some facts such that, if we knew those facts, the object of which they were true would be disqualified as an artwork no matter what anyone says? Imagine that we learned that the object before us, looks like a painting that would spontaneously move us if we believed it had been painted—say the *Polish Rider* of Rembrandt, in which an isolated mounted figure is shown midjourney to an uncertain destiny—was not painted at all but is the result of someone's having dumped lots of paint in a centrifuge, giving the contrivance of a spin, and having the result splat onto canvas, "just to see what would happen." And what happened is that, by a kind of statistical miracle, the paint molecules disposed themselves in such a way as to produce something to all outward appearances exactly like one of the deepest paintings of one of the deepest artists in the history of the subject, a painting through which a person might define his life? Now the question is whether, knowing this fact, we are prepared to consider this randomly generated object a work of art. Well, suppose someone declares it to be one and that, as with J, it *is* one. Then the question is whether it is by such a declaration that the *Polish Rider* got to be an artwork and, if this should prove true, whether there is nothing further to say about it than that it is an artwork by fiat. Or was it instead recognized an artwork through features the present object lacks, even though it is exactly like the *Polish Rider*? What can these features be? And if it

got to be an artwork through them, what theory can we have of art wide enough to cover the case of the *Polish Rider* and such objects as J's bed or this surprising array of paint, the *Polish Rider's* semblable? Or can there be no theory wide enough to cover both cases, so that in effect there can be no general theory of art? And suppose that indeed all there is to the matter is the honorific bestowed by discriminating citizens of the artworld, that something is an artwork just because it is declared to be that: then how are we to account for the profound differences between these two indiscernible artworks. Or are we prepared, as I believe we are not, to say of this fortuitously caused object that it, like its indiscernible counterpart, is "one of the deepest paintings in the history of the subject"? Is it deep at all—or even is it shallow, empty in the manner of J's work? These are questions the conventionalistic theory of art does not enable us to answer: so we must press further.

Content and Causation

2 That there should exist indiscernible artworks—indiscernible at least with respect to anything the eye or ear can determine—has been evident from the array of red squares with which we began this discussion. But the possibility was first recognized, I believe, in connection with literary works, by Borges, who has the glory of having discovered it in his masterpiece, *Pierre Menard, Symbolist Poet.* There he describes two fragments of works, one of which is part of *Don Quixote* by Cervantes, and the other, like it in every graphic respect—like it, indeed, as much as two copies of the fragment by Cervantes could be—which happens to be by Pierre Menard and not by Cervantes.

Now there is a problem of a familiar metaphysical sort concerning the identity of an artwork. It may be brought out by considering the relationship in which a poem may be said to stand to its various printings: is it identical with these, or has it a different identity altogether? I can, for example, burn up a copy of the book in which a poem is printed, but it is far from clear that in so doing I have burned up the *poem*, since it seems plain that though the page was destroyed, the poem was not; and though it exists elsewhere, say in another copy, the poem cannot merely be identical with that copy. For the same reason, it cannot be identified with the pages just burned. This immediately suggests that the poem stands to the class of its copies in something like the relationship in which a Platonic form stands to its instances, where it would have been acknowledged by Plato that the destruction of the instances leaves the form unaffected (forms being logically indestructible because eternal); and by parallel reasoning the Poem Itself appears to be logically incombustible. Often enough poets and philosophers have thought of artworks as thus only tenuously connected with their embodiments. Think, for instance, of the mode in which Roquentin, toward the end of Sartre's *Nausea*, sets forth to redeem his life to authenticity by creating a Work of Art—a novel, as it happens—on the view that artworks as such have slipped the radical contingencies of existence and abide in a special exalted domain. Roquentin, hearing a record of a fairly sleazy song, "One of These Days," notes that the record is scratched but not the song, which exists independently of its innumerable playings on the same and similar discs and does not wear out as the records do; the

writer, as well as the singer of the song, are therefore somehow saved.

The belief is widespread and pertains to artworks as a class: I can hit the man who *plays* Hamlet with a ripe tomato, but I cannot hit Hamlet with one, and when members of the audience find this as comical as I had hoped they would when I threw it, they are laughing at the hapless actor, not at Hamlet, who remains unsullied by the attack and can indeed only be touched by such as Laertes. Yeats supposes he can escape the mutabilities of nature by becoming an artwork—"Once out of nature I shall never take my form / From any natural thing"—and draws just this same contrast between the teeming sexualized world of ebbs and flows and the changeless realm of art. Keats embroiders on the same theme in "Ode to a Grecian Urn" with its unheard melodies (heard only by the Maiden and the Lover) and eternally unravished bride. Schopenhauer exalted art in the same vein, as an escape from the urgencies of the will into a realm of forms little distinct in ontological intangibility from their Platonic counterparts: "Art, the work of genius," Schopenhauer rhapsodizes, "repeats and reproduces the eternal ideas grasped through pure contemplation, the essential and abiding in all the phenomena of the world." All of these are glorifying theories, ironically vesting works of art with the same magnificent properties Plato inpugned them for lacking in contrast with the forms. But for the moment it is only worth remarking that the same relationship in which a song stands to its recordings is shared by the weather report with *its* recordings; that a false tooth made by a Grecian goldsmith would stand as much outside nature through the fact that it is false as anything else he might make through his craft; that the problem raised by the poem and its various copies could be raised in connection with a government agricultural pamphlet on the sexing of chickens (you can burn one of the darned pamphlets, a Vermont farmer might remark, but you can't burn the report itself.) And perhaps the entire concept is but an instance of the vexed question of the status of properties and universals. But whatever the case may be in this regard, it is a fact the two works identified by Borges, that of Cervantes and that of Menard, would generate classes of indiscernible copies, the one class copies of the work of Cervantes, the other copies of that of Menard: but these would be copies of different, even importantly different, works, though nothing would be easier than to mistake a copy of Cervantes for a copy of Menard. Two copies of the Cervantes work are copies of the same work, as are two copies of the Menard work; but a copy of Cervantes and a copy of Menard are copies of different works, though they look as much like one another as do paired copies of the same work. The question then is what makes them copies of *different* works? It is a consequence of a the-

ory of Leibniz that if two things have all the same properties they are identical, and that identity indeed means that, for every property F, *a* is identical with *b* in case, whenever *a* is F, so is *b*. It must follow that if the works in question have all the same properties, they must be identical. But Borges' point is that they do not. They have only in common those properties that the eye as such might identify. So much the worse for the properties that meet the eye, then, in individuating works of art. And Borges' example has the philosophical effect of forcing us to avert our eye from the surfaces of things, and to ask in what if not surfaces the differences between distinct works must consist.

Borges tells us that the *Quixote* of Menard is infinitely more subtle than that of Cervantes, while that of Cervantes is immeasurably more coarse than its counterpart even though every word contained in the Menard version can be found in Cervantes' and in the corresponding position. Cervantes "opposes to the fiction of chivalry the tawdry provincial reality of his country." Menard on the other hand (*on the other hand!*) selects for its reality "the land of Carmen during the century of Lepanto and Lope de Vega." These are of course descriptions of the same place and time, but the mode of referring to them belongs to different times: it would not have been feasible for Cervantes to refer to Spain as "the land of Carmen," Carmen being a nineteenth-century literary personality familiar, of course, to Menard. And "the tawdry provincial reality of his country" is a false characterization when applied to Menard's book, since the country designated is Spain and Menard was a Frenchman. It would have been ridiculous for Menard to have opposed the fiction of chivalry since that literature had already long since been demolished by Cervantes; and though Menard was perhaps making an oblique characterization of *Salambô* as a piece of historical fiction, no such intention would have been possible for Cervantes, who was after all a contemporary of Shakespeare. "The contrast in style is also vivid," Borges writes: "The archaic style of Menard—quite foreign after all—suffers from a certain affectation. Not so that of his forerunner, who handles with ease the current Spanish of his time." Had Menard lived to complete his (his!) *Don Quixote*, he would have had to invent one character more than was required of Cervantes' fancy, namely the author of the (so called uniquely in Menard's case) "Autobiographical Fragment." And so on. It is not just that the books are written at different times by different authors of different nationalities and literary intentions: these facts are not external ones; they serve to characterize the work(s) and of course to individuate them for all their graphic indiscernibility. That is to say, the works are in part constituted by their location in the history of literature as well as by their relationships to

their authors, and as these are often dismissed by critics who urge us to pay attention to the work itself, Borges' contribution to the ontology of art is stupendous: you cannot isolate these factors from the work since they penetrate, so to speak, the *essence* of the work. And so, graphic congruities notwithstanding, these are deeply different works. It is a matter worth speculating upon how indictments of the so-called Intentional Fallacy survive the literary achievement of Menard.

We may reflect for a moment on the relationship in which the two works stand to one another apart from the fact of their retinal indiscernibility. To begin with, in contrast with our array of red squares—each of which may be an independent creation in the sense that the artist who painted *Kierkegaard's Mood* had no knowledge of, say, *The Israelites Crossing the Red Sea*, so that the outward resemblances between the two works are matters of pure coincidence—Menard's work is not a miracle of coincidence: the preexistence of Cervantes' work enters into the explanation of Menard's work. Moreover, Menard is conscious of his predecessor as a predecessor: his is not the sort of case illustrated by Rodin who discovered that one of his *Ombres* from the *Porte d'Enfer* was an exact replica, rotated through ninety degrees, of the figure of Adam on the Sistine ceiling, sketched and admired by Rodin forty years earlier on a pilgrimage to Italy. Menard did not *discover* that what he had written was word for word what Cervantes had set down. His aim was to recreate a work already well known to him. So what he produced was a work and his: it was not a copy therefore, since any fool could copy Cervantes' work and the result would be just that, a copy that would have only the literary value of the original. It would require only those skills required by facsimilitation; the copyist would be merely a mechanism of duplication, like a xerox machine, and without having to have the slightest literary gifts; whereas Menard's act would be a literary achievement of some even amazing sort.

A forgery of so famous a work bespeaks that sort of gullibility involved in undertaking to convince the Duke of Wellington that you are the Duke of Wellington: it would be a fiasco. Menard's audience would have to be a subtle audience and realize, in reading his work, that it was addressed to a reality already including the work of Cervantes as a historical feature of itself, so that reference to the earlier work would be part of what the later work was about. Nor is Menard's a quotation of the original. There is a difference to be marked between a copy and a quotation, in the respect that a copy, as suggested, merely replaces an

original and inherits its structure and relationship to the world. A number of persons who receive copies of the same letter receive in effect the same letter, and stand in exactly the same relationship to the information the letter conveys. But if one of them, in a letter of his own, should quote the letter, what he writes is not a copy, since it denotes the letter rather that what the letter itself denotes and has, in consequence, a different subject and so a different meaning. It is a general truth that quotations do not really possess the properties possessed by what is quoted: they *show* something that has those properties but do not have themselves. A quotation cannot be scintillating, profound, witty, or shrewd; or, if it is, these qualities attach to the circumstances of quotation and not to the passages quoted. There are, indeed, theories of quotation according to which quotations lack any semantical structure, simply displaying what lies within the space marked by quotation marks, naming, as it were, the passage thus embraced; and a *name* either is without structure or at least will have a different structure than what is named by it. But in any case, if Menard were quoting that work, what his would be about would just be the book of Cervantes rather than "the land of Carmen in the century of Lepanto and Lope de Vega." Again, his cannot be easily assimilated to the concept of imitation, at least not if we retain the implication that an imitation x is not an x. Cervantes had his imitators and epigones, to whom he responds savagely and sadly in the second part of his masterpiece; but certainly Menard would have been none of these. Nor is it an imitation *Don Quixote:* it is a real *Don Quixote*, but Menard's rather than Cervantes'. And in some deep way it is an extremely original work, so original, indeed, that we would be hard pressed to find a predecessor for it in the entire history of literature. Who before Menard would have had the daring to attempt to rederive out of his own creative impulses a work which sprang from so different a set of impulses at so different a time and in the breast of so different, and in a way so much less sophisticated, an artist? It is worth thinking of another of Borges' mad literati, about whom he writes in *The Chronicles of Bustos Domecq*, who applied and generalized upon the principle of what Borges speaks as the "amplification of the unit." The principle is more or less this: Eliot took whole lines from other poets and incorporated them into his own work; Pound took over large sections of Homer in the *Cantos*. Borges' figure went one step further and took over whole works, such as *Captains Courageous* or *Huckleberry Finn*. To be sure, there is a question of what *work* of his incorporated these, and I suppose all that would have remained, were we to subtract *Huckleberry Finn* from *his Huckleberry Finn*, would be simply the principle of amplification itself. Still, this

writer's gift was exhausted by his powers of selection: he took over whole works, whereas Menard wrote a new work, and the difference in scale is evidenced by the fact that the most that Menard attained to in fact was a fragment.

Finally, I think, Menard's work cannot be considered a repetition of Cervantes'. Simply because two works resemble one another does not mean that the artist of the one is repeating the artist of the other. The painter David Burliuk once told me that he painted the things he loved: his wife, his friends, his part of Long Island. He also loved paintings, among others the *Shrimp Girl* of Hogarth, which he painted several times. These paintings represent the *Shrimp Girl*, much as others represent aspects of Hampton Bays. Well, suppose Burliuk were to love one of his own paintings as much as he loved Hogarth's, and he painted, in the same spirit as he did the *Shrimp Girl*, his own *Portrait of Leda Berryman*. He no doubt loved Leda, since he painted her, and loved the painting of Leda, since he painted *it*. But it would be difficult to say he was repeating himself, since the subject of the one painting was another: Burliuk's well of inspiration had not run dry. Nor, again, was he copying himself. We judge a copy by how accurate it is, and if someone were to criticize one of these paintings of paintings on the grounds that it was inaccurate, Burliuk might have laughed; the question of accuracy cannot arise when the painting in question is not to begin with an attempted copy. If inaccuracy is irrelevant, so is accuracy, leaving the possibility that the painting of *Portrait of Leda* should be exactly like the *Portrait of Leda* in every touch and detail. We must be extremely cautious in claiming that an artist is repeating himself or, for the matter, another artist. Schumann's last composition was based on a theme he claimed was dictated to him by angels in his sleep, but was (in fact?) the slow movement of his own recently published violin concerto. (Is it altogether an accident that Schumann was working on a book of quotations at the time of his *Zuzammensbruch*?) Robert Desnos' *Dernier poeme à Youki*—"J'ai tant rêvé de toi que tu perds ta realité"—is simply, according to Mary Ann Caws, "a retranslation into French of the rough and truncated translation into Czech" of his earlier and famous poem addressed to the French actress Yvonne George. But was Desnos delirious when he addressed this poem, at his death, to Youki, or think she was Yvonne George, or think it was a new poem—or *was* it as much a new poem as Menard's was a new novel? I mention Schumann and Desnos together with Burliuk in part to show that the problem transcends the differences between these arts.

Repetitions are maddening, but the main question is whether indeed these are really describable as cases of it. In Holland, in the seventeenth

century, artists who found a particular subject salable did not hesitate to repeat it for commercial purposes, and a certain stigma seems to attach to this treatment of paintings as commercial products, as if there were something incompatible between the concept of artistic authenticity and the application of what amounts to a kind of formula. No doubt Canaletto used something like a formula, but it is also possible to regard each work as a fresh artistic response to Venice. Morandi addressed himself over and over again to the painting of bottles, a kind of obsession, but would it be right to suppose that he had a formula or that he was repeating himself? What makes the difference between his case and that of Chagall, who has often been charged with that sort of repetition? It cannot be *just* that Chagall's works all resemble one another in treatment and topic, since this is true of Morandi as well.

The case of Menard can only carry us a certain distance toward the resolution of our problem. Close attention to the relationship between his work and that of Cervantes brings to light a number of deeply interesting relationships between the identity of a work and the time and place and provenance of the work, so much so that identification of its subject and style cannot be effected in complete historical abstraction. And by asking the relationships in which two seemingly indiscernible objects can stand to one another, we have brought to the surface a variety of elements that as a matter of intuition belong to the concept of an artwork. Still, the pairs involved are in either instance artworks, or appear to be, and the question is whether considering them helps to illuminate the boundary of ultimate concern to us—namely what separates any work from a mere object which, though it may resemble it precisely, happens not to be a work at all. Perhaps enough has been brought out through this brief exploration to enable us to begin to discern some of the things that appear to be involved. So let us construct one further example in order to make them explicit.

Neckties, by common consent, are absurd items of masculine haberdashery, and some concerted effort has been made in late times to rationalize costume by eliminating them in favor of turtlenecks or such explicit pieces of ornamentation as lovebeads. At the same time, neckties have begun to make an appearance in works of art. I have not traced the entire history, but the first appearance I am aware of was a representation in a witty etching by Jim Dine, showing a singularly banal striped cravat with the punning title "The Universal Tie"— which sounds cosmic and as if it were to have been an allegory of a Whiteheadian nexus, or the principle of causality, or the love that

moves the sun and the other stars. Not long after, a gigantesque tie stitched on a gigantesque shirt was exhibited by Claes Oldenberg, and then a combine made of a number of recognizably real neckties, discards from the world of fashion, appeared in a work by John Duff entitled "Tie Piece." In 1975 the floodgates were opened, and an entire exhibition was given over to ties in a gallery on Madison Avenue: "Artists are now obsessed by ties," Gary Lejeski is quoted by the *New York Times* of 10 January 1975 as having said: "Some artists love ties, some hate them, some dissect them. We have ties made of pins and ties made of hair." A stained-glass necktie was broken, and we must console ourselves with the windows at Chartres, though these themselves are succumbing to a recent effort to preserve them, which is another story.

In any case, let us suppose that just before his death, as the crowning work of his already amazing corpus, Picasso himself had made a tie, which I shall describe this way: Picasso, who of course had not worn one for years, found one of his old ties and painted it a bright blue all over. The paint was applied smoothly and carefully, and every trace of brushstroke was purged: it was a repudiation of painterliness (*le peinture*), of that apotheosis of paint-and-brushstroke (or drip) which defined New York painting of the 1950s as a movement. Picasso's smooth paint, then, may be reckoned part of the content of the work in roughly the same way in which *absence* of Giottesque perspective must be considered a positive part of the Strozzi altarpiece, if Millard Meiss is right about the deliberate archaism of that work. Picasso's tie (*Le Cravat*) is exhibited with other works from the master's hand, and someone filing past it is heard to mutter that his child could do that. And I want to agree: as far as this object is concerned. So let us imagine that a child gets hold of one of his father's ties and covers it with blue paint, which he makes as smooth as possible with blue paint from the same company (Sapolin) which manufactured the paint Picasso used, "to make it nice" as he explains. I would hesitate to predict a glorious artistic future for this child merely on the grounds that he had produced an entity indiscernible from one turned out by the greatest master of modern times. It is not as if the child had covered the walls of the living room with something not to be told apart from the *Legend of the True Cross*. I am prepared to go further and insist that even though there is the sort of indiscernibility our examples require, what the child has effected is not an artwork; something prevents it from entering the confederation of franchised artworks into which Picasso's tie is accepted easily, if without immense enthusiasm.

And, in order to derive the maximum philosophical structure from the example, let us suppose a forger, a sly opportunist, inserts a blue-

painted tie into the world to the confounding of connoisseurs. He could, to be sure, like Van Meegeren, have invented a gap in his chosen artist's history, to be filled with a forgery that was not a copy, in this instance perhaps a rose-coloured necktie to give a certain historical appropriateness to this chicanery. But we will stick to the simplest example, which makes it possible to imagine a Shakespearean situation of mistaken identities, no laughing matter if you happen to be an artdealer or in the business of insuring artworks. So suppose Kootz (or was it Kahnweiler?) takes every necessary precaution, in spite of which the things in question become comically confused, with these results: the child's tie hangs to this very day in the Palais des Beaux Arts in Luxembourg and is insured for a pile. Picasso naturally disputed its authenticity and refused to sign it; instead he signed the forgery. The original has been confiscated by the Ministry of Counterfacts and lies in limbo with Van Meegeren's *Christ at Emmaeus* and a cigarbox full of pieces claimed to be of the true cross, the one authentic occupant of a vault filled with shams. One day, perhaps, a doctoral candidate under the direction of Professor Theodore Reff will solve what is known in the literature as "Das Halstuchsproblem bei Picasso" by counting threads, though even when the identities are all suitably unscrambled, philosophers of art will have the task of determining the status of a forgery which bears a signature of unmistakable genuineness. But that takes us considerably ahead of our story.

Nelson Goodman, the foremost philosophical artdealer, has concerned himself with questions of forgery in *Languages of Art* (Bobbs-Merrill, 1968): "The hardheaded question why there is any aesthetic difference between a deceptive forgery and an original work challenges a basic premiss on which the very function of collector, museum, and art-historian depend" (p. 99). He says this in a context in which there is an obvious temptation to ask what aesthetic difference it does make, inasmuch as the three tie-objects are indiscernible—though I have heard this attitude expressed in connection with artworks of a measurably greater degree of sublimity than these, and with the intent of dismissing as irrelevant to experiencing them the sorts of allegedly grubby facts having to do with where and when and by whom the thing was done. I have read that the identical examination paper got different grades when the student who wrote it bore some such unhappy name as Elmer or Bertha than when it was presented as a paper by John or Mary, so the name attached to a thing quite plainly enters into our assessment of it. But the attitude expressed here has perhaps the force that such things ought not to figure, that we should give ourselves up to "the work itself." Our recent encounter with Pierre Menard should

imply a cautionary attitude regarding such purist aesthetic imperatives, such ahistorical views of artworks. But then the entire structure of the examples with which we have been working cries out for an answer to the inverse of Goodman's question, whether an unnoticed, and let us even suppose an unnoticeable, difference can make an aesthetic difference. To be sure, we are not yet in a position to ponder aesthetic differences, ours being a prior question of the ontological difference between artworks and their nonartistic counterparts, and there is a question whether this difference, which again is unnoticeable so far as examination of the objects is concerned, can make anything like an aesthetic difference. And it ought to, one feels: the purists who ask us to surrender ourselves to the work itself have supposed, after all, that it is a work to which we are to surrender ourselves, and it is not clear what they would urge regarding objects that are in no sense works, like our fortuitously splattered para-*Polish Rider* (or, if it is in some sense a work, its identity must be so different from that of the *Polish Rider* that, similarity of surface notwithstanding, it would be astonishing were there to be no difference in "aesthetic response," whatever that may be).

Goodman in a curious way rejects one of the conditions of the question, namely the condition of indiscernibility. And it appears to be his view that indiscernibility is only momentary, that sooner or later differences will emerge. Knowing that one of a pair of things is a forgery is already enough of a difference for me to believe that there may "be a difference between them that I can learn to perceive." And this belief, virtually as a regulative principle, "assigns the present looking a role as training toward such a perceptual discrimination." Goodman then goes on to argue that no proof can be given that a perceptual difference may not be found, so things that look alike today may look so different tomorrow that it will seem retrospectively amazing that confusion ever could have arisen. And he enlists as evidence the extreme acuity of the eye and ear in registering astonishing differences on the basis of the most minute changes. So it is almost a problem in psychophysics rather than one in ontology.

There is a great deal to be said for Goodman's analysis. It is beyond question that we may learn to effect discriminations by training, and that we may learn to make exceedingly fine distinctions as between, for example, wines. And often we can learn to see things that would have been invisible before, simply in consequence of the fact that ways of seeing are perhaps transparent to those whose ways of seeing they are, and these may turn, so to speak, opaque when they no longer *are* their ways of seeing. The history of art is filled with such examples. I have little doubt that the contemporaries of Giotto, astounded at the realism

of his paintings, should just have seen men and women and angels in those paintings and *not* a way of seeing men and women and angels which we now recognize as Giotto's way of seeing men and women and angels. Giotto's mode of vision has become a kind of cultural artifact, which anyone can learn to identify. Van Meegeren's forgeries of Vermeer can now be seen as forgeries when they could not have been so seen in the 1930s, not because of chemical or x-ray analysis, and not in terms of refined peering of the sort Goodman describes, but in virtue of the fact that they can now be seen as full of the mannerisms of 1930s painting, mannerisms which, in 1930, would not have been seen as mannerisms, as ways of representing: when we are *living* a period of history, we do not necessarily know what that period will look like to a future historical consciousness. So the mere passage from one period to another may bring to the perceptual surface features that were hidden before. Finally, it may be said that it is virtually a matter of logical guarantee that there has to be a difference between two things not identical.

But that is as much, I think, as can be said finally for Goodman's analysis. The logical point, while it guarantees that if a is not identical with b, then there must be a property F such that a is F and b is not F, does not require that F be a *perceptual* property, and we have had enough practice with indiscernibilia to be able to offer actual instances where the differences are not such as may be registered by the senses. So it is possible that future investigation may reveal differences between two objects which are not perceptual differences, allowing therefore the logical possibility that two things may be perceptually indiscernible. Knowing that there is a difference may make a difference to the way we look at two works, and even to the way in which we respond to two works, but the difference need not be in the way we see them. And it is striking as a matter of concealed bias on Goodman's part that he should spontaneously have assumed that all *aesthetic* differences *are* perceptual differences. Furthermore, I think, whatever may be the case with aesthetic differences, even supposing Goodman is right, and that sustained and protracted peering and comparison will ultimately make a difference, so that we can learn to tell Lippo Lippi from Filippino Lippi and Vermeer from Peter de Hooch, as we learn to tell vogne romanée from beaujolais, still this will not help us with the serious ontological question, namely that of deciding which is which between artworks and nonartworks. The three neckties, for example, may be noticeably different without this entailing that the noticeable differences will identify which of them is an artwork and which is not, and this primarily through the fact that it is not clear that concepts like

"work of art" and "forgery" are translatable into sets of simple percep-
tual predicates. We may in some cases be able to tell forgeries by in-
spection without its following that "forgery" is a perceptual concept.
Its being a forgery, one would think, has something to do with its *his-
tory*, with the way in which it arrived in the world. And to call some-
thing an artwork is at least to deny that sort of history to it—objects do
not wear their histories on their surfaces. There is one final point: to
suppose that the interesting differences between these three objects has
anything to do with perceptual differences is almost comically to mis-
classify their artistic interest. There are paintings that reveal them-
selves only through trained and careful scrutiny: the compositions of
Poussin, or of Cezanne, or the amazing touch of paint in Morandi, are
matters for appreciation and connoisseurship. But *these* objects are not
of this order; connoisseurship here is radically irrelevant, for Picasso's
necktie has all the subtlety of a mackerel thrown in one's face. What-
ever the aesthetic interest of the one indisputable work, whichever one
it may be, it cannot lie here.

It is of more than incidental interest that none of the artists
just mentioned could as a matter of artistic fact have created the work
we are pretending was created by Picasso. The fact bears mention be-
cause it is not, as with J, simply that he happens to have been an artist
that Picasso's necktie, but not that of the child, is a work of art, for the
thing has to stand in the right relationship to the person who causes it
to come into existence, even if he or she happens to be an artist. There
was a certain sense of unfairness felt at the time when Warhol piled the
Stable Gallery full of his Brillo boxes; for the commonplace Brillo con-
tainer was actually *designed* by an artist, an Abstract Expressionist
driven by need into commercial art; and the question was why War-
hol's boxes should have been worth $200 when that man's products
were not worth a dime. Whatever explains this explains, as well, why
the primed canvas of Giorgione, in our first example, fails to be an
artwork though resembling in every respect the red expanses which are
such.

In part, the answer to the question has to be historical. Not every-
thing is possible at every time, as Heinrich Wölflin has written, mean-
ing that certain artworks simply could not be inserted as artworks into
certain periods of art history, though it is possible that objects identical
to artworks could have been made at that period. It is easy to appreci-
ate the force of this dictum in the forward historical direction. A sculp-
tor who produced an archaic torso of Apollo in the period of Praxiteles

would have gone hungry, since the artworld by then had evolved so as to exclude this as a possible artwork unless it has been made when appropriate, and lingered on as an antique. The artworld of the period would have excluded from the expressive vocabulary of its contemporaries the deliberate exploitation of archaic forms, in contrast with the situation today when, if an artist should choose to employ archaic forms, this would be tolerated; but of course if someone uses limestone stele today, they could hardly have the same meaning as they would have had when Stonehenge was new. And if today an artist exhibits a painting in the style of Watteau, we should hesitate before declaring him out of date: this may be a self-conscious archaism, in which case he stands in a very different relationship to the Rococco style than Watteau would have done. In any case, these examples involve going against the direction of evolution, and are something of the same order of anachronism through which a dinosaur's egg might hatch at Malibu Beach. I am more struck by the reverse direction, in which we are to imagine an object from a later art-historical stage having emerged at an earlier one, a much earlier one: say a pile of hemp of the sort Robert Morris exhibits now and again turned up in Antwerp in the seventeenth century when it could certainly have existed as a pile of hemp but almost certainly could not have existed as an artwork, simply because the concept of art had not then evolved in such a way as to be able to accommodate it as an instance. Such speculations are, of course, exceedingly chancy. Duchamp's snowshovel was pretty banal in the early twentieth century, simply because chosen from the set of indiscernible industrial products from a shovel factory, with its peers to be found in garages throughout the bourgeois world. But the identical object—a curved sheet of metal attached to a wooden stick at the other terminus of which was a shape like today's snowshovel handle—would have been, I should think, a deeply mysterious object in the thirteenth century; but it is doubtful that it could have been absorbed into the artworld of that period and place. And it is not difficult to conceive of objects which, though they would not have been works of art at the time they were made, can have in a later period objects precisely like them which are works of art.

Pliny tells us of an object, indeed an object made by artists, which was regarded as a wonder in its time: a painting of a line within a line within a line ("of a line" does not mean that the painting had these lines as subjects, but consisted just of a line within a line within a line). One painter went to visit another, found him to be out, saw a blank panel, and drew upon it freehand a perfectly straight vertical line, so exact and orthogonal that it might have been done with a ruler. Confident

that his friend would know who could have turned this feat, he went for a stroll. His friend returned, saw a challenge on the panel, and drew a line down the middle of his friend's line, again freehand, but the skill in having this line bisect a line would be comparable to the difference between walking a straight line and walking that same straight line as a tightrope. So he split that first line in two, giving it a width it would not have been regarded as having to begin with. The second artist returned, drew a third line splitting this one, and won this amiable contest. The artists in question had demonstrated some spectacular reflexes, indeed a kind of skill that would be almost athletic, and people were enough amazed that they flocked to gasp at it (a hoax would have been for the lines to be laid down with ruler and ruling pen). But it was not counted an artwork, just a tour de force of superb dexterity. Something just like it, and with no one especially caring how the strips arrived on the canvas, could be exhibited today on Madison Avenue, and considered a synthesis of the breakthroughs of Barnett Newman (whose Zips come to mind) and Frank Stella (whose mechanical edges come to mind). Parahesios could not have imagined how such a thing could be a work of art, unless he could imagine something it was an imitation of (length of striped muscle?) and then he would have demurred at this choice of subject, since that was a relevant factor as well. In any case, it is for reasons of historical possibility such as these that the identical object could have been an artwork from the hands of Picasso—but not from Cezanne, who just happened, let us suppose, with his characteristic meticulousness, to have used this particular piece of cloth as a paintrag (we know that he wiped his brush after each stroke) and, because of his equally celebrated parsimony, did not throw it away until he had completely used it up, the result being a tie-shaped cloth covered from edge to edge with the same blue Picasso may be supposed to have used to execute his work. It is not clear that Cezanne could even have framed the *intention* to make an artwork this way, since the concept through which the intention could have been formed was not such as to allow its formation at that point. But Picasso was famous for transfigurations of the commonplace. He had made the head of a chimpanzee out of a child's toy; a goat's thorax out of an old wicker basket; a bull's head out of bicycle parts; a Venus out of a gasjet—and so why not the ultimate transfiguration, an artwork out of a thing, "Cravat" out of a necktie? There was room in the space of the artworld by then and in the internal structure of Picasso's corpus, which did so much to define the space of the artworld, for such an object by Picasso there and then. Cezanne, however staggeringly original within the boundaries of painting, had only the option of exploring the territory the boundaries circumscribed

without transforming the boundaries themselves, and had only the option of making apples and mountains out of paint.

These considerations serve solely to show, however, that it would have been possible historically for such an *object* to be an artwork at one time and not at another. It draws attention, as did our discussion of Pierre Menard, to certain contextual features of the sort which have a kind of application in connection, for example, with the description of something as witty. You cannot identify something as witty, by any necessary attributes of it, for the same line in one context can be witty there but not in another, so that it would be pointless to try to memorize a number of witty lines unless one also remembers the context of their utterance, which may never arise again. Disraeli, at the end of a dinner party in which everything was cold, said, when the champagne was brought in, "At last something warm"—which was devastatingly witty, though the words "At last something warm" are not as such exemplary of wit. Context makes such transformations from words to wit possible. But the distance from possibility to actuality is immense, and we have gone not very far in approaching a solution to our problem.

W hat, one may ask, is the *subject* of "Cravat"? Or has it a subject? In a way, one wants to say: this too is an historical question and in part at least depends upon what subject Picasso supposed it had. Suppose, however, that he denied, in the boorish manner of J at the beginning of our exploration, that it had any subject. I want to accept that answer, and apply to it considerations briefly alluded to at the beginning. Perhaps it does not have a subject, but the question of what its subject is, is not ruled out and rejected out of hand. The request for its subject would, in the case of what the child wrought, be rejected out of hand. To be sure, it may have significance as a gesture, revealing deep oedipal hostility toward the father (think of the sexual symbolism of the necktie!) and so be an expression of that; but though it is a symptom of something, it is not a thing with a subject, for reasons we shall explore later. Or, if the case is too marginal, at least the paintrag of Cezanne does not have a subject, being merely a paint-covered thing. So Picasso's tie and Cezanne's tie have no subject, but the *force of saying this* is different in the two cases. In the one case, the work lacks a subject because Picasso willed that it not have one. In the other case, it lacks one because it is logically of the wrong sort to have one, being only a thing (if also an artifact). There is an analogy to this elsewhere: asked his reason for raising his arm, an agent may answer that there was no reason, that he merely did it, *apropos de rien*, with no ulterior motive.

He may be wrong—there may be, may always be, a hidden reason—but if he is right, he is giving a negative answer to a question, not, as it were, negating the question. The question is allowed application, but within its range no positive answer is available. By contrast, if a man's arm moves in such a way that it cannot be reckoned an action, but is a spasm of some order, or merely happens to occur for causes of an unknown order, then, because it appears to us to have been an action, we might again ask why; and when he says there was no reason, he would be excluding it from the domain within which the question applies, negating, as just said, the question as such. The relationship then between an artwork and a thing just like it is in this respect analogous to the difference between a basic action and a bodily movement just like it, to all outward appearances.

Let us now return, before considering the other two ties, to the case of the fortuitous splat that looks like the *Polish Rider*. Once more we may ask what it is about, what its subject is, and the answer is (I should think) that it has no subject, though there might seem an argument to the effect that, given parity of form with the *Polish Rider*, it should be about whatever the *Polish Rider* is about, and ambiguous if the latter is ambiguous. But of course it is not even clear that the splat has any structure, even if it is congruent with an object—the *Polish Rider* itself—which has one; and even if it did, it would be far from plain that it inherits meaning from its structural counterpart.

Consider, if this should prove difficult to accept, the case of simple photography, where nothing more complex is involved than the bare taking of a snapshot. Let the snapshot be a photograph of the World Trade Center. We know pretty much what conditions must hold for this description to be true: it must resemble the World Trade Center itself, from whatever angle is relevant. And in order not to complicate the case, let it not be in any respect blurred. But more than this, it must be *caused* by the World Trade Center itself, radiations from which interact photochemically with the treated paper to produce just that pattern of darks and lights. Now imagine next to this a piece of photographic paper bearing the identical pattern of darks and lights, but let this one not be caused by the World Trade Center. Perhaps it materialized mysteriously on the paper. Perhaps it was the result of accidentally tripping the shutter while the camera was pointed toward the water off Cape Canaveral, and by that sort of coincidence upon which we are bit by bit erecting a philosophy of art, the result looks exactly like the photograph of the World Trade Center. But it is not that, because the causal condition for being that fails. The differently caused photograph is of something different from our first photograph, and it is pos-

sible to imagine causal histories inconsistent with claiming that the photograph is of anything at all, hence with claiming it in the first place to be a snapshot. I think these considerations have an immense philosophical significance, only part of which might be worth sketching out here, since the interconnections with our topic are so striking.

In the *Meditations,* Descartes supposes that "les choses qui nous sont representées dans le sommeil sont comme des tableaux et des peintures." He also raised the question whether we can tell whether we are dreaming or awake; and, as he was also a representationalist in matters of perception, what is represented when we are awake are "comme des tableaux et des peintures." The difference is that when we are awake and perceiving veridically, the representations are supposed to be caused by what they also resemble, so that a true perception is very like a snapshot, as I have just characterized it. But to the degree that this similarity is compelling, there is an immediate problem: Descartes supposes that we can identify a representation (an *idée*) as *of* this or that— of himself, for instance, seated at a desk in a dressing gown, considering the problems of the external world, and that this identification goes through despite whether he is only dreaming this or actually perceiving himself thus. But if indeed a true perception is like a photograph, then for just the same reason that a photograph is only of what causes and resembles it, while something exactly like it but with a different causal history is *not*, so an *idée*, or representation, is of what we believe it to be of only if *it* has the right causal history as well, while something exactly like it with a different causal history is *not*. Hence, if I am right in characterizing an *idée* as *of* something, I cannot intelligibly doubt that it has the sort of causal history it must have if it is to be identified as I have identified it. Either the doubts are unintelligible or the identification is wrong. So to the degree that my ideas are "clear and distinct," namely as *of* this or that, they must, if the representationalistic theory is right, exactly correspond to what I am constrained to suppose their causes must be, given that they are identified as they are. Of course, the representationalistic theory itself may be wrong and probably is wrong, but it is worth noting that at least one element in the structure must be sacrificed: either there is no problem of the external world, or I cannot identify representations, or ideas are not representations after all.

It is of course not our business here to sort Descartes theories out further, but his famous dilemmas provide yet another occasion for applying the thought that certain things which exactly resemble one another may not be of the same thing, or one of them may be of something only if the right causal history is presupposed while its counterpart may not be *of* anything at all. In the *Investigations,* Wittgenstein considers a

tribe which happens to use as decorations the same forms which we use in the calculus. Thus they might have

$$\int [F(x) + g(x)]dx = \int F(x)dx + \int g(x)dx.$$

But it does not follow that their decoration *says* what *this* says

$$\int [F(x) + g(x)]dx = \int F(x)dx + \int g(x)dx,$$

that the integral of a sum is equal to a sum of integrals. *How these marks arrived on a surface* determines whether the question of meaning arises, and hence the question of truth. Perhaps, to be sure, what is on the walls of the native's tent has itself a meaning; perhaps it is more than just a decoration. But until I learn what the notation means for them, I am not sure it has even the *syntax* of the formula for sums of functions.

L et us, this established, suppose that the Picasso tie indeed has a subject, and let us further suppose, in view of the way in which I described the smoothing out of all that blue paint, that part of what the work is about is painting. In the painting of the 1950s, the brushstroke was of such preeminent importance, because it immediately conveyed the action of depositing itself on the canvas, that it would have been unthinkable to conceal it, say in the manner of the glassy surfaces of academic painting of a certain era. And since painting was virtually defined as action—action was the cause and substance of these works—the brushstroke was a deeply charged emblem. Perhaps we can interpret the obliteration of brushmarks by Picasso as a polemical reference to this, saying, in effect, that there are many ways of performing the actions of painting than the narrow vocabulary of gestures tolerated by the Abstract Expressionists. And the point of this suggestion is that someone not privy to the metaphysics of brushwork would be blind to the significance of smooth paint in *Cravat*, in much the same way as someone unfamiliar with the art history of Florence and Siena after the Black Death, as given us by Millard Meiss, would be blind to the absence, in this instance the deliberate absence, of Giottesque perspective in the Strozzi altarpiece—would be blind to the nonnatural relationships between divine and human figures, these having been naturalized in Giotto. The deliberate rejection of a mode of representation implies a rejection of a whole way of relating to the world and to men, and in this case was an artistic effort to reestablish a relationship disastrously distorted by human arrogance in the name of realism, such as was felt to be found, in the paintings of Giotto. Someone looking at the work of Nardo da Cioni or Andrea di Orcagna, and who has mastered

some knowledge of painting styles, might easily locate these in the period before Giotto, and indeed these works could easily have been painted before Giotto. But they could not have meant what we have been taught to understand them to have meant, since Giotto was not yet born and the Black Death had not laid waste the cities of Florence and Siena.

This would then be one reason why Cezanne, even had his necktie been a work of art, could not have it mean what Picasso's means, since the relevant events were in his future and could not form a possible subject for art. And it would equally be a reason why the child's necktie could not mean, supposing it has a meaning, what Picasso's tie does; the child could not be expected to have internalized the recent history of the artworld, or to appreciate the mad polemics of the brushmark. It is not just that the shape of art history must change before such statements are possible, but that one must have *internalized* that history if one is to make that sort of statement. And this the child cannot have done. Or, to the degree that he improbably did know about Pollack and De Kooning and Kline, to that degree must the expression "My child can do that" undergo a transformation in meaning. It would be a remarkable child rather than a seemingly unremarkable work.

The status of the forgery, in this perspective, perhaps is only this, that it too stands in the wrong relation to its maker to be supposed a statement of his: it only pretends to be a statement of someone else's, namely Picasso. Forgers have varieties of motives. Van Meegeren wanted to prove that he could paint as well as Vermeer, but we would hardly suppose that this is a statement he makes by means of his emulation of Vermeer, only a statement he could justify on the basis of his trumperies. And whatever statement Vermeer might have made had he made it through the paintings in fact confected by Van Meegeren, these cannot be the statements made by means of *these* paintings since they were not painted by Vermeer. Van Meegeren is after all in a different position altogether from an artist who happened, in 1935 or whenever, to paint in the manner of Vermeer and to make whatever statement such deliberate stylistic anachronisms would enable a painter to make: perhaps a statement about the decadence of the Dutch art of the time.

Returning again to J's sullen square of red paint which he declared to be a work of art, perhaps only this is to be said: it came into existence in a theoretical atmosphere in which the boundaries between art and reality become part of what makes the difference between art and reality, and incorporating its boundaries in the work it manages somehow to transcend them. It becomes an artwork by incorporating a definition of itself as such. It still remains pretty empty.

We have gone, I think, no great distance in understanding the nature of artworks in this long and labyrinthine discussion: we have only seen the pertinence to this concern of a certain sort of question, the question of *aboutness*, which will easily be recognized as having relevance to a far wider class of things than the class of artworks. We have a considerable distance to go before we can pretend to much by way of philosophical achievement. But before we take a next step, let us pause to ponder J's painting in the light of some deep questions put by the philosopher Francis Sparshott, who asks, "Has any critic ever accepted as true a statement made by an empty painting that he was previously disposed to think untrue?" And, "Are there any statements made by empty paintings which could or would be interesting?" Finally, "Is the statement made by an empty work perhaps always of the form, 'There exists a painter who can get away with exhibiting such a painting as this in this gallery at this time?' " (in *Journal of Aesthetics and Art Criticism,* 1976, pp. 79–80).

Imagine that instead of a painter we think of a printmaker who splashes ink on a plank and prints it, showing just that. One artist did that, my friend Shiko Munakata, the great modern master of the Japanese woodcut. Shiko once wrote the following:

> I advise the layman to spread India ink on an uncarved board, lay paper on top of it, and print it. He will get a black print, but the result is not the blackness of ink, it is the blackness of prints.
>
> Now the object is to give this print greater life and greater power by carving its surface. Whatever I carve I compare with an uncarved print and ask myself, "Which has more beauty, more strength, more depth, more magnitude, more movement, more tranquility?"
>
> If there is anything here that is inferior to an uncarved block, then I have not created my print. I have lost to the block. (Yojuro Yasuda, ed., *Shiko Munakata* [Charles E. Tuttle, 1958], p. 5)

The critic certainly can learn something from this statement: the distinction between the black of the ink and the black of the print would redeem any essay in the philosophy of art, few of which are so stunningly enlightening as this. Could he learn this by looking at a black print if he knew what statement Munakata was making? I think he could, though clearly not by studying the print alone without benefit of understanding. Munakata's marvelous print of Mount Fuji, from his composite work "The 53 Stations of Tokaido," comes as close to a black print as any of his I know, but very few who see it appreciate its profundity. Would there be any point in doing a black print more than once? I could think: one might decide to do no other kind, *everything* else "losing to the block." Could "anyone get away with it"? I am not

sure what "it" means, but I know that anyone who understands the black print would no longer understand what "getting away with it" meant. Well, it may be argued that these prints are not all that empty after all—in contrast to J's work—and that the deep example of Munakata is not helpful after all. I will accept this, but it is going to mean that it is awfully difficult just to *tell* that a given print—or painting—is empty.

Philosophy and Art

3 Since it is my belief that philosophy has a special subject matter, and that in consequence not everything is a suitable subject for philosophy, it must follow, from the fact that art should be spontaneously susceptible to philosophical treatment, that an investigation of why this is so must tell us something at once about philosophy and about art—if my belief is true. In this chapter I shall therefore be as much interested in the philosophy of art as in what such a philosophy might be supposed primarily addressed to, namely art itself. So, as with any serious philosophical inquiry, this one will be immediately meta-philosophical and self-conscious, philosophy having that peculiar reflexive trait which Descartes pretended to discover in thought itself: whatever I think about, I at the same time learn something about it *and* about thought, so that the structures of its objects as revealed by thought are revelations about the structures of thought itself. The nature of philosophy is such as to be logically coimplicated with anything it might treat of, and this, if true, must raise to prominence a question very seldom mooted in the philosophy of art: why it is that art should be that sort of thing of which there *can* be a philosophy, and why, as a matter of historical fact, there has not been a major philosophical thinker from Plato and Aristotle, to Heidegger and Wittgenstein, who has not had something to say about this subject.

To be sure, this may be merely inductive: it might just be an external fact about philosophers that they have all addressed themselves to art, however intrinsically philistine they themselves may (like Kant) have been, simply because it was something they were expected as philosophers to do. I think otherwise: I believe the set of things of philosophical moment to be logically closed, and that the energy of philosophy requires the serious and systematic philosopher (and there can be no other kind) sooner or later to work through the whole cycle of internally related topics, so that inevitably he will come to art, if indeed it falls within that cycle, supposing he has started elsewhere, or that he will come to whatever else is within the cycle if he has begun with art. Nietzsche, who was deeply sensitive to art, began his philosophical cycle with that, but went on systematically to touch base with every major philosophical question, while Kant, who appears to have been

singularly insensitive to art, completed his cycle with what stands as one of the major philosophical treatments of art in the entire literature. It is difficult to think of a philosopher who wrote solely about art in abstraction from the wider conceptual matrices in which in fact and probably in principle it has always been embedded.

It is for this reason that the nonphilosopher who turns to what philosophers have written about art is apt to turn away in disappointment. It is not only that not everything about art happens to be that through which it makes its natural entry into philosophical consciousness, and that much that makes art entrancing and absorbing and important often is simply philosophically irrelevant. In addition, to just those points of intersection between art and the other things of philosophical interest, the philosopher is apt to bring to bear the entire weight of his system, and to pick from art only that which *happens* to be pertinent to his concerns. So not only must the lay reader find that in order even to begin to appreciate what the philosopher has written, he must acquaint himself with the system in question—come to terms with the critical structures of Kant, internalize the ontological schemata of Plato—and then realize that it may not have been worth the effort, considering how little of art, as a phenomenon, gets redeemed by the treatment and how much gets left out, puzzlingly discarded, as though the meat were cast out and the shell of the egg kept for inscrutable reasons. This of course is a constant chronic complaint against philosophies of x on the part of those who have a primary, perhaps just a human interest in x. The philosophies of science and of language, for example, have been subjected to just the same resentments, and it will be a question worth considering why it is that science and language are two further topics of natural philosophical relevance, in a way in which certain things that might superficially be considered close to art are not: fashion, craft, haute cuisine, dog breeding, and the like. Linguists are puzzled as to what, except some more linguistics, philosophers of language can do; and philosophers themselves have often enough been puzzled by this same question, and have become linguists through the backdoor as it were. But the philosophical questions about language are almost inevitably at perpendicular angles to the scientific ones (which does not mean that some of the questions practicing linguists are concerned with are not philosophical questions), and so with science. And so, I believe, with art. It is because, however richly illustrated, philosophy of art only intersects the plane of human interest in art at right angles, philosophical writing on art encourages, and encourages when it is best and most exemplary, the view that the philosophy of art is *deeply* irrelevant to the life of art, that nothing much worth knowing about art can be

gleaned from those dry and eviscerated analyses. Thus philosophers of art and the artworld itself, like facing curves, touch at a single point and then swing forever in different directions. And this reinforces the hostility toward theoretical and intellectual treatment of their activity which has always, from the time of Ion the Rhapsode down to the sturdy irrationalists of Tenth Street and the Club, been congenial to artists.

And so might matters have stood and continued to stand had art not itself evolved in such a way that the philosophical question of its status has almost become the very essence of art itself, so that the philosophy of art, instead of standing outside the subject and addressing it from an alien and external perspective, became instead the articulation of the internal energies of the subject. It would today require a special kind of effort at times to distinguish art from its own philosophy. It has seemed almost the case that the entirety of the artwork has been condensed to that portion of the artwork which has always been of philosophical interest, so that little if anything is left over for the pleasure of artlovers. Art virtually exemplifies Hegel's teaching about history, according to which spirit is destined to become conscious of itself. Art has reenacted this speculative course of history in the respect that it has turned into self-consciousness, the consciousness of art *being* art in a reflexive way that bears comparison with philosophy, which itself it consciousness of philosophy; and the question now remains as to what in fact distinguishes art from its own philosophy. And this then raises the question of what distinguishes the present book, an exercise in the philosophy of art, from being an artwork in its own right, inasmuch as artworks have been transfigured into exercises in the philosophy of art. But this raises to a new level, I expect, the questions we began with in Chapter One, of how something can be an artwork and something else, which exactly resembles it, not—like our humble canopener and our exalted piece of statuary.

In any case, the definition of art has become part of the nature of art in a very explicit way; and inasmuch as it has always been in some measure a philosophical preoccupation to define art (though not as a consequence of a philosophical preoccupation with giving definitions, since philosophy is not just lexicography and the question we are concerned with can be phrased as: why is it that art should be one of the things philosophers have been concerned to define?)—inasmuch as there has been this concern with definition, there must appear a congruence between philosophy and its subject surprising *except* in the case when philosophy has been its own subject. This then makes the suggestion almost irresistible that philosophy and art are one, and the

reason there is a philosophy of art is because philosophy has always been interested in itself, and only has come to recognize that art was a momentarily alienated form of itself. Almost irresistible: but it is a suggestion we might prudently resist. Nevertheless, as the matter has been thrust upon us, *we* had better turn self-consciously to the enterprise of giving a definition of art, which because boundaries between it and philosophy have come into danger of erasure, hardly can escape being a definition of philosophy, indeed a self-definition from within.

In view of the logical symbiosis of philosophy and its own subject(s), therefore, it comes as a kind of shock that some of our best philosophers of philosophy—and of art—have wished to insist that the definition of art cannot be given, that it is a mistake to attempt to give it, not because there is not a boundary but because the boundary cannot be drawn in the ordinary ways. Or, to the degree that a definition of art cannot be given, then to just the degree that the boundaries between philosophy of art and art have been washed away, neither can a definition of philosophy of art, nor for the matter of philosophy itself, be given. This challenge comes, predictably, from Wittgenstein.

For Wittgenstein, philosophy has always been a problem, stigmatized in the *Tractatus* as nonsense, inasmuch as no place can be found for its propositions (if they can be *called* propositions) in the final representation of the world; stigmatized as otiose and finally as nonsense in the *Investigations*, since no place can be found for its utterances in the forms of life we live. In the *Investigations* philosophy begins when "language goes on holiday"; in the *Tractatus* philosophy begins when we fall off the outmost edges of natural science into the void of senselessness. Philosophy represents no facts, though its practitioners may have believed it did, and does no work, though its enthusiasts believe that it must. So it is either misemployed language or underemployed language, and those who profess to speak it are to be driven, like the poets in Plato, into the outer silences. And when philosophy—in contrast with science—pretends to be informative, and to tell us something true—say about art—either it will be a disguised way of saying something we already know, in which case it is useless, or an undisguised way of saying something contrary to what we know, in which case it is false. Either it duplicates or it violates human knowledge, and nowhere has this been more so than in the philosophy of art. I want, accordingly, to explore the Wittgensteinian position on a question we cannot honestly avoid.

The Wittgensteinian thesis, as I understand it, is that a definition of

art both cannot and need not be formulated. It cannot because of the sort of concept with which we are dealing, a concept that excludes the possibility that there is a criterion for artworks and hence excludes that there is some set of conditions necessary and sufficient to works of art. There is, the Wittgensteinian wishes to assure us, no such criterion to be found, and the search for a definition meeting traditional philosophical demands for necessity and sufficiency has been one of the great vagrant crusades of misplaced intelligence, because the philosopher has not looked closely enough at the target and supposed apriori that the set of artworks constitutes a kind of species, like zebras, a logically homogeneous set of objects the principle of whose homogeneity must be found. How striking, if this were true, that the principle has managed to evade the best minds through the ages. To be sure, the task might just be superhumanly difficult. But might the explanation instead not be found in the possibility that the set in question is not structured in the manner supposed, with a curiously hidden and difficult principle, but that it is a *different sort of set altogether*, structured in a way philosophers have not grasped: a logically open set of things that share no common feature in order to be members of the set? What of, to use one of Wittgenstein's most celebrated examples, the set of games? "What is common to them all?" Wittgenstein asks in the *Investigations*, going on to say, "Don't say: 'There must be something common, or they would not all be called *games*'—but *look and see* whether there is anything common to *all*—For if you look at them you will not see something that is common to all, but similarities, relationships . . . a complicated network of similarities, overlapping and criss-crossing" (Sec. 66–67). Now it might as a matter of historical accident be true that all games have a common property, and we might think, bewitched by this contingency, that the definition of game lies here. In truth it would always have been possible for there to have been a game, which might be invented tomorrow, which we intuitively recognize as a game though it fails to conform to our pretended definition. And it is this *appeal to intuition* which is what renders any effort at definition otiose: we do, simply in being masters of the word, recognize which are games and which are not, and do not do so by applying a definition, since there is none. And none will make us any the wiser, since we get along without it so easily. Thus the definition of game both cannot and need not be given.

This analysis is effortlessly extended to works of art, which themselves form what we might, following Wittgenstein's formulation, call a *family-resemblance class*. "I shall say: games form a family," he writes, implying a contrast with a species, since the resemblances that connect the members of a family "criss-cross in the same way." And Morris

Weitz extends this precisely to our subject by writing: "If we actually look and see what it is that we call art, we will also find no common properties—only strands of similarities . . . 'Art' itself is an open concept. New conditions (cases have constantly arisen and will doubtless constantly arise: new art forms, new movements, will emerge . . . Aestheticians may lay down similarity conditions but never necessary and sufficient ones for the correct application of the concept" (in *Journal of Aesthetics and Art Criticism*, 1956, p. 27). The set of unhappy families would, I suppose, be an example of what Wittgenstein calls a family, since each unhappy family is unhappy in its own way, this not evidently preventing them from each being *called* an unhappy family. And happy families, being all alike, perhaps compose a class that is closed under necessary and sufficient conditions.

The concept of the family to designate this crisscrossing of phenotypical qualities is almost appallingly ill chosen, since the members of a family must, however much or little they resemble one another have common genetic affiliations that explain their "family resemblance" and someone is not a member of a family if he lacks this, even though he should resemble another (though a striking resemblance may be evidence for satisfaction of the genetic criterion). And the injunction to "look and see" carries some unfortunate implications, that the matter of definition is in some sense an exercise of recognitional skills. There is little doubt that we can find cases in which some such recognitional skill is involved, where we may recognize as "belonging to the same family" sets of objects which may resemble one another no more than games somehow do. Nor is the family whose members are so related that the daughter has the father's eyes (and note we do not say the father has the daughter's eyes) and the son the mother's chin. Think of what is involved in recognizing photographs of the same person at different stages of his or her life: Edith Wharton as a child looked remarkably like Edith Wharton as an old woman, though there were obviously all the differences that there are between children and old people. Or again, consider all the portraits of a given person at a certain stage of his or her life by different hands, such as those of Diderot by the several artists who painted him or of Virginia Woolf. And think of the works of a given artist, which though incongruent with one another, typically resemble one another so as to be recognizably by Mozart, or by Delacroix, or whomever. And think finally of all the objects from a given period, like the Age of Louis XIV or the Rococo, which have a stylistic similarity however much they may otherwise differ one from another. We can learn to recognize Hapsburgs, Wharton pictures, Diderot portraits, Mozart compositions, Baroque objects, and in fact if we

"look and see" we may conclude by saying that we are able to do this because each of them has a common property, however indefinable: the "Wharton look," the "Mozart style," the "feel of Rococo." But it is also not accidental, and this goes beyond recognitional considerations, that such a quality should characterize the members of such a "family," namely that they should be of or by the same individual or from the same culture at the same time. And given this common causal or genetic consideration, it is of course possible that something should be *by* Mozart but not resemble anything else by him, so that by recognitional criteria, the works of Mozart would be an open class while by causal criteria it would be a closed one. This must then raise questions as to the relevance of recognitional consideration.

So let us take up the other part of the Wittgensteinian analysis, that part which tells us that we simply do recognize something as a game— or an artwork—and that no definition is needed or wanted. What *sort* of intuition can be involved here? Consider the following Gedankenexperiment as described by William Kennick in his article, "Does Traditional Aesthetics Rest on a Mistake?"

Imagine a very large warehouse filled with all sorts of things—pictures of every description, musical scores for symphonies and dances and hymns, machines, tools, boats, houses, statues, vases, books of poetry and prose, furniture and clothing, newspapers, postage stamps, flowers, trees, stones, musical instruments. Now we instruct someone to enter the warehouse and bring out all the works of art it contains. He will be able to do this with reasonable success, despite the fact that, as even the aestheticians will admit, he possesses no satisfactory definition of art in terms of some common denominator. Now imagine the same person sent into the warehouse to bring out all objects with Significant Form, or all objects of Expression. He would rightly be baffled. He knows a work of art when he sees one, but has little or no idea what to look for when he is told to bring an object that possesses Significant Form. (*Mind*, 1958, p. 27)

"We know," Kennick writes in echo of a famous claim of Augustine's regarding time, "what art is when no one asks us what it is; that is, we know quite well how to use the word 'art' and the phrase 'work of art' correctly." We may note in passing that the "that is" just mentioned is that *c'est à dire* of Ordinary Language Analysis: adjoined to Augustine's claim that we know what time is, we would get a gloss to the effect that we know how to use the word "time" in the sense that we can comply with requests to say what time it is; can answer if someone asks how much time it takes to walk to Zabar's from the West End Bar; can say such things as "I don't know where the time went"; and feel no special puzzlement when Menard writes "truth, whose mother is history, rival

of time." I would not contest that if this is what is meant by "knowing what art is," namely that we "know how to use the word 'art' correctly," then the philosophy of art become the sociology of the language in which "art" and "artwork" function. But it will be plain to the reader who has followed me this far that such skills of usage as this may imply will not help the man sent into the warehouse. For it will be easy to imagine a warehouse exactly like the warehouse described by Kennick, but such that for whatever is an artwork in his warehouse, its counterpart in our warehouse is not one, and whatever is not a work of art in his warehouse has a counterpart in our warehouse which is one. So that the pile of artworks taken from his warehouse would be indiscernible from the pile of not-artworks taken from ours. Perhaps the man is master of such expressions as "Art is long, life is short," and can talk with the peripatetic women about Michelangelo. But he would be confused by the two warehouses for all that. Perhaps his inability to tell which are the artworks and which are not does not count against his knowing "what art is." Perhaps it is no part of mastery of the concept that one will be able to pick instances out. But we have now enough clarity on the matter to be able to say that *no perceptual criterion can be given*, that *whatever* is involved in knowing which are the artworks, it can only contingently be a matter of recognitional capacities of the sort exercised by Kennick's warehouseman. Kennick is right, perhaps, that "we are at a loss to produce any simple formula, or any complex formula, which will neatly exhibit the logic of this word and this phrase." And he is right if he means that we have no formula, and indeed can have no formula, which will enable us to pick out artworks in the way we can pick the bagels out in the bakeshop: for if "bagel" had the logic of "artwork," a pumpkin pie could be a bagel. But now that we recognize the futility of the task Kennick believes to have been essentially so easy to perform, and that no possible formula can serve that function, we are better able to see what might be expected of a definition of art: it cannot be expected to give us a touchstone for recognizing artworks. Neither, incidentally, we may now suggest, can a definition of game enable us to recognize games, if indeed the concept of game is as close to that of artwork as the extension of Wittgenstein's analysis suggests that it is.

Kennick writes, "Where there is no mystery, there is no need for removing a mystery and certainly none for inventing one." And as he conceived of his warehouse, there really was no apparent mystery. But now that we understand the principle that enables us to construct ontologically distinct but perceptually indiscernible counterparts, that his warehouseman was right was only a matter of happy coincidence. He

was like Plato's blind man who took the right road by accident. To what was he blind? He was blind to that on the basis of which what he picked out as artworks were artworks, since he could have been exactly wrong in picking out things exactly like them so far as the eye could tell. A definition may make him no better able to avoid the pitfalls of our factitious example, but it would be foolish to pretend that it would make him none the wiser. For the question remains as to why was he right when he was right since, nothing else being different, he could have been so wrong? The counterwarehouse is a very powerful instrument for destroying analyses of the concept of art which supposes recognitional capacities at all relevant. It destroys, for example, the suggestion that we can come to pick out artworks by performing inductions, or by emulating someone who knows which the artworks are, or by some sort of simple enumeration. Follow a man through the warehouse and note the things he picks out; then go to the next warehouse and pick out all the same things; and though your lists match, he will have picked the artworks out and you the things belonging to the complement of the class. And this but carries a bit further precisely the phenomenon recognized by Weitz and Kennick to begin with. For we may, in periods of artistic stability, come to recognize which are the artworks in some inductive way, and think we have a definition when all we have is an exceedingly accidental generalization. They themselves allow that something may enter the artworld, and indeed be an artwork, which upsets the generalization, and conclude, since it always is possible—always is possible that art will be revolutionized at the boundaries—that there can be no generalization: the generalization of today will be revolutionized into oblivion tomorrow. The child who learns to pick the artworks out will be stunned to discover that a disjoint set of seventy fuzzy objects, which are distributed throughout the museum like anemones, compose an artwork; just the same objects could be pads for elliptical sanding machines distributed for who knows what reason in just that set of positions in the museum, composing not an artwork but a distribution of pads.

But does it follow, from the fact that something may be an artwork which disresembles previous ones, that there can be no generalization about artworks and no definition? Only, obviously, if we restrict the elements of the definition to those properties that meet the eye. If we widen our scope to properties that do not, we may find an astonishing homogeneity in the class of objects heretofore regarded under Wittgensteinian perspectives as a mere family of heterogenes. Suppose something is an artwork, for example, if it satisfies a relationship with something else, as Maurice Mandelbaum has suggested regarding

games? And suppose things singularly disresemblant to one another may after all satisfy just that relationship and be artworks in consequence. So a definition can be given, though not on the basis of the sorts of properties the Wittgensteinians rather blindly supposed to be relevant.

Consider a child who may learn by simple enumeration who his uncles are. Asked to pick out his uncles, he can do this, as he has been taught to. But picking out implies not the slightest mastery of the concept of uncle, any more than being able to pick out the artworks by virtue of simple enumeration implies mastery of the concept of art. Suppose, however, that the child notices a "family resemblance" among his uncles, and on the basis of this is able to form an induction through which he picks out a long-lost uncle. He still has not, I think, got the concept of uncle. Let us imagine that his uncles are all middle-aged Caucasians, but that his grandmother decides just now to marry a Chinese by whom she then has a child and this oriental-looking infant is presented to our child as his uncle. This should shatter his confidence in induction and prepare him for the worst adversions of Hume. Or he may conclude, if he has a philosophical turn of mind, that "uncle" is not a descriptive predicate, that it has perhaps a performative use, like "good," so that when you call someone an uncle, you are not describing him but declaring a certain pro-attitude toward him—though the child might wonder why these individuals happen to qualify for the attitude. Doubtless it would be unavailing, in parity with Kennick's warehouse-man, to say that uncles do have something in common, namely the property of avuncularity or Significant Unclehood, but in fact once we have mastered the concept of uncle, we shall know for a fact that there is no set of simple properties on the basis of which we can pick uncles out, only (perhaps!) some set of simple properties on the basis of which we can reject certain individuals as uncles, say on grounds that they are female (and transexuality compromises even this). For something is uncle only if it satisfies a complex relationship to other individuals who satisfy certain complex relationships with one another. It is a genetic and institutional fact that one's uncles may bear a certain family resemblance to one another; but there is no necessity in it, and in different worlds from ours, uncles could be heterogeneous under one-place predicates and homogeneous under multiple-place predicates—like works of art perhaps.

Philosophers have always found it curiously difficult to cope with relations, and the history of their struggles is one of the least edifying in

the catalogue of their incapacities. Even as late as the *Tractatus*, Wittgenstein supposes that propositions employing relational predicates are not "elementary," though it is difficult to see how this claim might be justified since there is no way in which such propositions can be reduced to propositions that employ one-place predicates only. Abstractly, if there were properties F and G such that H(ab) could be replaced by a is F and b is G and this were perfectly general, the result would be paradoxical: for though first-order logic is known to be undecidable, first-order logic of monadic predicates is decidable, and the replacement would enable us to collapse the whole of first-order logic onto a proper part of itself. But it can be seen even more simply that this cannot be done. Imagine that Rab is "a is married to b" and suppose this were replaceable with a is F and b is G where F and G are monadic, that is, not covert relational predicates. So Rab is equivalent to Fa and Gb. Suppose, however, that it is also true that Rcd. Then it is easy to prove that if Bob and Carol are married to one another, and Ted and Alice married to one another, then Bob and Alice are married to one another and Ted and Carol married to one another. Which may be true, but hardly as a trivial consequence of their initial positions. So the inference fails.

Now if something were a work of art only through satisfying some relation or other to something or other, then the ability to pick out objects would almost certainly not constitute evidence that one was master of the concept of art. Indeed it might almost constitute evidence that one was not a master of that concept; for the properties on the basis of which one picked such things out would at best be properties works of art *have*, but being a work of art could not *consist* in having these properties, and this is why one would constantly have to be open to a revolution of art. But this should not surprise us very much, since we were able to sort out which of our indiscernibilia stood a chance of being an artwork only on the basis of differentiating out the sorts of relationships in which they variously stood to their makers. Something like the conditions of production appeared in those cases to figure in the identity of something as an artwork, in that they would be presupposed in attributing this predicate to them. For these reasons, I think, one can understand why such a concept as "having Significant Form" would be very poor as an analysis of art, inasmuch as this would be only a monadic predicate and hence incapable of being an analysis of "work of art" *if* that happens to be deeply relational in its logic. On the other hand, it also would explain why, to use Kennick's other example, it would not help to tell the warehouseman to look for objects which were expressions, since "being an expression" might entail standing in a certain re-

lationship to something, and there might be no way whatever in which one could pick out the things that were expressions on the basis of any simple inspection or intuition. A valentine can express love, and it may be easy to pick out the valentines without its following that it is possible to pick out all the expressions of love. A plate of tripes could be an expression of love. The sentence "I hate you" can be an expression of hatred, but so can a plate of tripes be an expression of hatred, or a plates of tripes can be a plate of tripes, expressing nothing at all. For that matter, the warehouseman would, to use another example from the classical literature of aesthetics, have difficulty in picking out the imitations or the representations, if in fact these are relational concepts.

It was just said that though relational predicates are such that no definition of them in terms of one-place predicates can be given, still, there may be some properties such that, F being one, if a is not F, then a cannot stand in the relation R to G. Thus fathers have to be male and daughters female. And in periods of artistic stability, there can be little doubt that works of art very frequently were found to have properties, failure of which would call seriously in question their status as artworks. But that time has long passed, and just as anything can be an expression of anything, providing we know the conventions under which it is one and the causes through which its status as an expression is to be explained, so in this sense can anything be a work of art: there are no one-place necessary conditions. Of course it does not follow from the fact that everything can be a work of art that everything is one. I am not seeking to stand as a Prophet of Universal Creativity. The typewriter I am writing on could have been a work of art, but it happens not to be one. What makes art so interesting a concept is that in nothing like the sense in which my typewriter could be a work of art could it be a ham sandwich, though of course some ham sandwich could be, and perhaps is already, a work of art. But this cannot be explained solely on the basis of the concept of an artwork's being a relational one, and the reason must lie in some still deeper consideration.

Meanwhile, even if the predicate attaches to an object when the latter should satisfy a certain relationship to something else, while it may explain away the superficial phenomena on the basis of which philosophers were led to propose the family-resemblance theory of art, it does not go any distance whatever in helping to answer the question with which we began this discussion, why it is that art is the sort of thing of which there can be a philosophy. There is nothing philosophical as such about relations, as may be seen from observing that while "is an uncle" is covertly relational, uncles are not the sorts of things that spring spontaneously to mind as topics for philosophical reflection. As an *example*

of a relational concept, the concept of uncle may acquire some importance as philosophical illustration without thereby standing as a philosophical concept. All our discussion will have shown is that one fashionable argument against a definition of art rests on a logical myopia. This is not to say that the definition of art is going to have to include a relational concept in the definiens, but only to insist that if it did so, that by itself would explain the difficulties in response to which an antidefinitional position has seemed inescapable. I shall in fact try to show that properties on which a definition of art must draw are not particularly relational, or at least that the kind of relationship in issue is special to the class of things to which artworks belong and of which philosophies can be given.

Let us therefore return to the beginning, somewhat enlightened by this excursion into logical form, and pick up the thread of Socratism. "Suppose a person were to ask us: In what wise things are painters knowledgeable," Socrates himself asks, rhetorically, at *Protagoras* 312-d. "We should answer: In what relates to the making of likenesses." Now "likeness" is a relationship, and we may do worse than ponder what makes it a philosophically interesting relationship if it characterizes a class of artworks, even if (as we know) some likenesses are not artworks, and not all likenesses artworks to be sure. Socrates almost certainly identifies likenesses with imitations, but even though the concept of imitation may have the concept of likeness at its core, more is involved in the concept than that.

It is by now a commonplace that the concept of imitation cannot be explicated solely in terms of likenesses or resemblances. If there is something *o* such that *i* is an imitation of *o*, then perhaps *i* will have to resemble *o*, or will have to do if it is a *good* imitation. One criterion of being a bad one is failure of resemblance, though a decision will have to be made, perhaps, when resemblance becomes so marginal that the status of one as an imitation is called in question: when I flap my arms wildly about, is that a bad imitation of a snake, or just not classible as an imitation of a snake or what? In any case, resemblance itself is a symmetrical relationship, and usually transitive, though in the case of family resemblances, *a* may not resemble *c* though it resembles *b* and *b* resembles *c*. Imitation meanwhile would be asymmetrical and certainly intransitive. A woman impersonating a female impersonator is not impersonating a female. The role of Octavian—a young male and lover of the Marschalin in *Der Rosenkavalier*—is usually sung by a female contralto. The action requires Octavian to disguise himself as a chamber-

maid, to thwart Baron Ochs. But in such scenes the contralto is not herself imitating a woman; she is rather imitating-a-man-imitating-a-woman. And hence the description of her performance is twice-over more complex than the description of Octavian's.

There is a temptation to explain the asymmetry through the asymmetry of the causal, or at least the explanatory relationship, inasmuch as one may want to say that the imitation has the properties it has because the original has the properties *it* has. But a father's having the properties *he* has may explain his child's having the properties *it* has, and the two moreover may resemble one another, without the child's being an imitation of the father. The child may come in time to impersonate his father, but then the way in which the father enters into the causal history of his impersonator will differ from the way in which he enters into the causal history of his child, though the two are identical in the present instance. Typically, one would think, mimesis will be irreflexive, though cases can be imagined in which the son, having become the impersonator of his father, himself a prime minister, falls ill, and the father, being a good father, replaces his son in the political skit and winds up thus impersonating himself. Chaplin once played the role of a waiter, a fact concealed from his sweetheart, who comes one night with merry friends slumming in the restaurant in which Charlie works, whereupon *he* pretends to be slumming himself, and pretends to be pretending to play the role of the waiter he really is. I can even see using the real thing to imitate a *trompe l'oeil* imitation of the real thing, pretending reality to be its own imitation and so imitating itself. But these raise logical nightmares we can forgo for the moment, until we have the concept somewhat straightened out. All this presupposes that imitation is a relational concept to begin with, and that can certainly be questioned.

Imagine a man who dresses and acts the way women in a given society dress and act. Mere resemblance to these women in habit and gait will, however, not make an impersonator out of a mere transvestite, for he may just by accident believe this is the way a young man is supposed to dress and act, or may not know that he is a young *man*, having, like Achilles, been brought up with women and surprisingly retarded in establishing his sexual identity—unlike Hercules, when he spun with the women of Omphale, glad to exchange that identity for a petticoat and distaff, though Hercules was not imitating a woman just because he had to dress up and behave like one (sometimes he is depicted with a beard, as witness the painting by Veronese). Wherein lies the difference between a female impersonator and a transvestite, supposing each of them to be imitating women? In part, I suppose, the transvestite is pre-

tending to be a woman, and hoping that others will believe he is one, concealing his identity behind pathetic frills. The female impersonator is pretending to be a woman for the amusement of those who had better be expected to believe he is not a woman, for otherwise whatever amusement they may derive from his conduct will just be the amusement that might derive from the conduct of a woman, and though he will have deceived them, this will be a kind of defeat, given Aristotle's inference. But we can, I think, go even further than this now. The impersonator's gestures are *about* women, whereas the effeminate mimesis of the transvestite has no semantic character whatever. Mimesis becomes impersonation when it represents the conduct of another. And imitation in general acquires finally the status of a possible art when it does not merely resemble something, like a mirror image, but is about what it resembles, like an impersonation.

But now we can go still a step further: someone can imitate something, can correctly be described as imitating something when the question of resemblance fails, not because, as before, it is a bad imitation but because there exists nothing for the imitation to resemble—as may be the case with *Der Rosenkavalier*. It is not analytical to the concept of imitation that there must be an original that explains or enters into the explanation of the imitation having the properties it has: there may be no such original, and the explanation itself fails for lack of the right sort of explanans. Consider an Indian shaman imitating the behavior of the Fire God. The shaman dances a flame dance, undulates his body, leaps like a flame, but he is not engaged in a charade in which he is simulating a fire; he is imitating the Fire God himself. And we know there is none. Perhaps one would want to say that though there is no original, the mime must believe there is an original, and this may be true for the Indian shaman. But will it be true for the man who plays the part of the unicorn in the play *The Taming of The Unicorn*, pretending to gore with his strapped-on horn all sorts of helpless creatures until he goes docile in the presence of a lady pretending to be a virgin? Must he believe there is a unicorn that he imitates, in order to imitate a unicorn? The answer, of course, is no; something can be a unicorn-imitation without being the imitation of the behavior or character of a unicorn, and the reason is not far to seek. It is that imitation is to begin with an *intensional* concept, so that something can be an x-imitation without this entailing that there is an x, of which it is an imitation. So it is not that imitation is a different sort of relationship from resemblance: *it may not be a relationship at all.* If it is an intensional concept, then of course we may accept Aristotle's notion that a play is an imitation of an action without having to wonder what action it is an imitation of—for

there may be none. The *Agamemnon* imitates the action of Clytemnestra and Agamemnon as described in the Homeric tradition, but the story told of them may itself be fiction, so that there is no original whatever; and though one may say that it is an imitation of a story, that is surely not what it sets out to be, but rather is, as Aristotle would want to say, the imitation of an action. How it can be this if there is no action is a question that arises only because we first take imitation to be an extensional notion, which it probably is not. Rather, as the relevance of *aboutness* implies, it is a *representational* concept. There need be nothing for an imitation to resemble. All, I think, that would be required is that it resemble whatever it is about *in case it is true*.

"Imitation" is intensional not only in the sense remarked upon earlier, according to which an imitation x may not be an x, but in the sense that something may be an imitation of o without this entailing that there exists an object o such that the imitation copies o. In this respect, "imitation of" is very like "picture of," for here too it will be widely acknowledged that a picture-x is not an x except with pictures of pictures—a picture-boy isn't a boy, a picture-grape isn't, as Zeuxis' birds learned to their dismay, a grape—but also that it does not follow, from truly being described as a picture of o, that there exists an o such that the picture pictures it. Only reflect, after all, that most will acquiesce in the pictorial identification of Masaccio's earlier masterpiece as of the Holy Trinity—or in innumerable pictorial identifications of annunciations—while being deeply divided as to whether there *is* a Holy Trinity for Masaccio's work to picture, well or badly; or whether there ever was an angel who announced to a virgin that she would be the mother of the Lord without undergoing change of genital state. If this is true, then, it follows immediately that a mirror image, Socrates' clever red herring notwithstanding, is not an imitation, since nothing (in our world at least) is a mirror image of x without there being an x the image mirrors. The fact that imitations are likenesses of originals, as mirror images are likenesses of originals, establishes nothing, since the latter do and the former do not logically or conceptually require originals. To be sure, nature has been niggardly with mirrors: they could be (or are in possible worlds?) like crystal balls or television tubes or dream glasses in which images pass before one's eyes magically materialized in a medium, much as Narcissus believed they do in water. Whether it is a fact about mirrors that they require originals for them to have images, or whether it is a conceptual truth, is not a matter to pause over. Perhaps Socrates had never encountered an imitation without an original, though by the time Aristotle took the theory of mimesis over, he had come to recognize that imitations must be largely different from mirror

images, the latter standing to the former in the way in which, to cite his stunning analysis, history stands to poetry. For poetry, though imitative, is not tethered to a particular entity the way history is and hence, since it can picture a widely exemplified pattern of action, is more universal than history.

It requires only to take the further step, and acknowledge that an imitation may be of a pattern which is never in actuality exemplified, for it to be apparent that the concept of imitation is nonextensional. In virtue then of this, we may say that Socrates' effort to assimilate imitations to mirror images concealed a piece of structure it is of the utmost philosophical importance to isolate, namely that he was talking about something we might term true imitations, where the term "true" has a semantical rather than a descriptive use, and where it is allowed that a false imitation can be an imitation—as a false proposition can be a proposition. In the descriptive sense, a false imitation might be something we merely take to be an imitation, but which is not one, as the *Quixote* of Menard is not an imitation of the *Quixote* of Cervantes, or as a moss stain that resembles the profile of George Washington is not really a pictorial imitation of our first president in the medium of moss. No: a false imitation would be an imitation that lacks an original, to say the least. And, not surprisingly, the same semantic-descriptive ambiguity that affects imitations and propositions affects pictures: the Washington-shaped moss patch looks as though it might be a picture but it isn't, and hence is a false picture, whereas certain works of Caillebotte might be counted false in the sense that the spaces depicted do not have in reality the geometry they are depicted as having. But pictorial semantics lie ahead of us: let us stick here with the case of a true imitation, which is an imitation *of* something, and true in case (1) it denotes what it is of, let this be o; (2) o enters into the explanation of the imitation; and (3) it resembles o. Indeed, so characterized, there is little difference to mark between what goes to make something a snapshot of o and what goes to make something an imitation of o, with this crucial difference: if the denotational and causal conditions fail, what we have is not a snapshot of o after all but only something that looks like one, whereas if they fail in the other case, it still remains an imitation of x if intended as that—for instance, if the Indian believes that facts about the god he is imitating enter into the explanation of his executing the imitation, which in turn denotes what he believes is that god. Snapshots are like names if, as Russell characterizes the latter, a name without a bearer is just a noise. But imitations do not necessarily collapse into pictorial noise when they lack in fact an original. So imitations are very

special sorts of likenesses, differing not only from images but from shadows and echos.

That imitations should have a denoting function was, indeed, considered by Socrates in the *Cratylus*, where he entertained the striking theory that names are imitations and that naming itself might then be an imitational art, "like painting and like music." Indeed, he conjectures that "a name is a vocal imitation of that which the vocal imitator names or imitates"—a claim that has almost a tractarian air about it, as though, in virtue of its being an imitation, a name and its bearer share some *form* the namer discovers. Vygotsky tells of a peasant who was not especially amazed that astronomers should have discovered what the chemical composition of the stars and planets is; what astonished him was how they found out what the *names* of those celestial objects were, as if this were a deep Paracelsian secret brought to light. Socrates, however, directly dismisses the theory on the interesting grounds that if it were true, "we should be obliged to admit that the people who imitate sheep, or cocks, or other animals name what they imitate." This is evidently meant as a refutation by counterintuition, leading Socrates to refine on the idea of a vocal imitation, but it is, in view of what I have been suggesting, not in the least counterintuitive: when someone really sets about to imitate something, when his imitation is true, he is denoting that thing (a bad imitation need not be a false one, any more than a blurred photograph is a false photograph). It is striking that Socrates should have supposed mirror images and imitations to be of a piece, and imitations and names *not* to be; he had all the pieces for an analysis, but put them together wrong.

Imitations are vehicles of meaning, and much as there have traditionally been two ways in which meaning has been understood, so are there two ways in which we might speak of an imitation as representing something. One sense of meaning is this: a term means what it stands for, or what it denotes, or, in the familiar logical expression, what its extension is; and what it stands for, or what it denotes, or its extension, has at times been regarded as the meaning of the term. But sometimes a term in fact stands for nothing at all, or has a null extension, and as we are reluctant to suppose that it is meaningless for that reason, something other than its denotation or extension must be invoked in order to account for this; while philosophers have differed as to what this other thing may be, whatever it is would be the second sense of meaning it seems necessary to distinguish. The two senses cor-

respond to the spirit of Frege's distinction between the sense (*Sinn*) and the reference (*Bedeutung*) of an expression. Imitations, too, have a sense and a reference, have two ways of being characterized as representing something. The contralto in Strauss represents a transvestite youth, even though there is no actual such youth for her to represent—which means that her imitation is not "true,"—there being nothing to make it true, but that in terms of the *content* of her representational actions, she represents a transvestite youth. So we may then distinguish an internal sense of representation, having to do with the content of an imitation or a picture or an action; and an external sense, having to do with what an imitation or a picture or an action denotes.

It is the second, or external sense of representation, however, which Nelson Goodman makes so much of, ostensibly in the cause of diminishing the importance of resemblance in the analysis of the concept of representation. "The plain fact is," he writes in the first chapter of his *Languages of Art,*

that a picture to represent an object, must be a symbol for it, stand for it, refer to it; and that no degree of resemblance is sufficient to establish the requisite relationship of reference ... a picture that represents—like a passage that describes—an object refers to and, more particularly, denotes it. (p. 5)

But it is obvious that a picture may represent something in the first sense marked above, and represent something quite different in the second sense; quite different, in the respect that we just happen to be using that picture to stand for something. Suppose, for instance, I want to indicate the position of my troops on a table and happen to be out of pushpins or flags. But there happen to be a stack of snapshots, which I just distribute in a certain way: *this* is Smith's patrol, *that* is Leinsdorf's tank outfit. By one of the happy accidents of our discourse, I might just happen to have a snapshot of Smith and his men, smiling under their helmets, and so the snapshot represents Smith's patrol, but in two senses that happen in fact to have nothing to do with one another in the present instance, and the resemblances are purely superfluous in the context of denotation. A map that has a tiny picture of New York where New York is designated need not for that reason be a more accurate, just a more decorative map than one that has a fat dot there: no one supposes New York looks like a dot, but "looking like" is neither sufficient nor necessary for designation of the sort Goodman wished to make central to his analysis. That it is not sufficient is plain from the fact that neither of a pair of resemblant things needs stand for the other, and Goodman observes that it is not necessary since "almost anything can be used to stand for anything." And this is so conspicuously true, for the

relevant sense of representation, that one wonders what is the force of "almost" in Goodman's phrase. It might be inconvenient to let the World Trade Center stand for *that* housefly, or to let a whistle sound stand for the Pyramid of Cheops but, these conventions of practicality apart, *standing for* is mere demonstration, or mere designation, and the essence of such representation is virtually absorbed by its function, so that it might as well be what Russell speaks of as a logically proper name, which would be a bare point of nomination abstracted from all descriptive connotations. Thus the properties of a collar button are inscrutable when this object is used to stand for Leinsdorf. When, however, we put next to the adventitious case of Smith's patrol being represented by a snapshot of Smith's patrol, the nonadventitious case of Smith's patrol being represented by a photograph of Smith's patrol, there certainly seems to be a connection between what Smith's patrol looks like and what the snapshot shows; for while any picture can represent anything in the barren sense of denotation, it is false that any picture represents in the other sense of "represents" anything whatever. The *View of Toledo* represents Toledo, *Mrs. Siddons as the Tragic Muse* represents Mrs. Siddons; and though we could make, by a matter of decision, the former stand for that city and the latter stand for that woman, it would surely be false that the *View of Toledo* pictures Mrs. Siddons, or that Reynold's portrait pictures that Spanish town. And it is far from plain that picturing does not require resemblance to its denotation when it denotes, and far from obscure that imitation actually requires it. So not only must some structure be assigned the imitation or the picture, but some projective relationship between this and what is denoted when imitation or picture is true. This is what I meant in saying that there is a sense as well as a reference for pictures and imitations, just as there is for terms. And both of them have to be connected in the right way for successful communication; though you may let the expression "The Evening Star" stand for the moon, the moon in fact is not the referendum of "The Evening Star."

Of course Goodman must know this as well as the next person whatever his semantic ideologies. For he himself has to mark somehow the difference between the meaning and reference of a picture. A picture of Churchill as a baby and a picture of Churchill in his last days as prime minister are coreferential (they stand for the same individual), but it would be absurd to say that the first picture is of Churchill in his last days as prime minister and the latter a picture of Churchill as a baby. As "Morning Star" and "Evening Star" are coreferential without the former being what we might call an evening-star description and the latter a morning-star description. These are respectively descrip-

tions of what the pictures are of, or the descriptions about, in our first sense of representation. And the difference is that representation in the second sense is a relational concept, whereas in the first sense it is not. It is, as Goodman would want to say, a concept used for the classification of representations; the predicates that fall under it are used to sort pictures into different kinds, namely those which represent Pickwick, those which represent Christ, those which represent Don Quixote, and the like. And we can usually tell which pictures these will be, whereas there can be no telling which pictures represent in the second or the relational sense unless we are specifically told. For a picture of Pickwick can be used to stand for Christ *or for anything*. And here as elsewhere one cannot tell by examining one of the terms of a relationship that the relationship is satisfied: Identifying something as a picture of *x*—or an *x*-picture—is an exercise of recognition, but we do not, in this sense, recognize names.

L et us, in this connection, reactivate the case of a child taught to inventory things, and equipped sufficiently with the necessary recognitional skills to be able to sort out the chairs, the tables, the rugs, the cups in a given household—an activity continuous, one would suppose, with simply mastering the use of such terms as "chair," "table," "rug," "cup." There will always be problems at the borderline, when an object can be classed in two ways or where it is not clear in which way it is to be classed to begin with. But nothing very profound rests on these matters, for I want to go on to say that by using the same criteria of identification, a child should be able to pick out the pictures in the household, except that this would hardly dispose us to say that he had the concept of a picture: for that, the child must be able to say what something is a picture *of* and be able to sort the pictures of ladies out from the pictures of houses. True, this may simply be a taxonomic exercise, such as being able to sort out the Heppelwhite from the Sheraton, but surely there is a difference to be marked in that "of" or "about"— these predicates of content—have no application to the other items in the household except, perhaps, books. The recognitional skills are very early acquired and are perhaps innate: a nineteen-month-old child, we are told by the psychologist Julian Hochberg, in "The Representation of Things and People":

who had been taught his vocabulary solely by the use of solid objects, and who had received no instruction or training concerning pictorial meaning or content (and indeed had seen practically no pictures) recognized objects that were portrayed by two dimensional outline drawings as well as photographs

... Thus the learning must occur not as a separate process, but in the normal course of whatever learning may be needed in order to see the edges of objects in the real world. In line drawings, the artist has not invented a completely arbitrary language: indeed, he has discovered a stimulus that is equivalent in some way to the features by which the visual system normally encodes the images of objects in the visual field, and by which it guides purposive action. (E. H. Gombrich et al., *Art, Perception, and Reality* [Johns Hopkins, 1972], p. 70)

And the chimpanzee Nim Chimpsky has no difficulty, evidently, in recognizing pictures of objects he is also familiar with outside pictorial contexts, such as dogs and balls, and in using the same sign for both (which by the way never entails a confusion: he does not try to pester a picture of a dog or throw a ball-picture). It is a striking fact that just the same vocabulary is involved for pictures and their nonpictorial counterparts in reality, and though the child learns bit by bit which things are pictures of objects which don't exist—trolls and goblins and monsters—he would have little difficulty in recognizing the latter were they to exist by just the sorts of recognitional parities signaled in Hochberg's account—so we could imagine the case of a child whose entire vocabulary was learned from pictures, and who had had no commerce whatever with solid objects, and yet who would have no difficulty in extending his predicates when thrust into the three-dimensional world. And surely as much resemblance as holds between two objects called by the same name must be presupposed between either object and a picture of it, if anything like this recognitional skill is to be explained. Of course it is not clear that on the basis of this sort of recognitional skill, the child or chimpanzee who learns to identify pictures as *of* something learns that they *stand for* what they are of, since that is a logically distinct matter. But for just that reason it should be clear that learning when pictures stand for something has little to do with learning what they are *of*. And hence we need a pictorial concept of representation in addition to the designatory sense of representation in which pictures *denote* things they resemble, in the manner of a portrait. A child may be able to pick out the pictures of Mommy, and may even be able to add to the set of such pictures, long before it acquires the concept of portraiture, which does involve the possibility of designation. There is a difference between drawing a Mommy-picture and making a portrait of Mommy.

Often a picture may, and indeed for the purposes at hand must, be recognized as a picture of something without the picture serving to designate anything. Think in this instance of hieroglyphics. In Egyptian hieroglyphics there occurs a hawk-picture, stylized and conventional

when compared with a hawk-picture by Audubon, but then for the purposes the former serves, the latter would bring the act of inscription to a halt. Typically, the hawk-picture serves as a phonogram in what happens to be a pictographic syllabary, and serves to carry a certain phonetic value that belongs to a word that may have nothing to do with hawks. In much the same way, the letters c-a-t in the word *concatinate* have nothing to do with cats but, were we to put a picture of a cat in that context, it would be the sounds of the *word* "cat" that the *picture* of the cat brings with it. In this respect, I think, the pictures serve much the same sort of function they do in rebuses. But sometimes the hawk-picture is about what we would spontaneously suppose it were about, namely hawks, the word for which has, of course, the sound picked out by the shape in the hieroglyphic string. When it so serves, a special mark—a kind of *Inhaltsstreich*—indicates that it is to be taken not as the vehicle for an acoustical charge, but in its own right, as a pictorial morphene that means what it shows. But though it need not yet denote, if it denotes, it denotes what falls within its extension as the word, in Egyptian, for "hawk" in English. And because it is a picture it will re-semble what it denotes. To be sure, it will resemble things that do not fall within its extension—further hawk-pictures, say—but nothing falls within its extension it does not resemble, given the conventions of Egyptian resemblance. That there are things it will not denote though it resembles them is simply one of the consequences of pictorial ambi-guity. In the *Tractatus* a sentence will resemble a sentence under parity of logical form as much as it resembles the fact it is supposed to mirror; but it will not mirror, unless made to do so, that other sentence. And a picture may resemble another picture as much as it resembles what it denotes when it denotes, without its following that it will denote that other picture. In many cases pictures have no intended denotation at all, are not used in the relevant sense to represent anything, but when they denote *as pictures*, resemblance is a *conceptual* requirement—as it is in imitation as such.

It could, one feels, hardly be otherwise if mimetic representation were generated out of that sort of magical re-presentation paridigmati-cally exemplified in the Dionysian rites as characterized by Nietzsche, where the god is actually invoked into re-presence by the appropriate religious technology. Each appearance of the god resembles each other, and an imitational representation of the god's appearing resembles this again, except that in this instance the epiphany is denoted by the tragic structures. And so again if statues of kings and gods were originally set up in the spirit of making the king or god present wherever his form was present—the statue would have to be believed to resemble what

was believed to be the king or god re-presented. And when this magical relationship of complex identity was dissolved, and statues were interpreted merely as representations of the kings and gods, they did not have to undergo change in form to undergo change in semantic function. Or better, under the structures of magic, these figures and rites had no semantic structure; they only acquired that when they began to be representations in the sense of standing for what it was also believed they resembled. And then, over time, standing for or denoting came to be less and less an important thing for artworks to do, except in special commemorative cases, portraits, historical paintings, and the like. But this takes us considerably ahead of our analysis. All I wish to stress at this point is that what *we* would call statues, gravures, rites, and the like, underwent a transformation from being simply part of reality, itself magically structured by virtue of the fact that special things, regarded as possessing special powers, were capable of multiple presentations, into things that *contrasted* with reality, standing outside and against it, so to speak, as reality itself underwent a corresponding transformation in which it lost its magic in men's eyes. Artworks became the sort of representation we now regard language as being, though even language—words—once formed a magical part of reality and participated in the substance of the things we would now say merely form parts of their extensions.

If we suppose that Nietzsche's account has any historicity whatever, this transformation of the vehicles of representation from magical incarnations to mere symbols took place in ancient Greece. So the concept of art was itself undergoing transformation or, rather, was only beginning to be formed there, for what preceded it would have been less a concept of art than a concept of magic. Images were seen contrasting with a reality they were previously supposed to participate in—and not surprisingly both these relations are seen exemplified in the Platonic theory of forms. Because a distance between art and reality was finally beginning to be discerned, certain questions could for the first time be raised about art, since for the first time it was seen as standing in this new relationship to the world—a relationship in which, incidentally, language was also seen as standing. This semantic relationship probably dawned at the very dawn of philosophy itself. Though there was art in Egypt and Mesopotamia and elsewhere, it is not clear that it was seen as what we today would call art—representations in the semantic rather than in the magical sense of the term. But neither, really, was there philosophy in Egypt and, in Mesopotamia, only science. It is my view that art, as art, as something that contrasts with reality, arose together with philosophy, and that part of the question of

why art is something with which philosophy must be concerned may be matched by the question of why philosophy did not historically appear in every culture, but only in some, and preeminently in Greece and India. This is hardly a question we can answer without characterizing philosophy itself, and when we have done this it will not be difficult to see why art is a natural philosophical subject, indeed an inevitable one, once, of course, it *is* art and not just magic.

My thought is that philosophy begins to arise only when the society within which it arises achieves a concept of reality. To be sure, any group of persons, any culture, acquires some set of concepts or beliefs that defines reality for it, but that is not the same as saying that they have a concept of reality: that can happen only when a contrast is available between reality and something else—appearance, illusion, representation, art—which sets reality off in a total way and puts it at a distance. For me, in many ways the paradigm of a philosophical theory is what we find in the *Tractatus*, where a contrast is drawn between the world, on the one side, and its mirror image in discourse on the other (and where in addition that discourse is composed of sentences that correspond one-on-one to the facts of which the world itself is composed). It is a theory full of problems and obscurities as set forth by Wittgenstein, but I am interested in enlisting it solely as the *form* of a philosophical theory, all the more because what is philosophical about it is the picture it presents of the relationship between language and the world, a relationship that cannot somehow be represented in the language the theory itself speaks of. That language for Wittgenstein is the "total natural science" and philosophy is not in any respect part of that: it mirrors no facts, for there are in the world no philosophical facts, and its propositions accordingly do not attach to the world the way the propositions of science do; they describe no part of the world, hence no singularly arcane part of the world. The language characterized in the *Tractatus* has no room for the propositions of the *Tractatus* itself. Indeed, relative to that language, relative to the "total natural science," philosophical propositions are inscrutable; they cannot be replaced by sentences in the language. Hence, relative to that language, the propositions of philosophy are such that they cannot be spoken, and hence we must consign ourselves to silence. They are unutterable. Were we to speak the tractarian idiom solely, we should be able to represent the whole of reality without being able to represent reality as a whole. For that we would have to take a position outside the language and talk about the language and the world; and the tractarian proposition allows

us *only* to speak about the world but never *as* the world. The representation of reality in cultures that had no philosophy at all would be: the tractarian language, purged to be sure of its somewhat dotty semantics. Its members could certainly represent the world, could certainly have something of a natural science. But not a philosophy, since it requires some way of putting reality at a distance in order to have that, and hence an opening up of some gap bounded on one side by reality and on the other by something else that contrasts in a global way with reality. It is a curious fact that though there has been no culture without some kind of science, philosophy has arisen only twice in the world, once in India and once in Greece, civilizations both obsessed with a contrast between appearance and reality.

For some while I have been urging the view that philosophy is concerned *au fond* with what I metaphorically speak of as "the space between language and the world." The metaphor is intended to dramatize the fact that, though words are plainly parts of the world in the respect that they are spoken at times and in places by persons, and that they have causes and certainly effects, and stand as subjects for a variety of sciences of a linguistical order, nevertheless may be regarded as "external" to the world in the respect that the world (and themselves included in their interworldly modes of being) may be represented (or misrepresented) by means of them; and that the world is what makes them true or false when they are used in a representational capacity. Taken as having representational properties—as being about something, or of something—and hence subject to semantic identification— there exists an essential contrast between words and things, between representations and reality, as the latter in each instance is logically immune to such assessment since devoid of representationality. Things stand to representations in a quite different relationship (or set of relationships) than those in which they stand to one another, just as words stand to one another in very different relationships from that in which they stand to things (it is not as bits of ink that sentences entail one another). We have a class of terms we may speak of as our semantic vocabulary—"inference," "denotation," "satisfaction," "exemplification," and the like—and a further class of words for registering success or failure of semantic liaison—"true," "exists," "empty," and many others along with their appropriate antonyms. My claim has been that all and only philosophical concepts require in their analysis one of each sort of term. I shall not here seek to defend or even to support this general claim, and I wish only to add that these semantic notions may be extended, with suitable variations, beyond the mere class of words or propositions, to semantic vehicles of all sorts—to images, concepts,

ideas, gestures, beliefs, feelings, to pictures, maps, diagrams—citing only some cases in which the question of what they are of, or what they are about, may naturally arise.

If we have two objects that resemble one another, two crows, two marbles, two tokens of the same sentential type, no question would ordinarily arise as to which of the two was "real"; whatever is true of the one as an instance would appear to be true of the other as an instance; and though they must, on Leibnizian grounds, differ at some point and be disresemblant at just that point, a will be no different from b than b is from a, and the issue of reality can hardly arise there. But it is possible to suppose two things just as resemblant as either pair in the previous example, where the question will arise. Suppose we have two marbles, one a portrait of the other, and the latter the original, the "real" marble. But for their different histories, and but for the fact that one of them enters into the history of the other, there may be no basis for telling them apart, and so no criterion in observation and comparison for stating that one of them is real and the other not: each has weight and sphericity, causes and effects, and so on. "The wile of the metaphysician," wrote J. L. Austin, "consists in asking 'Is it a real table?' (a kind of object which has no obvious way of being phony) and not specifying or limiting what may be wrong with it, so that I feel at a loss 'how to prove' it is a real one." And he vividly illustrates this with a magician who asks a man to assure himself that a hat is a perfectly ordinary hat, "which leaves us baffled and uneasy" since we have not "the least idea of what to guard against." So the second marble looks perfectly like the first; and which is therefore the real marble and which the representation must quite evade us on an epistemological check-over—until we realize that the word "real" here contrasts with the word "representation" and in the contrived instance nothing tells us which is which: the one stands for the one it resembles. We can imagine a boy very attached to a certain white marble going into a profound melancholia until his mother finds a white marble that does not so much replace the other as memorialize it: it stands in a special show-case, like a relic, and reminds him of his lost treasure (it could be the very marble he lost). As the marbles are quite alike, the question of which of them is real and which one is false would be impossible to settle. But in fact "real" has more contrasts than merely with "fake"—as in "real money" and "fake money." It also contrasts with "representation" and it is possible to use, say, a real butcher block, as in a famous work by the American sculptor, George Segal, to represent a butcher

block. Being a representation in this instance is a role the butcher block is made by the artist to play, but in every other sense it is just like a real butcher block. How could it not be, since it is one? When, then, "real" is used in contrast with representation, it is almost what we might term an inverse semantic predicate. Something is "real" when it satisfies a representation of itself, just as something is a "bearer" when it is named by a name. And Austin brings this out magnificently in the following barely noticed passage:

If there is to be communication at all, there must be a stock of symbols of some kind ... and these can be called the "words," though of course they need not be anything very like what we should normally call words—they might be signal flags, etc. There must also be something other than the words, which the words are used to communicate about: this may be called "the world." There is no reason why the world should not include the words, in every sense except the sense of the actual statement itself which on any particular occasion is being made about the world. (*Philosophical Papers*, Oxford University Press, 1970, p. 55)

"In every sense" of course implies: may have all the properties possessed by items in the world except the sense that the one is about the other, and the other is what they are about, "aboutness" being the crucial differentiating property—and that is what cannot easily be observed. Swift once envisaged a language, the elements of which were replicas of the objects the persons wanted to refer to, each person carrying about a sackful. They could have been of course, questions of inconvenience to one side, duplicates as readily as replicates, so that nothing would serve to differentiate sign from signified save the imperceptible relationship of designation and being designated. "To be real is to be the value of a bound variable," Quine said, with a kind of deep impishness. To be real is simply to satisfy a semantic function but not as a semantical vehicle; the fact that what satisfies or is a value of the variable in $[(Ex)\ x$ is a word] only complicates without altering the issue. Things make up the world, but some things—what Austin had in mind by his generalization on the concept of words—are also *outside* the world in the sense that the world is what they are true of. There is no reason why there should not be linguistic facts, facts about language, recorded in the "total natural science" in Wittgenstein, hence enjoying a double role, being at once within and without the world, part of reality in one dimension and part of representation in the other. (Berkeley has a picture according to which everything is representation, the world being made of Divine Visible Language. Materialists have a picture according to which everything is real, representationality not being a serious or basic property of the world.)

What I want to propose, on the basis of these immensely schematic and vulnerable remarks, is that works of art are logically of the right sort to be bracketed with words, even though they have counterparts that are mere real things, in the respect that the former are about something (or the question of what they are about may legitimately arise). Artworks as a class contrast with real things in just the way in which words do, even if they are in "every other sense" real. That they stand at the same philosophical distance from reality that words do, that they accordingly locate those who relate to them as artworks at a comparable sort of distance—and as this distance spans the space philosophers have always worked with—it is to be expected that art should have a philosophical pertinence.

Self-consciously mimetic art arose together with philosophy in Greece, almost as if the latter found in the former a paradigm for the entire range of problems to which metaphysics is the response. It is to the great credit of ancient theory that it got the relationship right between art and reality, merely being wrong, or parochial, in supposing representation to be restricted to imitational structures, which rendered the theory of art as representation at a loss to accommodate artworks which, though they could have been perceived as representational, were clearly not mimetic. But one must not be condescending: the bewitching power of mimesis led even so modern a thinker as Wittgenstein to the belief that, if language is to represent the world, it must in the most literal sense picture it; this forced Wittgenstein, in order to get the connection to go through, to rethink the world as a set of facts, and hence as having virtually the structure of propositions, ready to be mirrored forth in sentential icons. But since the language in any case was an idealized one, the logical form of its sentential parts perspicuous, it left the question open as to how our own natural languages might represent the world. And it is possible to read the later Wittgenstein as having answered this question with a theory that natural language does not represent reality at all, that it has a use but not a descriptive meaning, as if the pictorial theory of representation had never been given up and still served as an impossible model, failure to conform to which made it necessary to think out what connection to the world ordinary language possibly could have.

Post-Wittgensteinian semantics can then be appreciated in terms of working out how sentences can be representational without being pictorial—and much the same sort of problem faces the philosophy of art (think of how compelling the theory traditionally was the poetry should be assimilated to the model of painting: *Ut pictura poesis*). But even with imitative art, it need not follow, as our argument has shown, from

the fact that it is mimetic that there *must* be something ulterior that it matches. Matching would be a relevant condition of representation only when questions of truth and falsity arise.

In any case, our concern is less with the question of how artworks might fit reality—we are not even yet concerned with the question of whether there ever is this issue of fit—than with the difference between reality and art, which we have sought to show must lie in the fact that art differs from reality in much the same way that language does when language is employed descriptively (so the issue of whether an artwork is true or not is at least legitimate). This is not at all to say that art is a language, but only that its ontology is of a piece with that of language, and that the contrast exists between reality and it which exists between reality and discourse. For this reason one could not imagine, any more than one could a world made up just of shadows, a world made up solely of artworks. One could imagine a world without artworks, or at least nothing its denizens would refer to as artworks, for such a world would be exactly that in which the concept of reality had as not yet arisen. The philosophical value of art lies in the historical fact that it helped bring that concept to consciousness along with itself. None of this is so much to have advanced a philosophical definition of art as it is to have shown why the definition of art is a philosophical matter.

Since the class of things that are representationally characterizable—which are about something, or in connection with which the question of what they are about is not logically ruled out—is considerably wider than the class of artworks, the problem of specifying what differentiates artworks from other vehicles of representation must be at least as pressing as the question of what differentiates artworks from real things, and I shall address that in Chapter Six. Assuming, however, that we have located artworks in the right ontological space, we are at least in position to appreciate that the program of closing the gap between art and reality, in response to that challenge laid down by Plato, is logically misconceived: the man who said a poem should not mean but be has voiced a kind of incoherence. We might, therefore, before passing to the next stage of our analysis, consider one or two striking attempts at closure which the contemporary artworld has brought forth in its ingenuity.

The artist Jasper Johns has exploited a class of objects in connection with which it seems initially difficult to suppose that they can be imitated, and which hence seem logically real through the fact that anything sufficiently like them to be reckoned an imitation immediately

becomes a member of the class to which they belong. A target or a flag, for instance, or a numeral, seems to have this striking feature, inasmuch as anything sufficiently like a flag to be a mimetic representation of one becomes a flag; and so with a target or a numeral or a map. With these objects, the dream of Pygmalion to use art as an avenue to the creation of reality appears logically assured of fulfillment. Vermeer thus achieved with the maps in his paintings what he never achieved with his women; the women never self-metamorphosed from paint into flesh, but his maps refused to be pictures of maps, and immediately turned into what they only started out to be representations of. It is worth mentioning that Johns too knew only a limited success; his representations of lightbulbs and flashlights did not turn into direct instances of those objects. And his bronzecast *Savarin Can* had the mixed success of Vermeer's paintings of women with maps. Let us dwell for a moment on the example. The iconography of *Savarin Can* would have been transparent to anyone familiar with the artworld of the time. De Kooning kept his brushes in Savarin cans, and with the tropism of fashionable emulation, Savarin Cans became the favored receptacle for the New York painters to put their brushes in. Johns made, as it were, a monument to this in his bronze effigy of a coffee can with brushes, the mold for which may very well have been a Savarin can and some real brushes. This was then realistically overpainted (like a Greek statue) to resemble its subject, the bronze being sardonically submerged beneath the paint (another art-historical or at least aesthetic innuendo regarding the integrity of the materials). Still, the work did not become an instance of its real counterpart, though the letters that spelled S-A-V-A-R-I-N *were* real letters. So at least they crossed the boundary and made it safely back, as it were, to the world—I suppose in the way in which the shadows counted upon by a sculptor as part of his work are after all real shadows.

All this being said, the logical issues remain just as they were before Johns's striking experimentations. However much a picture of something may look like what it is of, it remains an entity of a logically distinct order, even if what it is of is a picture. The painter Degas portrayed his friend Tissot, also a painter, in a room with some paintings, one of which, a Flemish portrait, bears a witty resemblance to Tissot himself. Imagine cropping the painting, leaving only this Flemish picture. It may look like a Flemish painting, perhaps a nineteenth-century copy of a Flemish painting, but in fact it is neither of these; it is a picture of a Flemish painting, resembling what it denotes. The painting itself would perhaps be about some Flemish gentleman, but the correspondent fragment of Degas' portrait of Tissot is not at all about that: *it*

is about a Flemish painting about a Flemish gentleman, and *aboutness* is not transitive. Consider, for a more dramatic instance, that Phillip Pearlstein might portray an Abstract Expressionist in a loft, with an abstract expressionist painting propped against the wall. Crop this out, and it will look just like an abstract painting, but in fact it will merely be a picture of an abstract painting, and itself an exercise in that hyperrealistic vein Pearlstein is such a master of: a photorealistic depiction of an abstract painting. Returning to Johns, the same will be true: a picture of a numeral, shaped just like a numeral, need not be and probably is not a numeral; it denotes a numeral, no doubt, but numerals don't denote numerals, they denote *numbers*. Thus 2 and II are codenotational when taken as numerals in different notational systems. But a picture of 2 is not a picture, certainly not a likeness, of II. And so it is with maps: a painting by Vermeer with a map of (say) Borneo does not, in that relevant fragment, denote Borneo so much as a map that denotes it, and so is about a different thing altogether from a map it may exactly resemble. Even in the most straightforward case, where we have a homogeneous population of objects, one of which is arbitrarily withdrawn and set over and against its fellows as a sample, it remains a member of this homogeneous population, and must indeed do that if it is to represent the population. But that is what it does, it *represents the population,* and the rest of the population does not do *that,* though any member of it could have done so had it been chosen instead. We may see the logical difference marvelously in some sly jokes Johns authored, in which color words are drawn in the color of paint they as painted words denote: "Blue" in blue, "Yellow" in yellow. But occasionally he painted "Blue" in yellow, setting up a kind of self-referential falsehood; and nothing can be false which is not about something we in this instance rather foolishly would have supposed it must exemplify, as "English" exemplifies an English word, and "Writing" exemplifies a written word, "Speaking" misexemplifying the latter as "French" misexemplifies the former.

It is of course always possible for a work of art to *contain* a relevant bit of reality, without in any sense being reducible to the relevant bit of reality it contains. By a "relevant bit of reality" I have in mind not all the properties of an artwork, but only such of its properties as its representational part may denote. I suppose, in fact, that the blue paint of which the color words are constituted in the Johns painting just described would be instances in point, being made of what the word itself denotes. These have the structure exactly of those mischievous sentences that have given rise to the famous semantic paradoxes, such as "This sentence is false" which *is* the sentential reality it also is *about.*

The use of words enables such self-referentiality to structure a work very readily: the American *trompe l'oeil* artist Peto did a painting once which included among various other realistically rendered ephemera a painting of a newspaper clipping describing an artwork which was so "realistic" that the cat scratched at it, where the work was the painting in question, which included a rendering, as I recall, of catscratches. And from other members of that school I have seen works that were paintings of their own backs, that is, paintings of canvas and stretchers, shipping labels, and whatever its verso would reveal to the eye.

But it is possible to be a great deal more subtle than this, as may be confirmed through the works of Frank Stella which, so brilliantly interpreted by Michael Fried, incorporate a kind of *deductive structure*, where "the paintings came to be generated *in toto*, as it were, by the different shapes of the framing edge." A typical early Stella would appear to the eye as a series of concentric stripes, thinly painted on a monochrome ground. They would look, indeed, like so many swatches of fabric and seemed resolutely abstract, in the respect that there seemed nothing they could obviously be about (unless one supposed they were about stripes rather than in themselves stripes)—when it might suddenly occur to one that they were about the shape of their own physical support. "Might suddenly occur" must be stated tongue in cheek if Fried is right in writing that "I think it fair to say that art criticism, even when approving, has shown itself unable to comprehend his painting in formal terms, as well as unaware of its significance—and probably the existence—of deductive structure itself." It is worth pursuing Fried's argument in *Three American Painters*:

[Stella's] progression from black to aluminum to copper metallic paint in his first three series of paintings, in conjunction with his use of shaped convases in the latter two series, can be fitted neatly into a version of modernism that regards the most advanced painting of the past hundred years as having led to the realization that paintings are nothing more than a sub-class of *things* invested by tradition with certain conventional characteristics (such as their tendency to consist of canvas stretched across a wooden support, itself rectangular in most instances) whose arbitrariness, once recognized, argues for their elimination. According to this view, the assertion of the literal character of the picture support from Manet to Stella represents nothing more nor less than the gradual apprehension of the "truth" that paintings are in no essential respect different from other classes of objects in the world. (Fogg Art Museum, Harvard University, 1965, p. 43)

This view, which Fried says is repugnant to him, could hardly be confirmed by Stella's works, which are full of even pictorial content and could be regarded almost as definitions of their own edges, inverses to

the method of extensive abstractions of which Whitehead made so much and which consisted in nested concentric "regions" such that of any two members of a set of regions, one will include the other nontangentially and no region is included by every member of the set, these converging to points, lines, and areas, which Whitehead sought to *define* through sets of regions. And, paradoxically enough, if the paintings were to be understood as saying, about themselves, that they were only things in the world, the fact that they said it would refute them: an apple does not commonly assert that it is just an apple. In one sense nothing could be more easy and more difficult at the same time than to create a work that only was to be identical with its own physical support, since the latter would *ipso facto* be the subject of the work, whereas physical supports logically lack subjects. The problem is analogous to that in which contemporary artists struggled to achieve a surface that was flat; for while nothing seemed easier—the surfaces *were* flat—the task was impossible in that, however evenly paint was applied, the result was a piece of pictorial depth of an indeterminate extension. And the effort to anchor the surface by painting a stripe (as in Newman's work) directly gave rise to the question of what was the relationship of stripe to surface, which we shall explore in time.

Edges have always been important in painting, and they certainly can be said to have generated the composition that occupies the space they mark out, since it would be in relationship to the edges that foci and eyepoints are compositionally relevant. This pertinence of edges is nowhere more evident than when it is flouted, as in the work of Bonnard where the edges were just where the painting stopped, bounding a space they did not define; but even in classical painting, the work did not refer to its edges. *The Rape of the Sabine Women,* which is exquisitely composed, is about a scene of violence, not about the elements that enter into the depiction of that. But Stella, though resolute and inventive within the limits set for him, merely advances a tradition in which physical edges on occasion are referred to, as in Guercino's *Entombment of Saint Petronilla* and, not surprisingly, in certain striking works of Vermeer where the edge of the painting is also the edge of an illusory frame the curtains in the painting blow out past impossibly. Such paintings are virtual embodiments of the ontological argument, presenting as part of their structure what they are about—self-instantiating entities. As such they contrast logically with *impossible* paintings, paintings the structure of which excludes their being instantiated, as in the typical work of Escher and in the sorts of impossible objects that have come to play a central role in the psychology of visual perception. These are almost to be regarded as pure representations, since

they are in one sense *of* objects they could not be *of* in the other sense: painting that could not be "true" since there is in three-dimensional space nothing they could possibly resemble. Hence, as they are necessarily false (as Stella's are 'necessarily true'), they might plausibly be considered pictorial analogues to sentences which, though not through their form inconsistent, can nevertheless not be true in any world.

It is not difficult to find analogies to these in the other arts. The hunting call in the second act of *Tristan und Isolde* is, and at the same time is about, a hunting call, just as the shepherd's song in the third act is what it is also about. And Pope's witty line 347 in the *Essay on Criticism*—"And ten low words oft creep in one dull line"—happens to consist of ten low words in one dull line which, because of its wit and self-instantiation, is not dull in the least, saved from and transcending that through the arch self-consciousness of the artist.

When contemporary artists use words in their paintings, a complex decision as to their status always has to be made because words are at once vehicles of meaning and material objects, and because a picture of a word has to be distinguished from a word *tout court*. Robert Indiana's EAT is a word in paint, rather than a painting of a word, such as we find when Hopper paints the word *Stop* on a stop sign, where STOP belongs to the subject of the painting but not to the painting itself. The subtle tension between these possibilities constitutes much of the structure of the panels in Arakawa's spectacular work, *The Mechanism of Meaning*, which almost rises to the level of philosophy through the fact that it is about the sort of decision I have just described. Arakawa's panels look like showcards in a demonstration of some daffy IQ test, on which the words are not mere shapes but genuine imperatives, to which the viewer must respond, these not being paintings you merely look at. Yet you cannot subtract the imperatives from the paint, though in fact there is nothing that requires imperatives to be painted. Imperatives can be issued orally. So if it were but a matter of giving instructions, Arakawa could have played a tape or used headsets of the sort rented at museums. Ronald Feldman could stand next to the paintings and intone the instructions or, for the matter, hand out sheets with instructions printed on them. But what then would be left of the paintings, which require the imperatives as parts of themselves and which refuse, in consequence, to be vaporized into mere meanings? And so after all you find yourself delivered back to the paint as something to look at and not merely heed, and the letters themselves are rewardingly painted. Yet they cannot be treated merely as that either, and a viewer from a different language community needs a translation if he is to respond other than illiterately. The German publisher of the book *Der Mechanismus*

der Bedeutung has to translate the paintings, which would make no sense in a book that reproduces paintings of, say, flowers, the names of which it would be nice to know, no doubt, but which themselves, as names, have no role or position in the structure of the works.

The complex interconnections between what is shown and the way in which it is shown remain to be discussed, but for the moment I would like to deepen the insights we have won, and to return to them through territory not yet touched in the analysis.

Aesthetics and the Work of Art

4 After reading Viollet-le-Duc's late volume, *Le massif de Mont Blanc*, Ruskin commented with a wry twist on the French response to the Charge of the Light Brigade: "C'est magnifique, mais ce n'est pas la géologie." Indeed it was not geology; it was a visionary scheme for restoring Mont Blanc to what it must have looked like in its beginning grandeur. A kind of utopian nostalgia seems more and more to have been the defining motif of the nineteenth century—the dark obverse of its faith in progress to a luminous future. And under this perspective Viollet-le-Duc, the great restorer of the Gothic edifice, must be its exemplary artist, even if in fact what he achieved was more what the nineteenth century believed what the medieval architect believed was architectural and social integrity than what the medieval architect believed as such. Whatever Viollet-de-Duc touched became "plus gothique que la gothique même"—which could scarcely have been true of "la gothique même." Given his admiration for the First Architect, it was an extravagant extension of his impulse to return a monumental bit of nature of an imagined primordial majesty. So it is intriguing to imagine that he might have found his own good mad King Ludwig to subsidize a hyper-Wagnerian folly, spilling regiments of masons and hodcarriers, surveyors and geologists, across those vast slopes. And there it stands as it stood *am ersten Tag!* or as Viollet-le-Duc supposed it must have stood. Viollet-le-Duc will have made a mountain out of a mountain but, even more strikingly, an artwork out of a peak.

There are metaphysical as well as practical difficulties in juxtaposing stages of the same mountain, and hence in comparing Mont Blanc *jeune* with what we may as well name "Mont Blanc *jeune*." But we can imagine them as indiscernible to whatever degree we wish. From the beginning of this inquiry, I have been obsessed with paired cases where only one member of the couple is an artwork. To be sure, there are theological views to which Viollet-le-Duc was hospitable, according to which God was an artist and Mont Blanc one of his masterpieces. But let us just suppose this false: Mont Blanc is logically mute, however Viollet-le-Duc—and Ruskin—may have rhapsodized before it, but "Mont Blanc *jeune*" makes a statement about the grander aspects of nature.

Viollet-le-Duc's magnificent conception gives us a dramatic opportunity to ponder that nice question of whether our responses, aesthetically speaking, would be the same to objects that are outwardly exactly the same, though one is a work of art and the other a mere object, however spectacular. Such a question raises serious philosophical questions, for should our responses *differ*—and I shall argue that they must—it will be extremely difficult to suppose that aesthetic response is at all like a form of sense-perception, all the more so if our knowledge that one is an artwork is what makes the difference in how we respond. In that case aesthetic response must be conceptually mediated in ways it will be instructive to identify.

There is another consequence of perhaps even greater moment to us. If knowledge that something is an artwork makes a difference in the mode of aesthetic response to an object—if there are differential aesthetic responses to indiscernible objects when one is an artwork and the other a natural thing—then there would be a threat of circularity in any definition of art in which some reference to aesthetic response was intended to play a defining role. For it would not be just aesthetic response that belonged to works of art in contrast with the kind that belongs to natural things or blasé artifacts like Brillo boxes (when not works of art)—and we should have to be able to distinguish works of art from natural things or mere artifacts in order to define the appropriate kind of response. Hence we could not use that kind of response to define the concept of the artwork.

Anyway, aesthetic considerations have always been viewed as having a natural place in discussions of art, and this is as good a place as any to come to terms with this easy association. The question is whether aesthetic considerations belong to the definition of art. If they do not, then they simply will be among the things which go with the concept without pertaining to its logic, and not really more important philosophically than countless other things, such as preciousness or collectability, which have also been part of the practice if not of the concept of art.

An aesthetic condition has been deemed necessary in the definition of art formulated by George Dickie in his influential discussion of the institutional theory of art. A work of art is a "candidate for appreciation," a status conferred upon an artifact by "the artworld," in Dickie's use of the term—an institutionally enfranchised group of persons who serve, so to speak, as trustees for the generalized *musée imaginaire*, the occupants of which are the artworks of the world. "If something cannot be appreciated," Dickie writes, "it cannot be a work of art." Dickie denies that he means specifically *aesthetic* appreciation, but he has been taken to mean that by a prominent critic, Ted Cohen, whose argument, if

sound, has some meaning for us. It is that there are certain objects which *cannot* be appreciated, hence cannot be works of art by Dickie's own contrapositive formula. Hence the citizenry of the artworld is bounded by the constraints of appreciability and cannot by fiat declare just anything a work of art. So there are at least negative conditions on what a work of art can be, and this is evidently not as wholly an institutional matter as Dickie pretends. Presumably, unappreciable objects would be those which would not support the claim that every object can be viewed practically *or* aesthetically. These objects cannot be psychically distanced, and so the objection pertains to more than Dickie's theory and has in consequence a conspicuous philosophical importance.

There nevertheless are two difficulties with this position as defended by Cohen. Among the objects alleged immune to aesthetic appreciation, Cohen cites "ordinary thumbtacks, cheap white envelopes, the plastic forks given at some drive-in restaurants" and, most particularly, "urinals." Now I do not know whether the claim is that these cannot be appreciated or simply cannot be appreciated favorably. Terms like "cheap," "ordinary," and "plastic" are expressions of distaste, and it is not clear that even by Dickie's criterion every object elevated to the stature of an artwork by the artworld must *ipso facto* be favorably appreciated. As a matter of textual fact, Dickie does say something like this: "I am saying that every work of art must have some minimal *potential* value of worthiness." But in fact aesthetic qualities compass, it seems to me, negative considerations; we are repelled, disgusted, even sickened by certain works of art. To restrict to the favorable cases the application of the epithet "work of art" would be parallel to regarding moral considerations as arising only with persons and actions which had some "minimal potential value or worthiness." And while there may indeed be good in everything, moral theory had better accommodate the swine, the wicked, the morally lazy, the bad, the evil, the revolting and the mediocre. So "appreciation," if aesthetic at least, can be negative, and the very use of the adjectives he does use tells us a lot about the way in which Cohen appreciates throwaway forks, vulgar envelopes, and ordinary thumbtacks (in contrast with pushpins?). I should be astonished if negative aesthetic appreciation entailed that the objects which elicited it could not be works of art.

These questions can obviously not be settled without some discussion of aesthetic appreciation—or of appreciation *tout court*—but there is another and more damaging difficulty that would remain even if these questions were resolved in such a way as to leave Cohen's objection unshaken. Even were we to grant that an ordinary thumbtack could not be aesthetically appreciated (positively or negatively), it would not fol-

low that a thumbtack could not be a work of art. Of course a thumbtack that is a work of art would have to differ in some way from a thumbtack otherwise like it in every external respect that is not a work of art. This we have seen from the beginning (remember the canopener). But in that case it is far from plain how things would stand with appreciation. Even granting that the thumbtack itself was beneath appreciation, it would not follow that an artwork materially like a mere thumbtack could not be appreciated; and that to which we might respond appreciatively would be the properties of the artwork without necessarily being the properties of the thumbtack. To be sure, the connection between the two may be very intricate to work out—as intricate perhaps as the connection between a person and his body. We may see this somewhat more clearly perhaps by pondering the notorious example of Duchamp's *Fountain* and Dickie's own analysis of it.

Dickie is adamant in insisting that there is no such thing as "a special kind of aesthetic consciousness, attention, or perception." And he goes on to say, "The only sense in which there is a difference between the appreciation of art and the appreciation of nonart is that the appreciations have different *objects*." Presumably he does not mean by "different objects" the difference between artworks and mere things, for then his definition would go circular: he would be defining appreciation of art in terms of its objects, whereas candidacy for appreciation was supposed to have gone into the explanation of why something is an artwork. So I gather he is trying to say that what we appreciate in artworks is just what we would appreciate in nonartworks, when in fact they happen materially to be the same, as *Fountain* is from countless urinals distributed for the convenience of gentlemen wherever they congregate. "Why," Dickie says, "cannot the ordinary qualities of *Fountain*—its gleaming white surface, the depth revealed when it reflects images of surrounding objects, it pleasing oval shape—be appreciated? It has qualities similar to those of works by Brancusi and Moore which many do not balk at saying they appreciate." These *are* qualities of the urinal in question, as they are qualities of any urinal made of white porcelain, which do resemble certain qualities of *Bird in Flight*. But the question is whether the artwork *Fountain* is indeed identical with that urinal, and hence whether those gleaming surfaces and deep reflections are indeed qualities of the artwork. Cohen has supposed that Duchamp's work is not the urinal at all but the gesture of exhibiting it; and the gesture, if that indeed is the work, has no gleaming surfaces to speak of, and differs from what Moore and Brancusi did roughly as gestures differ from bits of brass and bronze. But certainly the work itself has properties that urinals themselves lack: it is daring, impudent, ir-

reverent, witty, and clever. What would have provoked Duchamp to
madness or murder, I should think, would be the sight of aesthetes
mooning over the gleaming surfaces of the porcelain object he had
manhandled into exhibition space: "How like Kilamanjaro! How like
the white radiance of Eternity! How Arctically sublime!" (Bitter laugh-
ter at the *Club des artistes.*) No: the properties of the object deposited
in the artworld it shares with most items of industrial *porcelainerie,*
while the properties *Fountain* possesses as an artwork it shares with
the *Julian Tomb* of Michelangelo and the *Great Perseus* of Cellini. If
what made *Fountain* an artwork were only the qualities it shared with
urinals, the question would arise as to what makes it an artwork and not
those—the offense to egalitarianism being of a piece with what moved
J's political indignation chapters back. Is it just an oversight of the art-
world? Should there be a mass transfiguration, like a mass conversion to
Buddishm of all the untouchables in Calcutta? What Dickie has over-
looked is an ambiguity in the term "makes" as it occurs in the question:
what makes something a work of art? He has emphasized how some-
thing gets to be a work of art, which may be institutional, and neglected
in favor of aesthetic considerations the question of what qualities con-
stitute an artwork once something is one.

My own view is that a work of art has a great many qualities, indeed
a great many qualities of a different sort altogether, than the qualities
belonging to objects materially indiscernible from them but not them-
selves artworks. And some of these qualities may very well be aesthetic
ones, or qualities one can experience aesthetically or find "worthy and
valuable." But then in order to respond aesthetically to these, one must
first know that the object is an artwork, and hence the distinction be-
tween what is art and what is not is presumed available before the dif-
ference in response to that difference in identity is possible. After all,
we have been struck from the beginning by Aristotle's insight that the
pleasure one derives from works of mimesis presupposes knowledge
that they are imitations, for one will not derive that pleasure from the
originals, however indiscernible originals and imitations may be. And
Diderot has brilliantly argued that we may be moved to tears by repre-
sentations of things which by themselves will move us not at all, or
move us differently. We may cry at a representation of a mother's de-
spair at the death of a child, but he would be hardhearted who just
wept at the correspondant reality; the thing is to comfort and console.
What I wish to say, then, is that there are two orders of aesthetic re-
sponse, depending upon whether the response is to an artwork or to a
mere real thing that cannot be told apart from it. Hence we cannot ap-
peal to aesthetic considerations in order to get our definition of art, in-

asmuch as we need the definition of art in order to identify the sorts of aesthetic responses appropriate to works of art in contrast with mere real things. True, something may not be a work of art without, as Dickie says, the minimal potential for aesthetic value. But I wonder if there is anything at all of which that is not true? He himself allows, against Cohen, that "thumbtacks, envelopes, and plastic forks have qualities that can be appreciated if one makes the effort to focus on them." So what cannot? Yet there is, I shall argue, a special aesthetics for works of art and indeed a special language of appreciation, and inasmuch as both seem to be involved with the concept of art, it will not be amiss to address ourselves to some features of aesthetic and thence of artistic experience, even if it will not especially help us in finding the definition we seek.

I t will be an analytical convenience to begin by supposing, even if false, that there exists, just as a great many philosophers of merit have believed there to exist, an aesthetic sense, or a sense of beauty, or a faculty of taste; and that it is (or these are) as widely distributed among men as the so-called external senses, such as sight and hearing, are. I should suppose them more widely distributed even than that, for there must be as much reason to suppose that animals are driven by aesthetic preferences as men are, and that if they are, there is evidence that we are dealing with something innate. I should be surprised were someone to propose that there is an innate "sense of art"—it would be like supposing there was some special sense, wired in, for telling which were the Baroque churches. There is more to the matter even than this. Whatever the occasional commendatory force of "work of art," it is plausible to suppose that it is after all a matter of fact whether something is a work of art or not. But it would beg every relevant philosophical question there is to suppose that it is a matter of fact that certain things have aesthetic value or worthiness, or whether arguments over the aesthetic merits of something can be settled remotely by appeal to the sort of evidence pertinent to whether something is a work of art or not. It is not clear, for example, taking "is beautiful" as the paradigm aesthetic predicate, whether "x is beautiful" has descriptive meaning or not, in the sense of being true or false. Perhaps the sentences that use this predicate belong to a kind of noncognitive discourse, and are used simply to express feelings toward the objects designated; perhaps we do not characterize objects but coo, as it were, in their presence by means of such language. Indeed, there is a structure of controversy available in connection with aesthetic language which exactly matches that avail-

able in connection with the language of ethics. Obviously, not all possible positions are compatible with the claim that there is an aesthetic sense, just as not all positions in the metalinguistics of morals would be compatible with the claim that there is a moral sense. So we had better ponder somewhat carefully what sort of sense the sense of beauty is, if indeed there is such a sense. In the end, having a sense of beauty will certainly differ from having a nose for art.

Whether such a sense ought to be understood on the model of the sense of sight, or whether it might rather be more like the sense of humor, which is also widely enough distributed that its absense in an individual is deplored, merits preliminary scrutiny. It may of course be argued that we do not in fact have two models, and that the sense of humor is not at all different from the sense of sight, or that it differs from it only in the way in which, say, the sense of hearing does, so that we are dealing with mere additions to the ordinary repertoire of the "five senses": we have here, as it were, a sixth and seventh sense. Thus it is true that the sense of taste and the sense of humor are capable of education and refinement; but then it may be countered that the sense of sight itself can be trained to make finer and finer discriminations, as can the sense of taste for which the aesthetic sense of taste is a natural metaphor. In none of these cases can education make good an initial deficiency: you cannot *teach* the blind to see, but rather you must reequip them. Or, again, it may be argued that the senses of taste and humor are culturally conditioned, so that people of a given tribe find hysterically funny things that appall us, such as the death throes of a wounded antelope; and it is notorious that there are people who find aesthetically valuable things that repel us: exaggerated earlobes, tiny feet, immense lips, huge scars, ponderous bellies. But it may be countered that even color predicates vary from tribe to tribe and culture to culture, so that differences erected upon this basis amount to very little.

These surface parallels notwithstanding, I believe there is a difference between these models deep enough to make a difference in our understanding of the mooted aesthetic sense, and, though not altogether central to our task, it will not be a rank digression to explain wherein the difference seems to lie. It lies in the fact that the sense of humor consists in part at least in *responding* to certain things because they are amusing. Laughter, when at a thing or act because the thing or act is comical, is a good enough example of what I mean by a response, though of course there are other modes of response. But there is more to the matter than this. Having a sense of humor affects one's life globally; one does not take everything tragically or earnestly; one looks on the light side; one mutes misfortune with jokes—having a sense of humor is

almost like having a philosophy. Something of the same sort is true of the aesthetic sense, as indeed it is true of the moral sense, there being as much justification for postulating it as either of the others. "Minds in which the transformations of nature were mirrored without any emotion," Santayana supposes would have no moral sense. "For the existence of good in any form, it is not merely consciousness but emotional consciousness that is needed. Observation will not do, appreciation is required." But the fact of responsiveness is built into the concept of emotion, and it would be difficult to know what moral life would be like, or if indeed there could be such thing as a moral life, if there were not responses like indignation, concern, shame, or sympathy. And this contrast between observation and appreciation is certainly part of what Wittgenstein must mean when he claims that values are not in the world. If they were, he argues, they would be of no value, implying that we do not simply note that something is valuable ("observation will not do"): values involve a relationship between ourselves and the world, though there may be a natural tendency to project these responses back onto the world and think of them as if they were there, as Santayana supposes beauty to be the objectification of the pleasure that things elicit in us when we respond to them as beautiful.

It seems to me that responsiveness does not go with the so-called five senses. Thus it is true that a man may respond to certain things he sees as red, the way a bull is said to do. But the response may be due less to the fact that the object is sensed as red than to the fact that red makes him angry; and anger *is* the sort of thing whose essence comprises responses, such as lunging violently or expressing irascibility. It is a possible philosophical position to argue that anger simply is a set of responses, not some inner state separate from them. But only an extreme verificationism would hold that this is true of sensing red. When I say, for example, that having a sense of humor entails responding to things because they are funny, I am not trying to impose an epistemological criterion, not trying to answer the question of how we know that someone is amused. Whatever the reasons for supposing the sense of humor to consist in a set of responses, such a theory would be far less radical than one in which the sense of red is defined in such terms as saying "Red" when presented with the epistemologist's red patch. "Mirroring the transformations of nature" is a natural and suitable metaphor for minds equipped solely with the five senses.

An area of animal response which bears comparison with the aesthetic sense—or the sense of humor—is that of sexual response. The *Erotics* is the unwritten Aristotelian masterpiece the *Poetics* cries out for as a companion volume. To find something sexually exciting is not

passively to register the fact that it is so, but is rather to be aroused, and it is difficult to imagine that someone could be aroused without responding in the familiar physical ways: to be aroused is just to respond those ways. There may seem to be a difference in the fact that sexual response is not disinterested; to respond sexually is to want to possess sexually, whereas it has been widely held that the aesthetic sense is disinterested and is content with mere contemplation. But this thought may derive from the fact that certain paradigms are used with regard to which no serious alternative to contemplation may be available—say sunsets. But wanting to paint or photograph—or to remember—these things is not misleadingly thought of as a way of possessing them; and though one cannot own a sunset, the history of taste and the history of acquisitiveness run pretty much together, and men are pleased enough to claim ownership of the beauties of the world. Indeed, attempting to possess may be one form of aesthetic response, as laughter is of the sense of humor.

Each of these examples, but none of the ordinary senses, admits of perversion, conspicuously so in the sexual dimension, but no less so ultimately in matters of taste and humor and moral conduct. Perverse preferences are different from bad ones: perverse sex is not bad sex—it may be marvelous—and in contrast with bad taste, perverse taste may be the mark of high if miscarried refinement. But I have no idea what a perverted sense of hearing could amount to. When someone sees green where we see red, this is color blindness, not chromatic perversion.

The concept of perversion, of course, carries enough of a connotation of normative judgment that there seems room for the application of imperatives: there are things we respond to which we feel we ought not to, and things we ought to respond to which we cannot; there is a kind of aesthetic weakness as there is of moral weakness—as there is for the matter a kind of emotional akrasia. But none of this again is true of the ordinary senses, which traditionally at least would have been regarded as not subject to interventions of the will. All of this is consistent with regarding the aesthetic sense as innate, but my main interest in drawing the distinction does not lie here. It lies in the fact that no knowledge of an object can make it look different, that an object retains its sensory qualities unchanged however it is classed and whatever it may be called. To put it in a more contemporary idiom, one's sensory experiences would not be expected to undergo alteration with changes in the description of the object; that remains invariant under changes in description, as Santayana's useful if philosophically tendentious image of a mirroring intelligence implies. If the aesthetic sense were like the other senses, the same would be true of it, but in fact one's aesthetic re-

sponses are often a function of what one's beliefs about an object are. True, there may be cases where my sensory experience of an object may differ when the object is brought under a certain description, in the sense that knowing it to be of a certain kind, or knowing it to be described in that way, I may concentrate attention and pick up certain qualities I missed the first time around. Told that a certain wine has the taste of raspberries, I may learn to discriminate this taste, which I did not discern when I first tasted it. Yet it was there to be tasted before as well as after it has been described that way: the object did not *acquire* these qualities by being described, nor did it change its status thereby. But the qualities an object has when an artwork are in fact so different from what an indiscernible counterpart has when a mere real thing that it is absurd to suppose I *missed* these qualities in the latter. They were not there to be missed. No sensory examination of an object will tell me that it is an artwork, since quality for quality it may be matched by an object that is not one, so far at least the qualities to which the normal senses are responsive are concerned. That much I should hope has been established by my argument. If aesthetic response were constant as to the difference between art and nonart, the same would be true of these. But it is false. Our aesthetic responses will differ because the qualities to which we respond are different.

I do not mean, even if it is incidentally true, that our attitude toward an object may not alter when we discover it to have been artwork. We may, upon learning that an artwork is before us, adopt an attitude of respect and awe. We may treat the object differently, as we may treat differently what we took to be an old derelict upon discovering him to be the pretender to the throne, or treat with respect a piece of wood described as from the true cross when we were about to use it for kindling. These changes indeed are "institutional" and social in character. Learning something to be an artwork, we may, just as Dickie says, attend to its gleaming surfaces. But if what we attend to could have been attended to before the transfiguration, the only change will have been adoption of an aesthetic stance, which we could in principle have struck before. It is a matter merely of attending to what was there to be perceived—like the taste of raspberries in the glass of gigondas. No: learning it is a work of art means that it has qualities to attend to which its untransfigured counterpart lacks, and that our aesthetic responses will be different. And this is not institutional, it is ontological. We are dealing with an altogether different order of things.

It is not difficult to construct examples in which this difference may be made plain, examples in which recognitionally indiscriminable objects prove to have very different qualities and indeed very different structures depending upon whether one of them is an artwork or not or, less interestingly, upon the different artistic identities of both, which, like certain of our initiating red squares, are artworks already. Even if there is an innate sense, the aesthetic responses will differ, even in the same individual, depending upon how the indiscernible objects are classed. The differences are as deep as those between bodily movements and actions, between a person and a zombie, between a divinity and an idol.

Imagine six panels of ricepaper used as a room divider, say in an apartment in Tokyo, a city whose air quality has degenerated alarmingly over recent years. Soot has been deposited on the roof which, one day, springs a leak in such a way that splotches and splashes of soiled water get deposited in various irregular patterns while the apartment stands empty. The new tenant, an aesthete, recoils upon beholding the sordid sight: he demands removal and replacement with some nice clean panels, so the place "is fit to live in." Whereupon he is informed that a rare screen, six panels wide, by one of the great masters of the art, has come onto the market; that it would fit the space to perfection; that it is a once-in-a-lifetime opportunity. It is bought and installed, and it is thrilling to look at it. To be sure, the same distribution of grays and blacks may be found that defaced its merely domestic predecessor, and for our purposes the panels in fact are exactly congruent. *These* blacks, however, are mountains, *those* gray smudges clouds. The fine splatterings in the panel to the extreme right compose a token representation of rain softening into mists. The irregular streak over here is a dragon ascending, at times indistinguishable from the mountains, at others from the clouds, making his mysterious way—Way—through the boundless, softly articulated universe to whatever is its destiny and our own. It is a philosophic work, dense with depth and mystery and beauty: before it one is moved to the profoundest meditations, transfigured by its power—though its indistinguishable counterpart rightly provokes us only to disgust. Our aesthete spends hour upon hour in contemplation of its bottomless wonder, now and again shuddering at the recollection of the desecration it replaced. Those dirty panels had no mystery and certainly no depth and absolutely no beauty.

It may be argued that the example is unfair. The artist J has a Japanese doppelganger, concerned with the Oriental version of *l'art brut.* Flinging an epithet against the entire rotten preciosity of a decadent feudal tradition, he presents us with six panels of filthy ricepaper, as of-

fensive as bird droppings on one of Guido's angel-struck maidens. It is nothing more than it pretends to be: so many stretches of soiled rice-paper. Will it be beautiful, mysterious, cosmic, deep? I have no idea what aesthetic qualities it will have, for the object is insufficiently described and I cannot tell much from the small reproduction in *Art International*. I know that my responses to it will be different from those the great screen elicits. This work, I imagine, will be described by connoisseurs as "sordid," without this being necessarily an expression of disgust or even of aethetic dispraise. And I am certain that the logic of this expression's use will be different when applied as an artistic predicate, true of an artwork, than an aesthetic predicate true of a mere Sordid Thing. And it will go with quite different responses as well. I can do no more at this point in our analysis than indicate that there is this difference, and to commit myself to work it out when I am in better position to map the semantics of the Language of Artistic Appreciation. But when I say that the object has been insufficiently described, I mean that a number of decisions must be made in identifying it as a work—decisions that do not come up at all in connection with its recognitionally congruent cousin, the long-since discarded set of soiled panels. Meanwhile it is agreeable to have established that whatever the divisions between East and West, the identical philosophical-aesthetic questions can be raised for either tradition.

Each member in any arrayed example, of the sort I have been constructing, has a kind of common denominator—a base as it were, supporting variable superstructures but which, in counter-Marxist fashion, underdetermines the structures that share it. What they have in common may be thought to be simply everything that is congruent with the mere real object. My claim throughout is that an artwork cannot be flattened onto its base and identified just with it, for then it would be what the mere thing itself is—a square of red canvas, a dirty set of ricepaper sheets, or whatever. It would be whatever the real thing itself consisted in that we proposed to subtract from the work of art, in order to see what the remainder might be, supposing that the essence of art might lie here. It was as though the artwork in every instance was a complex entity with the red square, for example, as a proper and indeed an easily interchangeable part: our arrayed examples were almost as though several souls shared the self-same body.

But now there has come up the first shadow of a set of questions which will lengthen as our work advances, and which casts a certain darkness over the Wittgensteinian subtraction. Is every part and qual-

ity of that material base, is every sensory quality that remains invariant under the shift from thinghood to artwork, or from artwork to artwork, indeed a part or quality of the work itself? And, if not, can we so much as say that the work contains *it*, that is, with "all its qualities and parts"? If the answer is negative, small wonder that what we took as base underdetermines the set of artworks which have it as a seeming common base. For if the work determines which parts and qualities of the bases belong to it, it might be possible to imagine cases in which no material parts and qualities are shared by works whose photographs exactly resemble one another, or which to all intents and purposes are totally similar under sensory scrutiny. And the complexity of the artworks accordingly renders virtually useless the subtraction formula, inasmuch as until the work is identified, there is no telling what is to be subtracted.

Let us consider a fairly straightforward case. There is at Columbia University's Arden House Conference Center a statue of a cat in bronze. It stands on a floor at the head of a stairway that leads into a common room at a lower level. Presumably it is of some value, or believed to be of some value, inasmuch as the managers have chained it to the railing—to forestall theft, I suppose, as if it were a television set in a squalid motel. Such might be the obvious interpretation. But I am open to the suggestion that it is not a chained sculpture of a cat but a sculpture of a chained cat, one end of which is wittily attached to a piece of reality (a chain from art to reality is what we have been looking for). Of course what we take to be a bit of reality can in fact be part of the work, which is now a sculpture of a cat-chained-to-an-iron-railing, though the moment we allow *it* to be a part of the work, where does or can the work end? It becomes a kind of metaphysical sandpit, swallowing the universe down into itself. In any case, suppose we have just catcum-chain. The question is what is to be subtracted, if anything? Is the chain part of the work or not? Are the scratches part of the work or defacements of it? Metaphysicians have studied the reasons why a chained object is in fact two objects and not one, correctly surmising that we cannot draw up a basic ontology until we know where such lines are to be drawn. The intuition is that there are two things, the boundaries being where commonsense would draw them. But whatever the difficult conclusion may be, all rules are in abeyance with works of art: cat and chain can be parts of a single work, though different objects outside the world of art. Nor is the problem purely a contrived one. A piece by Richard Serra was exhibited in a show of contemporary sculpture at the Museum of Modern Art in June 1979. It was called *Corner-Piece*, and chiefly it was a metal bar that stood to two walls as a hypotenuse to two

sides, perpendicular to the floor. Beneath it was a lead plate. The piece was located in the center of a large gallery, and there was a special corner built there, in the middle of the room, in which the bar could be seen. The question facing the viewer is whether the corner itself is part of *Corner-Piece*. Or must the owner furnish his own corner, as he must furnish his own wall if he wants to hang a painting? What would one be getting for one's money when one buys *Corner-Piece*? As with a frozen pie, one must look at the label to find out what the artwork here contains, which as it happens is "Lead plate and lead wrapped around steel core." Thereupon one erases from scrutiny the factitious corner constructed by the museum for its cherished acquisition.

There are Tintorettos where the coarse canvas is so in evidence, since he was a rough and hurried painter, that standing at museum distance it is very difficult to overlook it, or to sublate it in order simply to concentrate on *The Miracle of Loaves and Fishes*. Is the canvas to be read out? I suppose it is, but the question ought not to be answered lightly—think of the bottom edge of the *Entombment of Saint Petronilla*. There are some paintings I once saw by the second-generation Abstract Expressionist, Joseph Stefanelli, where the canvas is specified as being allowed to breathe through the paint, where it is intended not simply as support for the swags of paint but struggles, as it were, with the paint for identity and a kind of artistic Lebensraum: it is part of the work, and this is so even for the areas that do not succeed in coming through. I shall speak in a moment of the logic here, but for now, and at the level of a slogan, we might simply say that a decision must be made as to what the work is before we can tell what must be subtracted.

Beyond this, there is a question of whether we are dealing with one work or more which have been mistakenly read together. Two works of the gifted artist Eva Hesse were shown in the same show as *Corner-Piece*. The two were in a single alcove. One consisted in a set of irregular cylinders made of fiberglass, which were set in a kind of congregation on the floor of the alcove. The other was a sort of curved wire that went from floor to wall in a striking curve; there were pieces of some unidentifiable stuff attached to the curve at what appeared to be random intervals. When I spied the alcove, I saw what I thought was a single work with two main components, rather than two distinct works shown together by curatorial decision. Were it a single work, there would be a bright contrast between the soaring curve and the squat herd of dopey cylindroids. It could almost be a political allegory. But the only contrast is between the two works, *Viculum Two*, made of rubberized wire mesh, and *Repetitions 19*, made of fiberglass. Nor is this a problem simply with the extreme avant-garde art of our time. There

is a painting in Santa Maria del Popolo in Rome, of a saint with eyes turned up in what appears to be exaggerated Baroque rapture. We, who prefer things *sec*, are revolted by this, especially when it goes with clasped hands: it is as cloying as Carlo Dolci. Leo Steinberg turns everything round through his discovery that the painting is a fragment of the chapel's decoration: there was shown a miracle on the ceiling, since disappeared, and the saint was looking at it. And *we* were looking at a *piece* of a work and not a work, and accordingly judged it wrong.

The relationship between the work and its material subtrate is as intricate as that between mind and body. Or, following P. F. Strawson, with his distinction between P-predicates and M-predicates, it is as if there were properties of the work exemplifying what we may call W-predicates and properties of the mere things that are visually indiscernible from the work, exemplifying what we may call O-predicates, where there is the task, which may vary from item to item in an arrayed example, of determining which O-predicates are also W-predicates and which are not. Thus "is chained" may be true of the object, that piece of shaped bronze, without being true of the cat. And when it is true of the cat, its logical status, as we shall see, is going to differ markedly from that same predicate when true of the object. Again, "of something chained" is true of the work but not of the subject of the work, and certainly not of the material counterpart. The distinction between artworks and mere real things reappears as a distinction between the language used to describe works and the language of mere things. Until one has constituted the work, as the phenomenologists use that expression, to what is one responding aesthetically, and will it after all be the right thing and the right response?

Let us continue to speak of the mere thing, various parts and properties of which will be parts and properties of the artworks that compose the other members of a given arrayed example, as the *material counterpart* of any of these. It will not merely be that the work itself will determine what of the material counterpart will have to be subtracted; the works will in the nature of the case have properties that are not properties of the material counterpart. Only, for instance, *Nirvana* in our originating example will have "depth," a term that will be false of a mere square of red painted canvas, or will be used in a sense as different as the sense of a metaphoric use will be from a literal use of the same predicate. It is finally for this sort of reason that I am reluctant to admit the entities Cohen proffers as counterinstances to Dickie's thought that an artwork is a candidate for appreciation. As mere objects, thumbtacks may have little to recommend themselves aesthetically. But as artworks? Suppose there is an artwork whose material counterpart is a

mere thumbtack. It will, as we shall see, have a structure that it would be fallacious to attribute to thumbtacks. Until I have constituted the work, of course, which may take into consideration some fairly serious art-historical and art-philosophical investigation, nothing can be said. I am not here going to say what my response to it would be: familiar as I am with thumbtacks, I have yet to see a work whose material counterpart is one. And a work whose material counterpart consists of three thumbtacks may have abysses of meaning to which the appropriate aesthetic response might be a religious-cosmic shudder.

For the moment, my concern is only to point out the possibility of differential aesthetic responses depending upon whether we are dealing with an artwork or its material counterpart. We now know, of course, that anything in the world, and any combination of things in the world, can be material counterparts to artworks without its following that the number of artworks will equal the number of things and combinations of things in the world. Think of how many peers a mere red square of canvas has. John Stuart Mill worried himself into a state of nineteenth-century blues at the fact that there were just so many tones and combinations of tones, and so the musical combinations possible would be finite and sooner or later would be run through and music would come to an end. As though the relationship between musical composition and combinations of tones would be all that different from the relationship between works of art and their material counterparts! Music is not interestingly finite at all.

There are doubtless works of art, even great works of art, which have material counterparts that are beautiful, and they are beautiful in ways in which certain natural objects would be counted as beautiful—gemstones, birds, sunsets—things to which persons of any degree of aesthetic sensitivity might spontaneously respond. Perhaps this is dangerous to suppose: sailors might respond to sunsets only in terms of what they foretell of coming weather; farmers might be indifferent to the flowers they tramp on; there may be no objects to which everyone must respond that can be offered as paradigm cases. Nevertheless, let us suppose a group of people who do in fact respond to just the things we would in fact offer as paradigms: to fields of daffodils, to minerals, to peacocks, to glowing irridescent things that appear to house their own light and elicit from these people, as they might from us, the almost involuntary expression "How beautiful!" They would partition off beautiful things just as we would. Except these people happen to be "barbarians," lacking a concept of art. Now we may sup-

pose these barbarians would respond to certain works of art as well as to natural objects just as we would—but they would do so only to those works of art whose material counterparts are beautiful, simply because they see works of art as we would see those material counterparts, as *beautiful things:* such as the rose-windows of Chartres, or thirteenth-century stained glass generally; certain works in enamel; confections wrought by grecian goldsmiths; the saltcellar of Cellini; the sorts of things collected by the Medici and the later Habsburgs—cameos, ornaments, precious and semiprecious stones, things in lace and filagree; things luminous and airy, possession of which would be like possessing a piece of the moon when that was thought to be a pure radiance rather than a ranch of rocks. There is some deep reason, I am certain, why these things attract, but I shall forgo any Jungian rhapsodizing.

There is little doubt why the old masters warm the heart. It is because they capture the sort of inner light that true gems possess: their paintings *have* a light in addition to whatever light they show. Daubers may manage to show light, but their paintings have only the luminosity of mud. My personal criterion of great painting has in part to do with this mystery of light, but I wonder how many of the great paintings of the world would be seen that way, in possession of this curious grace, if they were perceived solely as we might perceive their material counterparts: would their material counterparts have light, granted that they might not show any? Think of some great drawing, and then imagine it as seen by you when seized by a kind of pictorial dyslexia, hence as so many splotches and smudges and scratches and puddles. It would be to look at those drawings perhaps as the theory of formalism would enjoin us always to look at everything artistic. But to the degree that the imperative makes sense, the beauty of the work may vanish when the work is reduced to its material counterpart, or replaced by it as a princess by a changeling. Indeed, the demand that the beauty of the work be identical with the beauty of the material counterpart is virtually a definition of barbaric taste, magnificently exemplified in the goldwork of the Scythians. But a work with a beautiful material counterpart could just be gaudy as a work.

Imagine now our sensitive barbarians sweeping across the civilized world, conquering and destroying like Huns. As barbarians reserve the fairest maidens for their violent beds, we may imagine these sparing for their curious delectation just those works of art which happen to have beautiful material counterparts. Some paintings, certainly, will survive. Those with lots of goldleaf will certainly do so, and certain icons with highly ornamented frames. Or paintings where the colors have a kind of hard mineral brilliance, as in Crivelli or perhaps Mantegna. But how

many Rembrandts would make it through under this criterion, how many Watteaus or Chardins or Picassos? Appreciation of these requires them to be perceived first as artworks, and hence presupposes availability of the concept we are disallowing the subjects of this Gedankenexperiment. It is not that aesthetics is irrelevant to art, but that the relationship between the artwork and its material counterpart must be gotten right for aesthetics to have any bearing, and though there may be an innate aesthetic sense, the cognitive apparatus required for it to come into play cannot itself be considered innate.

Let us consider some remarkable paintings by Roy Lichtenstein, his *Brushstroke* paintings of the late 1960s. These are paintings *of* brushstrokes, and one who is aware of the role that brushstrokes played in Abstract Expressionism in the 1950s has to see Lichtenstein's paintings as comments upon that movement. The brushstroke lay at the logical intersection of two concerns with paint. The first concern was with the physicality of paint itself, as a substance out of which paintings had always been made but which was somehow disguised by painters, who sublated it in favor of some subject. Returning to the physicality of painting was somewhat in the spirit of a modernist revulsion against the Victorian suppression of the flesh, as in D. H. Lawrence, who came with a kind of prophetic urgency to announce that we *are* flesh in just the way in which the Abstract Expressionist wished to announce that paintings *are* paint. So he used it thickly, and eschewed the transfigurations of it which images and subjects always induced: substance and subject were one. Since paint was the subject, an artist was a painter and the basic artistic action was painting (not copying, imitating, representing, stating, but painting). The artist, as in the description by Harold Rosenberg, uses the canvas as an arena; he makes upon it a swipe of painting which means nothing ulterior and is at most what it is about. It is of course true that painting is an action, but so is sketching, and so too are copying, representing, and the like. But this was a puritanical movement, concerned with the most basic artistic action there is; and while representing and copying and the rest all entailed something like painting, painting entailed none of these, and so was fundamental. Just think of what sort of metaphysics one has to have internalized in order to want to "get down to basics": it is a metaphysics of basics and nonbasics, complicated by a moral attitude that only the basics matter, everything else being hypocrisy. A straight line, one would think, would be basic in some deep geometrical sense, but lines are too easily seen as generating forms and hence as having a

representational role. So the thing was to use strokes of paint, heavy and fat, laid down with as big a brush as one could manage in as large a sweep as one could execute, a stroke so consumatory that the question of what one was doing through the stroke could hardly arise: there was no way of getting the stroke to form part of an image, it stood alone, it was what it was. (De Kooning's contribution, incidentally, may in part have been that even these wildly anarchistic strokes, which seemed to be unintegrable into a representational structure, could in fact be regimented to form images of—of all things—women. Not Venuses and Madonnas or Mme. Renoirs, but paint-ladies of an almost ferocious character, who seem to resent having been given existence.)

The entity that concentrated and emblemized this complex of attitudes was the drip: drips acquired a kind of mystical exaltation of status in the 1950s, and it is easy to see why. In an earlier period, a drip would be an accident or a blemish, a sign of ineptitude (an attitude charmingly reinvented by the "masters" of subway grafitti, who have assistants whose purpose is to wipe drips away, the masters having contempt for those who allow the paint to follow a life of its own, which is exactly the inverse of the attitude of the 1950s painter). A drip is a violation of artistic will and has no possibility of a representational function, and so, when one occurs, it immediately disfigures a picture—as a typographical error disfigures a text—especially when it is the function of the medium to disguise itself in favor of what it means to show. There traditionally had been a complicity between artist and spectator, in which the latter was to disregard the paint and gape (say) at the Transfiguration, while the artist, on his side, worked to make it an honest possibility for the spectator to do this by making the paint as inconspicuous as possible. (There are exceptions, of course: Rembrandt and Valesquez are stunning masters of pigmentational accidentality, and Tintoretto refused to cooperate.) The drip, meanwhile, calls attention insistently to paint as paint. So in the tradition just alluded to, drips would have had the role that static does in the transmission of music, supposing it to be the role of acoustical engineering to make the medium between the source of music and the ear of the listener as transparent as the physics allows. Hence someone who wanted to call attention to the transcriptional aspect of contemporary audition would celebrate static as a mark of integrity, to be heard rather than listened through. Drips then are monuments to accident, spontaneity, giving the paint its own life, so much so that it could almost be supposed that the function of painting was to provide an occasion for drips; and Pollack was himself celebrated for having discovered the drip, which at the

time was regarded as on a par with Columbus' discovery of America or Freud's of the unconscious.

More important, the drip itself is possible only when paint itself is fluid, so it not merely underwrites the way paint must be but the way in which it is put on canvas: the dabs of paste laid on with a brush and systematically diluted with medium give way to the battery of paint cans and the dipstick, as the canvas itself describes a rotation through ninety degrees from its vertical position on the easel to its horizontal position of the floor, which the painter crouches over like a frog-god. But the drip is also evidence for the urgency of the painting act, of pure speed and passion, as the artist swings loops and eccentric arabesques across the surface, sending up showers and explosions of spatters. And since he merely executed the will of the paint *to be itself*, the artist had nothing of his own to say. This went with that studied brutishness of the Dumb Artist exemplified over and over again in the artworld of the time by really quite intelligent men and women who pretended to a kind of autism, and went around in clothes so splashed with paint that the very costume was an advertisement for the closeness between the artist and his work. The bluejean and the workshoe—so distant from the velour jacket and beret of the time of Whistler—connoted a kind of proletarian honesty and down-to-earthness. In any case, the drip also makes an appearance in Lichtenstein's paintings, along with the brushstrokes. The paintings show those ropy, fat, incarnated spontaneities of brushstrokes and drips, and would be recognizable as such to anyone familiar with the high period of Tenth Street Art. Their iconography is patent, and I have dwelt upon it at length because it is absolutely important to understand the subject if we are to "appreciate" the way in which it is treated.

The first thing we must note about Lichtenstein's paintings is that *they* have none of the properties associated with what they are of. One would traditionally have expected this as a matter of course, since paintings of landscapes seldom have the properties of what they show, but it is somewhat remarkable here through the fact that these are paintings of painting. These, for example, show brushstrokes but do not consist, in their own right, of brushstrokes, and for just the reason the spectator must grasp the discrepancies between what is shown and the way in which it is shown, surface and subject being virtually antonymic. The brushstrokes are shown in a way that is inconsistent with what they are in further ways still: they are imprisoned in heavy black outlines, as in Leger's work or, better, as in a child's coloring book. But the brushstrokes these paintings are about were not filled into preexisting bound-

aries; they were densely swept across the canvas in a single impulsive gesture, defining their own boundaries. By contrast with the free and liberated spirit with which those strokes emerged onto their canvases, these strokes are shown almost mechanically, almost as though printed onto Lichtenstein's canvases; and indeed Lichtenstein uses the Ben Day dots of mechanical reproduction processes. So the canvases look like mechanical representations of vital gestures.

But there is another level still, which we ascend to when we realize that the dots were not printed but painted in, each one deposited onto the surface by hands: so we have artistic representations of mechanical processes. The monotony of the process of painting these in was somewhat mitigated through the fact that Lichtenstein used a lot of students from his classes at Rutgers, and again, I think, the knowledge of this history has to be taken as a comment upon the ridiculously heroized view of The Artist in the period when brushstrokes meant the opposite of what *this* mode of representing them shows. The interposition of the Ben Day dot has a profound symbolism of its own, inasmuch as it encodes the manner in which we perceive the major events of our time, through the wine-service photograph and the television screen; the depiction of the victims of the Vietnam war takes on an added dimension of horror when the mechanical mode of depiction is incorporated as part of the image, for our experiences are modulated through the medium which has indeed, in MacLuhan's slogan, come to be part, at least, of the message. The brushstrokes of the masters of the 1950s were meant not to represent anything, simply to be: fresh created realities. And Lichtenstein has treated them as artists have always treated reality, namely as something to put into works of art. Thus victimized, these poor deflated swags stand like specimens of something once vital, in *representational* works that belie at every point the intentions of those painters whose life was defined by squeezing paint out like hoses gone mad. These paintings are a minor victory in the battle with reality. If the canvas is indeed the arena in which the battle goes on, it has been lost to representation in the canvases of Lichtenstein.

I have dwelt at such length upon Lichtenstein's paintings in part because they are so rich in their utilization of artistic theory: they are about theories they also reject, and they internalize theories it is required that anyone who may appreciate them must understand, and they allude to yet further theories, ignorance of which impoverishes one's appreciation of these works. What point could there be, for instance, to the dots, were someone unaware of the role dots play in mechanical reproduction and to the role of mechanical reproduction in the life of our culture? The paintings are points of intersection of so

many strands in contemporary culture that it is not only difficult to imagine what some stranger to our culture would make of them, but, consistent with the form of artistic experimentation that has characterized my analysis throughout, it is difficult to see what works exactly like these but painted, suppose, in the 1860s would have meant. And my argument has been that, whatever we are to say about aesthetic responses, it is possible to imagine that works with a common material counterpart elicit very different responses. *These* paintings are deeply theoretic works, self-conscious to such a degree that it is difficult to know how much of the material correlate must be reckoned in as part of the artwork; so self-conscious are they, indeed, that they almost exemplify a Hegelian ideal in which matter is transfigured into spirit, in this case there being hardly an element of the material counterpart which may not be a candidate for an element in the artwork itself. I shall return to a proper analysis of this subsequently, but for the present I mean only to stress that whatever the counterfactual nineteenth-century counterparts to the Lichtenstein paintings may have been about, they could not have been about what the Lichtenstein's are about. Even if they were in some mad way about brushstrokes, the brushstrokes they were about would not have connoted a set of associations only available to those who had known about the dense artistic controversies of the 1950s. Of course, those paintings could have been a kind of crystal ball through which the art of the future might be glimpsed, but what could anyone have made of what they saw there?

I am trying to state that the "aesthetic object" is not some eternally fixed Platonic entity, a joy forever beyond time, space, and history, eternally there for the rapt appreciation of connoisseurs. It is not just that appreciation is a function of the cognitive location of the aesthete, but that the aesthetic qualities of the work are a function of their own historical identity, so that one may have to revise utterly one's assessment of a work in the light of what one comes to know about it; it may not even be the work one thought it was in the light of wrong historical information. An object of the sort made by Tony Smith could have been made almost any time in modern times—at least the material correlate could have been made at any such time—but imagine one having been made in Amsterdam in the 1630s, set down where there is no room for it in the artworld of the times, the golden age of Jan Steen and Van Goyen, and it enters that world as the Connecticut Yankee does the court of King Arthur. What could it be, what could it be about, even if the possibility of its being an artwork could have arisen for those whose concept of art consisted in portraits of one another in ruffed collars and tables piled up with grapes and oysters and dead rabbits, or peonies

with a single drop of dew, a convex mirror in which the whole world could be reflected as in the Arnolfini wedding portrait? And since, if I am right in supposing that it could not be about whatever Tony Smith is about, how could this object have had any structure other than the structure of so many big slabs of black plywood nailed together?

In *Sein und Zeit*, Heidegger speaks of tools as forming a kind of total system—a *Zeugganzes*—which is a complex of interreferential tools, not remarkably different from a language game, if we follow Wittgenstein in thinking of sentences as tools in their own right, to be brought out for various choreographed uses. There cannot, thus, just be nails. If there are nails, there have to be hammers to drive them and boards to drive them through; and changes at one point in the system entail changes at other points. You cannot imagine someone saying that the Etruscans were the first to have typewriter ribbons, not even if you find some carbon stretch of silk ribbon at Cervetri, for that cannot have been a typewriter ribbon, not even if found wrapped round some bronze wheels that look like the spools in a bronze age typewriter, for the whole system has to be there at once: paper, metal, keys, and so on. Some while ago a cache of Da Vinci manuscripts was found which excited cartoonists to make drawings in the Da Vincian style of such things as lightbulbs and electric sockets, like a Renaissance form of the sorts of things we see in drawings by Claes Oldenberg. This is a parody of the idea we have of the genius "ahead of his time," for there are certain ways in which nobody can be ahead of his time: a notched bronze wheel exactly like a bicycle sprocket found in excavations in Tibet could not have been a precocious bicycle sprocket, whatever its identity as an artifact. And something like this is true of artworks as well: you can certainly have objects—material counterparts—at any time in which it was technically possible for them to have come into existence; but the works, connected with the material counterparts in ways we have hardly begun to fathom, are referentially so interlocked into their own system of artworks and real things that it is almost impossible to think of what might be the response to the same object inserted in another time and place. A portrait painted by a Jesuit artist of the favorite concubine of the emperor of China, which used shadows to round her lovely face, was rejected by her as hideous, since she believed she was being represented as half-black and that the painting was a joke, even if, to our eyes, it might have rivaled in sensitivity the Genevra da Benci of Leonardo. A painting by one of our contemporary artists in the style of Giotto simply could not be responded to the way a Giotto could, to its "touching naiveté," not unless the artist were ignorant of the history of art and in some miracle of coincident creation had reinvented a

Quattrocento style. And this would be like someone who, in contrast with Menard and out of springs of invention one can hardly guess at, wrote in ignorance of the original something we might consider indiscernible from *Don Quixote.*

These are by now familiar extensions of Wölfflin's thought that not everything is possible at every time. I have reraised these points here because we now have at least this piece of theoretical apparatus to work with: if we may distinguish between the artwork and its material counterpart, then it is possible to imagine two works done at very different times—Lichtenstein's brushstroke painting of 1965 and an imaged painting exactly like it done in 1865—which share a material counterpart but which *have* to be distinctive works of art since they cannot conceivably be about the same thing. I have tried to sketch the intricate tensions between subject and surface in Lichtenstein's painting, in a partial effort to say what they consist in (they consist in part in just these tensions). It cannot be true the painting of 1865 is about what Lichtenstein's is. The question before us, accordingly, is what connection there is between the artwork in either case and the common material correlate, and this is what I wish to address myself to now. It obviously involves something I shall term "interpretation," and it is my view that whatever appreciation may come to, it must in some sense be a function of interpretation. That in a way is not very different from the slogan in the philosophy of science that there are no observations without theories; so in the philosophy of art there is no appreciation without interpretation. Interpretation consists in determining the relationship between a work of art and its material counterpart. But since nothing like this is involved with mere objects, aesthetic response to works of art presupposes a cognitive process that response to those mere things does not—though the matter is inevitably complicated by the fact that once the distinction is available, and because of the fact that works of art may so closely resemble mere real things, an act of disinterpretation may be required in cases of inverse confusion, where we take a mere thing to be a work of art. Of course there doubtless are cases where this is not required: sunsets and the Evening Star are properly not regarded as works of art inasmuch as artistic intervention has not yet made artworks of things that have sunsets and the Evening Star as material counterparts. But the options are available if in fact unexercised.

In any case, aesthetic response presupposes the distinction and hence cannot *simply* enter into the definition of art. The matter is even deeper than that. As we shall see, aesthetic appreciation of artworks has a different structure from aesthetic appreciation of mere things, however beautiful and irrespective of whether the sense of beauty is innate. It is

not a philosophical question, but a psychological one, whether indeed there is an innate aesthetic sense. What is philosophical is the question of what the logic of such appreciation may be, and what the structural differences are between responding to artworks and responding to mere things. I shall place a marker here, and return to the question after we have worked through the more immediately pressing question of the nature of artistic interpretation.

Interpretation and Identification

5 A companion and I are admiring Breugel's *Landscape with the Fall of Icarus,* in Antwerp. Suppose we have not yet noticed the title or that, because we are purists and believe the painting should "speak for itself," we have refused to examine the title. My companion says, pointing to a dab of white paint over to the lower right, "That must be someone's legs, sticking out of the water." Remarks like that are not uncommon in front of paintings, once the eye has executed its routine saccades, for one wants to make sure one has not overlooked something. Thus one says: "What do you make of the extra arm in the *Rondanini Pietà?*" Or: "Does it strike you that the woman in Degas's *The Tub* seems to have three legs?" In art as in life it is easy enough to overlook things that do not fit the spontaneous hypotheses that guide perception. In life, where perception is geared to survival and guided by experience, we structure the visual field in such a way as to relegate to inessential background whatever does not fit our schemata, and such habits of looking are carried over into the gallery, much in the way that the habit of scanning, which is essential to reading, is brought with us into the study, where we may find ourselves reading texts, until we deliberately intervene, somewhat as we would read a newspaper article. I have met people who have seen the *Rondanini* without having noticed that extra arm, largely I suppose because there is no room in their preformed concept of a statue for detached and disembodied arms, and hence no room in their constitution of the work for what, if noticed at all, is read out as a perceptual excrescence under inductive habit. Michelangelo could have cut it out, had he wished to, as he cut out the left leg—a loss also not often noticed—from the Duomo *Pietà with Saint Nicodemus,* and the assumption is that he left it there for some reason deeper than indifference to its presence. Perhaps it plays a role analogous to the lines left on the paper by an artist seeking for a form, where the sketch remains as much a record of the search for form as the presentation of the form itself, and where often the form is lost in the effort at finding it (which is the quality of a sketch). And perhaps the *Rondanini's* arm is left there for something like that reason, a stage in the process of discovering the form finally liberated from the marble column in which it lay imprisoned (we know what Michelangelo had to say about

such things). There are, as a guard once said at the Uffizi, no unfinished Michelangelos—"Si Michelangelo è finito, è finito!"—so perhaps everything matters in some way, and certainly anything as obdurate as an arm has to be worked in somehow. But it is difficult to work it into an image of the *Mater Doloroso* and her stony son who fades into the rock he comes from, as she and he fade into one another, which is what most people no doubt see. Similarly, someone may not see the third appendage as an extra leg in the Degas, there being again no room for three-legged women in one's conceptual scheme; and one has almost to see it as an arm unless brought up short by the suggestion that perhaps Degas is reinventing the female body in a way which our familiarity with Picasso enables us to understand, and rearranging parts to suit some inner feeling about the bodies of women, toward whom it is known that Degas had complicated misogynist feelings. In any case, we seem to be on the subject of detached or reattached limbs, and here we are, noticing those limbs in the Breugel.

The third leg in Degas, the extra arm in the *Rondanini:* these are unusual and call for explanation once they are pointed out. It would be weird to point out the two legs in Botticelli's Venus, since there is nothing to pay attention to there beyond whatever interest the legs as such may have; but there being two legs is of no interest whatever. A detached arm in the painting of a battle would again call for no special explanation: it serves as an indicator that it is a battlescene; you expect limbs in battlescenes as you expect trees in landscapes or bottles in a still life. The legs in Breugel's landscape need call for no special explanation, not if, as the title of the picture indicates, it is a landscape. But with the further identification of the legs as belonging to Icarus, the whole work changes. The work will have a different structure than it would have had were you not to have noticed the legs at all, or not to have known they were Icarus' legs, and hence have believed something else central to the painting than what actually is: these legs are the focus of the whole work, not in the sense that the legs are the subject and the rest background, but in the sense that the whole structure of the painting is a function of these being Icarus' legs, the rest not being background at all; or, though there is some background, a decision has to be made as to what belongs to it and what does not. Take, for instance, the orange sun, which could just give the information that it is a sunny day if you did not know that it is causally related to the boy in the water who made the mistake of flying too close to it at the cost of melting the wax that held the feathers in place: if the *sun* were not *there*, the boy would not be *here*. But let us proceed step by step.

To begin with, it plainly has to have been part of what Breugel had in

mind that the legs should be easy to overlook, and his title, telling us
that here is the fall of Icarus, sends us on a search that comes to an end
when someone points to the legs, which are really pretty insignificant in
themselves, and says, this must be Icarus. It was after all a Mannerist
painting, and one of the features of Mannerism is just this: the subject is
important inversely to its scale. Mannerism is said to have begun with
Raphael's *Fire in the Borgo*, where the prominent figures are some
large, muscular athletes in postures of panic, seeking to climb over
walls, which themselves recede in orderly perspective into the back-
ground of the painting where the Pope stands, tiny by contrast with the
foreground athletes. He is holding his hands up, and by so doing has ex-
tinguished the fire that caused the panic in the first place. The painting
is about him and about that act, but you could not tell that by conven-
tions of ordinary scale, which might lead you to believe it was a paint-
ing of athletes with, as it happens, a pope in the background, perhaps as
spectator. It is an art-historical problem to identify the bridegroom in
Breugel's *Peasant Wedding*, just as it takes a lot of looking in a modern
Mannerist work to locate the Christ in the *Triumphal Entry of Christ
into Brussels* by Ensor, as if these paintings were literal embodiments of
the thesis that the first shall be last and the last shall be first. In any case,
once we know those are Icarus' legs, as well as information about Icarus
himself, we can begin to put the painting together in a way impossible
if we lacked that information. You cannot say, for instance, as an inter-
esting fact about the work, that the plowman is not looking at the boy,
if the boy is not someone like Icarus in point of tragedy. There are, after
all, many things the plowman is not looking at in the picture, and none
of these negative facts is especially interesting and certainly none is
compositionally relevant. It is not just that the plowman is not paying
any attention, but that Icarus has fallen, and life goes on, indifferent to
this tragedy. Think of the deep significance of this indifference, and
hence of the relationship between the compositionally dominant and
the cognitively dominant figures, in the light of Auden's remarkable
poem on the painting.

Think now of how differently the picture must be read if it is titled
simply *Plowman by the Sea*, a bucolic painting or a piece of early prole-
tarian art. Or, for the matter, if it were called *Landscape #12*, and
someone noticing the legs might see them as a mere Flemish detail, like
the shepherd's dog or figures winding along some distant path. If it
were so painted that everyone were looking at the legs and their bodies
were deployed in intense Baroque gestures, it might be a drowning boy
(and *Landscape #12* would be a cruel title). But since they are not
turned that way, they are not turned any way so far as the structure of

the picture is concerned; that is, they are no more turned away from the legs than from the ship or from the castle. They are not turned, merely placed where they are with the orientation they have, narratively and hermeneutically independent of one another. Giacometti sometimes succeeded in placing figures in a space where they could have nothing to do with one another, and this becomes an interpretive fact about the work, and perhaps a metaphor for loneliness and crowds. Or the painting could be called *Industry on Land and Sea* and the legs would belong to a pearl diver or an oysterman; there is nothing about the legs which tells you they belong to someone fallen from the sky or, for the matter, that they even belong to a boy. My children thought it was someone swimming. The picture could then be *Works and Pleasures;* the plowman would contrast with the boy; the relationship would be different; there would not be the tension there is "now." What tells us the boy is or is not swimming? Suppose Breugel had done the whole painting with no legs. Then, titled as it is, it would be mystifying, unless someone were to say: the boy has fallen in the waters and they have closed over him, calm is restored, life goes on (as in *The Israelites Crossing the Red Sea*). Or they might say: Icarus is plummeting down, has not yet entered the space of the picture. If Icarus were shown falling through space, the picture would be an illustration and would have many of the formal features it now has, but it would not make a comment: there would only be an odd object hurtling down the sky. Or it would make a different statement, and a more banal one.

The plowman must be read together with the boy. It is hard to read the plowman together with the ship, though they both connect via the boy in Auden's poem. If the picture were entitled *The Departure of the Armada*, the boy would relate to the plowman differently, and each would relate to one another via their contrasting connection with the boat. The boy would only add to the ordinariness of the summer day upon which the Armada sailed away. He would be a detail that might be regarded simply as a cluttering of the landscape. You might point to the legs as evidence for the Flemish propensity to crowd pictures with details. You might, indeed, point it out as an obtrusive and gratuitous element: nothing depends upon it, the purist would say; it should be eliminated in the interests of pure design. Or we could, finally, imagine someone looking in a puzzled way at the legs and wondering whether they were meant to be there at all; perhaps they should have been painted out, and would have been but for an oversight—like the extra arm in the *Rondanini*.

One may regard Auden's interpretation of the painting as literary, but something fairly literary was clearly intended by the artist, given

the Mannerist dislocations already remarked on; apart from this, it is an interpretation that is not visually inert, where the painting merely illustrates a moral text. To see the painting in these terms, if one had not so seen it before, works to transform the entire composition, to pull it into a different shape and hence to constitute it a different work than it would have been without benefit of interpretation. The painting suddenly becomes organized around Icarus, and classes of relationships spring up which simply could not have existed before the identification. True, there may be inert elements in the painting in the respect that it makes no difference whether the legs belong to Icarus—there may be elements in a painting like the fixed stars in the cosmos—but in any event the very concept of "inert element" presupposes the analyses I have been seeking to sketch. Enough has been said, then, to underwrite what may seem a consolation prize to the inartistic, that responding to a painting complements the making of one, and spectator stands to artist as reader to writer in a kind of spontaneous collaboration. In terms of the logic of artistic identification, simply to identify one element imposes a whole set of other identifications which stand or fall with it. *The whole thing moves at once.*

It is instructive to speculate on how we would see the painting not only if we did not know the story of Icarus, but if we knew it but did not know the pertinence of the story to the work, say because the title was lost or no title was ever given. In a way, to identify the painting's parts as I have done is to imply what its title might be. Veronese's painting of Hercules with Omphale, which shows him transvestite, could be taken by someone unfamiliar with the story as a painting of a bearded lady, but then it could not be Hercules and Omphale. A title in any case is more than a name or a label; it is a *direction* for interpretation. Giving works neutral titles or calling them "Untitled" does not precisely destroy, only distorts the sort of connection here. And, as we saw, "Untitled" at least implies it is an artwork, which it leaves us to find our way about in. As a final implication of the practice, since the title itself is given by a painter, it presumably implies what he intends by way of structuring of the work. And this is ipso facto to admit the possibility of different structurings. If it is an artwork, there is no neutral way of seeing it; or, to see it neutrally is not to see it as an artwork.

To interpret a work is to offer a theory as to what the work is about, what its subject is. This must, however, be justified through identifications of the sort we have been canvassing. To interpret Breugel's painting as simply about Icarus involves at best identifying the

legs and the relationship between their owner and the sun, implying a narrative structure, a story the painting not so much tells as presupposes in order to integrate the elements. This interpretation then leaves much idle incidental depiction that interacts in no particular way with the central elements of the work. To interpret it with Auden as about suffering—about "the meaning of suffering," rather, since it is not a depiction of suffering as a painting of the martyrdom of St. Laurence would be—brings into the structure many more elements that must be redescribed as indifferent to what transpires. Breugel's painting of the conversion of Paul is not just of that particular crucial moment, though to be sure, as much as Caravaggio, he shows a man fallen off his horse. It is also about how such momentous events are seen and is a pictorial essay in, so to speak, moral optics: what we see almost immediately is the prominent feature of the work, the rear end of a horse. Then we may notice people in the painting noticing something, which carries us, almost as if we were there, to the cause of their excitement. The indifference of some and the excitement of others are registered as part of the structure of the work. *Not* to interpret the work is not to be able to speak of the structure of the work, which is what I meant by saying that to see it neutrally, say as what I have spoken of as the material counterpart of an artwork, is not to see it as art. And the structure of the work, the system of artistic identifications, undergoes transformation, in accordance with differences in interpretation. We saw this work with reference to relationship within *The Fall of Icarus*, but it can go far deeper than that. Let me elucidate this with a contrived example.

Consider two paintings we may imagine commissioned by a library of science to be executed on facing walls, these to be in an appropriate contemporary manner, as suited after all to science, but to be about some famous laws in science, perhaps to celebrate the fact that science has a history of discovery. The laws chosen by the artistic commissioner are the first and third laws of motion from Isaac Newton's *Principia*. Two artists, one of whom is J and the other his arch rival K, are commissioned and because of their mutual contempt, great efforts are taken on the part of either not to reveal the work in execution to the other; it is all carried out with the greatest secrecy. When all veils fall on the day of revelation, the works of J and K look like this:

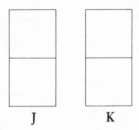

J K

Inevitably there are charges and countercharges of theft and plagiarism, controversies over who had the idea first, and so on. But in truth these are distinct, enormously different works, however visually indiscernible: as much different, once interpreted, as *The Israelites Crossing the Red Sea* is from *Kierkegaard's Mood*.

J's painting is of Newton's third law, on which he did some research. The law, as J understands it, says that every action has an equal and opposite reaction, a physical gloss on F is equal to ma. There are, J tells us, two masses shown in the painting. The upper mass is pressing down with a force proportional to its acceleration and the lower mass is pressing up in just the same way in reaction to its counterpart's force. They have to be equal—hence of the same size—and opposite—hence one up and the other down (though J concedes that one could be left and the other right, which he avoided in order not to confuse things with the principle of conservation of parity, which he read had been overthrown). And after all one needs masses to show force, for how can there be a force of this sort without a mass? Newton's first law, turning now to K's work, holds that a body at rest will remain so forever, since a body in motion will move uniformly in a straight line, unless acted upon by impinging forces. That, K says, pointing to what, had it been J's painting, would have been where the two masses meet, "is the path of an isolated particle." Once in motion, always in motion: hence the line goes from edge to edge and could be protracted indefinitely. Were it to have begun in the middle of the painting, it would still be about the first law, since it implies dislocation from the state of rest; but then, K explains, he would have needed to show the force impinging, and the whole thing would have become complicated where *he* was seeking radical simplicities, "like Newton," he adds, modestly. Of course the line is straight, but its being equidistant from top and bottom has an ingenious explanation: if it were closer to one than to the other, that would require an explanation; but since no force is pulling it in either direction, it bisects the painting, inclining neither way. Thus the painting shows the absence of forces. How extraordinary, were one to hear

these explanations, to discover the indiscernibility of the works. And at the level of visual discrimination, they cannot relevantly be told apart. They are constituted as different works through identifications that themselves are justified by an interpretation of their subjects. In J's work there are masses, in K's work none. In K there is movement, in J there is none. If J's work is dynamic, K's is static. Aesthetically, it is widely agreed that K's is a success while J's is a failure. Too weak by far for the subject, writes the critic for the avant-garde journal *Artworks and Real Things*, who, while praising K, wonders if J was the right person for the task, even whether J is not beginning to "lose his touch."

Let us ponder just what, in an effort at descriptive neutrality, we shall designate as the "middle horizontal element." Shall we identify it as an edge? If we do so, we are logically constrained to regard it as belonging to a shape, since there are no unowned edges. Edges are the boundaries of forms. Does the edge belong then to the bottom rectangle or to the top one? As it happens, in J's painting it has a richer description than "edge": it is a *join*, which entails two edges and hence two forms. But there could be just one in a visually similar painting: imagine the bottom form thrust up in empty space. The point only is that if the element in question is an edge, the whole surface must be made up of two forms, or at least one form and one nonform. But then the element need not be an edge, much less a join; it could be, as in K's work, a line. To be sure, K describes it as a path, and a path divides, as it were, some preexisting space without defining, as an edge, a boundary of the space. But then it certainly requires another sort of decision, namely what is the relationship of the path to the space it sections, for a line or even a path can be on or through or above or under. K's commentary enables us to know that the path is through absolute space, but whichever way we identify it, some complex further matters must be resolved. Imagine that we are looking at a projected plane *at right angles* to the plane depicted by K, seeing a line head on, so that it may be represented by a dot. Then there are these four possibilities to chose from:

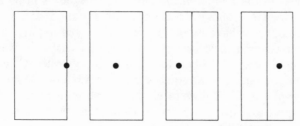

In (1), a painting indiscernible from K's depicts a plane with, as it happens, a line on it; it could be an aerial photograph of a road through a desert. K is actually represented by (2): a path through space, there being no plane depicted at all. In (3) the plane must be transparent enough to see the path through it; it could be the surface of the sea, and the path that of a swimmer. In (4) the plane could be transparent or opaque, but the path is at least above it, like that of a plane over the surface of the sea. Of course there is another possibility: where the surface of the painting is the plane in question (but then it is not depicted) and the dot the endview of a line inscribed on it, by a horizontalist follower of Barnett Newman.

Save with respect first to an "interpretation" and hence some artistic identification of the relevant element, no sensible or possible answer can be given to the question of how many elements the work contains. Are there two only, a line and a plane? Or maybe only one, in which case we have a portrait of a line with no more relationship to the surrounding pictorial space than the green paint around a portrait has to the head: it is simply painterly space, no more interpretatively relevant to the head than the paper is when one draws a head on a sheet of it. Or perhaps there are two elements, namely two rectangles, as in J's work. The middle element is not really an element at all, only part of one, and it is not clear that parts of an element are elements in their own right. But then there are always questions as to whether something is part of an element, hence belonging to the work or not. Are the edges of the surface on which the work is painted in any way part of the work? There are certainly paintings, as we saw, in which edges matter. In Poussin, for instance, respect for the edges is a compositional datum, in the respect that composition is defined with regard to the integrity of those edges. But the edges cannot be part of the work, since the interpretation of most of those works excludes them; they function, so to speak, like the boundaries of the visual field which, Wittgenstein marvelously observes, are not themselves seen (they are not because then they would have to be included in the visual field), much in the way that death is not part of life, since it is not something we live through (which is a definition of "an event in one's life.").

There are, by contrast, paintings where the edges do not much matter, where composition is a great deal less a dominating concern, so that the painting itself could go on and on, past the edges; the painting simply happens to stop there, in contrast with the painting being resolved by means of them, just as there are accounts that simply stop without in any structural sense coming to an end. I think of Bonnard, or the Impressionists by and large, as producing works of this somewhat *décousu*

order. In J's work, the edges could be part of the work, in that the boundaries of the canvas are the boundaries of the masses that the canvas shows. They are edges brought into the work in the manner of a painting by Picasso in which a frame is painted outside a scene, so that the edges of the canvas and the edges of the frame are one. But when this happens, the work itself undergoes a transformation of genre: it becomes, as it were, a three-dimensional work, a sculpture in very flat relief. In this respect, we bring the object into *our own* space, to the extent that the space we live in includes the edges of Poussin's paintings but not the spaces included in those paintings; we are not and cannot ever be cooccupants of the space in which the rape of the Sabine women transpires as an event. Moreover, if the edges are part of our space, so is the surface, which belongs to the masses in a way in which the surface of the Poussin is never coincident with the surfaces of anything he ever shows. It is, as it were, untouched by the surfaces of the men and women or the buildings which are logically submerged and cannot come up for air. The surface belongs to us, not to them. Thus there is no geometry that contains us both, nor for the matter is there a time scale. But this is generally true of art. There is no answer to the question of how far away are Anna and Vronsky; the bedroom in which they consummate their passion is certainly not included in the bedroom in which you read about it, though the book may indeed be there. And what about the corners? J's work can have real corners, coincident with the corners of the masses (four "real" vertices, he tells us, and four illusory ones, the painting occupying two worlds at once). But K's painting can have no corners at all, or edges, given the constraints on the concept of absolute space, which has neither surface nor boundaries. K's work, if you will, is more "classic," and in the manner after all of Poussin.

A chapter back I cited the slogan in the philosophy of science, which holds that there is no observation without interpretation and that the observation terms of science are, in consequence, theory-laden to such a degree that to seek after a neutral description in favor of some account of science as ideally unprejudiced is exactly to forswear the possibility of doing science at all. My analysis of the works of J and K—not to mention the Elder Breugel—suggests that something of the same order is true in art. To seek a neutral description is to see the work *as a thing* and hence not as an artwork: it is analytical to the concept of an artwork that there has to be an interpretation. To see an artwork without knowing it is an artwork is comparable in a way to what one's experience of print is, before one learns to read; and to see it as an artwork then is like going from the realm of mere things to a realm of meaning. But to go from J's work to K's is like exchanging one world or another

inasmuch as these have, so to speak, disjoint sets of identifications, with almost no overlap. It is, in a way, like living through one of the great transformations in the history of the sciences, say from the Ptolemaic to the Copernican system. Nothing in the world will have undergone change, but *you*, through a vertiginous transformation of theoretical parallax, are thrust out into the heavens from having hugged the center; the earth itself is between planets (which would never have made sense before); and the sun does not move relative to us on the other planets—and all this is true even if (speaking anachronistically) a camera pointed at the sky would show the same configurations whether the revolution had occurred or not. In art, every new interpretation is a Copernican revolution, in the sense that each interpretation constitutes a new work, even if the object differently interpreted remains, as the skies, invariant under transformation. An object *o* is then an artwork only under an interpretation *I*, where *I* is a sort of function that transfigures *o into a work: I(o) = W*. Then even if *o* is a perceptual constant, variations in *I* constitute different works. Now *o* may be looked at, but the work has to be achieved, even if the achievement is immediate and without any conscious effort on the observer's part. Charles Lamb, in writing of the engravings of Hogarth, says that they, in contrast with pictures we merely look at, must be read. So they have the power of texts. But so has any pictorial or for the matter artistic work which we may in fact think we are looking at rather than reading. In such cases, we read as we look because we interpret as we see.

It should not be automatic to assimilate the distinction between interpretation and object to the traditional distinction between content and form, but in a rough way the form of the work may be that gerrymandered portion of the object the interpretation picks out. Without the interpretation, that portion lapses invisibly back into the object, or simply disappears, for it is given existence by the interpretation. But that gerrymandered portion is pretty much what I mean by the work, whose *esse* is *interpretari*. That it should disappear without the interpretation is on the other hand somewhat less startling than Bishop Berkeley's thought that objects disappear when unperceived, since their *esse* is *percipi*. One may be a realist about objects and an idealist about artworks; this is the germ of truth in saying without the artworld there is no art.

Seeing an object, and seeing an object that interpretation transforms into a work, are clearly distinct things, even when in fact the interpretation gives the object back to itself, as it were, by saying the work *is* the object. But what kind of identification is this? By the constitutive character of interpretation, the object was not a work until it was made

one. As a transformative procedure, interpretation is something like baptism, not in the sense of giving a name but a new identity, participation in the community of the elect. The religious analogy will deepen as the analysis advances, but for the moment it is the logic of artistic identification that will concern me.

The logical fulcrum on which a mere thing is elevated into the Realm of Art is what I have casually introduced as the act of artistic identification; its linguistic representation is a certain identificatory use of "is," which I shall merely designate the "is" of artistic identification: as when one says a dab of paint that it is Icarus, or of a smudge of blue paint that it is the sky, or—pointing to a certain knock-kneed actor— that he is Hamlet, or singling out a passage of music and saying it is the rustling of the leaves. It is a usage mastered in the nursery when the child pointing to a picture of a cat says that it is a cat, and perhaps in the animal laboratory where the chimpanzee signs "ball" when presented with a picture of one. It implies, in self-conscious cases, a participation in the artworld, a readiness to acquiesce in a literal falsehood.

This is an *is* which is of transfigurative kin to *magical* identification, as when one says a wooden doll is one's enemy, sending, by means of pins, vexations to his body; to *mythic* identification, as when one says the sun is Phoebus' chariot (not as a manner of speaking but as a matter of unobvious fact); to *religious* identification, as when one says that wafer and wine are flesh and blood; and to *metaphorical* identification, as when one says that Juliet is the sun (though not that she is Phoebus' chariot, since it would be a false inference that Juliet has wheels even metaphorically). Each of these identifications is, of course, consistent with its literal falsehood, but there is a pragmatic difference between some of them—I except metaphorical identification—and artistic identification, consisting in the fact that the identifier had better not believe in the literal falsehood in the nonartistic cases. The moment one believes it false that wafer and wine are flesh and blood, communion becomes a ritual enactment rather than a mystical participation. The moment one gives up one belief in magic, pinsticking in an effigy becomes a substitute for doing true harm rather than a devious way of truly doing that harm. And once one's beliefs about the world exclude one from the circle of myth, identifying the sun as Phoebus' chariot degenerates into a mere metaphor. But nothing like this is the case with artistic identifications, where if a and b are artistically identified, this is all along believed consistent with the failure of literal identity. Literal identity need not fail. Something may be, as we shall see, artistically

identified with that which it is in fact identical already. But there is nevertheless a logical difference to be marked, as we shall also see, in the two statements of identity.

But the standard case, where there is acquiesence in a kind of make-believe, a is not one with what it is artistically identified as, namely b. For Icarus did not literally have legs made of white paint. It may, of course, be objected that artistic identification thus works best for those arts in which mimesis is a natural theory: for painting and sculpture, for acting and dancing and opera; for music in certain of its instances—for all those cases in which a contrast is available with what Plato speaks of as *diegysis*. And hence the structures of interpretation I am elaborating only arise within these genres. It is too early to meet this objection, but a proper way to do so, I should think, is to show that discursive language, say in novel writing, is artistically identified as description, which is what enables fiction to be convincing: we acquiesce in the fiction that we are being given facts. So that the difference between factual and fictive description is not that the former is true and the latter false—for something may after all be meant as factual and be false without thereby being elevated to the status of fiction, and fictional prose may in literal fact be true—but in the fact that the former is artistically identified as description and the latter literally identified as that.

This takes us somewhat ahead of our story. For the moment I am more interested in working out some of the constraints on identification and hence on interpretation, after which, in this and the chapters to follow, we can elaborate on the intuition that the identical language falls under different constraints depending upon whether it is art or not. We have still the question to address of what makes a representation into an artwork, a problem that in fact the logic of artistic identification will not itself solve. The astute reader may have a deep objection at this point, that something uncomfortably like what I have called artistic identification is involved with representations whose status as art is pretty moot. The picture of a cat in the child's alphabet book, while not literally a cat though said to be one, may not be a work of art either. But let me complete this stage of the analysis, allowing that what I have to say only carries us to the point at which our real problems begin.

In one respect, the limits of interpretation are the limits of knowledge, much in the way that the limits of imagination are the limits of knowledge. Consider the way in which a child can play with a stick: it can be a horse, a spear, a gun, a doll, a wall, a boat, a plane; it is

a universal toy. But two cognitive conditions must be satisfied in order for the child to execute his acts of imaginative reconstitution. The first, of course, is that he knows that the stick is not a horse, not a spear, not a doll. This is Aristotle's point once more, that in order for the child to take the sort of pleasure play is supposed to produce, he must know that the stick is not what he plays with it as. Here there is only one limit, it seems to me, on pretense or imagination: he cannot pretend the stick is a stick. The other sort of limit is of more immediate moment. For a child to be imagining or pretending that a stick is a horse, he has to know something about horses, and the limits of his knowledge are the limits of play. This is a variant of Aristotle's other point about the cognitive constraints on imitation, namely that to take pleasure in an imitation one has to know the original. Of course it is possible, if a person has false beliefs about the original, to imagine all sorts of things: if the child moves the stick and says choo-choo, and also claims the stick is a horse, I would have to conclude that he believes trains are horses. Such a child is not "more imaginative" than one who gallops along with the stick between his legs, simply less well-informed. Locke supposed that imagination consists in assembling given materials in novel ways, and he denied that the given materials themselves can be imagined. He claimed you cannot imagine what a color never experienced is like, and it hardly counts as an objection that someone might imagine that heliotrope is like deep indigo, though there is the sense of "imagines" which simply means "falsely believes"—as when we say someone imagines there are thieves in the kitchen, a description that requires rejection when in fact there are thieves in the kitchen. Our interest is whether there are limits on the ways in which the elements can be put together "in the imagination," and it may go somewhat counter to Locke's theory to say that *here* too one's ability to imagine is limited by what one knows or at least believes. I mean that if I ask a child to pretend to be Queen Anne, I don't expect her to know much about the differences between Queen Anne and Queen Charlotte, and hence could not see myself saying that she is pretending to be Charlotte when I asked for Anne: I ask her only to do some queenly things, which *may* include some haughty sniffing but must exclude crawling on all fours, even if she says that she is a queen looking for a needle, for nothing marks her pretense as different from that of any needle seeker. But if I ask a child to pretend she is an aardvark, it would be enough for me to have her crawl round on all fours, making growling noises, since I don't expect her to know much about aardvarks beyond their being animals of some sort; but if she flaps her arms like wings I would have to say she is not following my request. And she has to know something or just be lucky

when she spins around saying "zoom" after I have asked her to pretend to be a positron.

But then where is there room for imaginativeness, for the novel compounding of given elements? It obviously comes up this way: the child rejects my dismissal of her aardvark performance when she says she is pretending to be a flying aardvark. Then I allow this as imaginative if I allow that she knows that aardvarks do not fly. And this then gets to be almost of a piece with Aristotle's first point. One can pretend that something is an x only if one knows it not to be; and one can pretend that x is F only if one knows that x's are not F's. Still, there have to be some constraints. You can be considered imaginative when you tell the story of a talking dog or draw a picture of a plaid horse, when you know indeed that dogs are mute and that horses neglect to appear in that pattern. But you have to know enough about horses and dogs for it to be a dog that talks and a horse got up like the Macdougals. There is an obvious unexpungable porosity here: you can give your plaid horse tentacles if you know they don't have them, but the question remains as to how extreme the metamorphoses are before we disallow that it is a horse any longer: if there are eight tentacles, for instance, it may be a plaid octopus you are thinking about rather than a tentacled plaid horse. And if it has eight tentacles with a horse's head, the decision as to whether it is a horse with an octopus body, or an octopus with an equine head, is subject to the same analysis as to why we speak of a mermaid as a female human with a fish tail rather than a fish with, as it happens, a human female torso (Locke, as it happens, regarded mermaids as a sort of fish). Usually, a piece of imagination, in which it is a precondition that the person considered imaginative have his cognitive feet on the ground, is applauded only when the attribution of a property alien to the subject *illuminates* the subject in some way; otherwise it is mere conceptual extravagence or Gothic excrescence. But we wander from the central point all of this is meant to establish, namely that we cannot apply the predicates of imaginativeness to works or their authors unless we know what they believed—unless we know what the world looked like to them. When Caillebotte painted the *Place d'Europe* in an optically impossible way, was he being imaginative or deceived? When Piranesi depicts the tower on the road to Benevento as immensely higher than the stunted reality, was he being imaginative or inept?

In any case, it seems to me that the same such considerations have general application to the structures of interpretation, which in part at least must be governed by what the artist believed. This is one reason why an object that looks just like the works of J and K could not be interpreted as their works are once it is learned that it was produced be-

fore publication of Newton's *Principia*. This is certainly germane to what is called the intentional fallacy, inasmuch as the work-as-interpreted must be such that the artist believed to have made it *could* have intended the interpretation of it, in terms of the concepts available to him and the times in which he worked. Not only must you know something about Newton's first law in order to interpret K's painting as you do; you must also believe that K knew something about Newton's first law; otherwise interpretation is simply like seeing faces in clouds. The limits of *your* cloud musings are the limits of *your* knowledge, but we have the artist's limits as special constrains when interpreting works of art. Moreover, the limits of our interpretation even when it was intended as Newton's first law are defined by how much K knew about the first law. Say we seek a grounded explanation for the fact that the line goes from edge to edge, but this cannot be part of our interpretation if J really knew no more about the law than that it said something about linear velocity. His ignorance sets some limit to the range and variety of identifications we are justified in making. But I have so far said too little about the structures of artworks to have anything more profitable to say on the vexed issue of artistic intention than that it is difficult to know what could govern the concept of a correct or incorrect interpretation if not reference to what could and could not have been intended. It will be enough for our immediate purposes that knowledge of the first law will enable identification and interpretation to proceed, since a line can be a path, can be an edge, can be the horizon: it is the artistic counterpart to the stick.

So call the line the horizon, and let a painting be produced like our scientific pair, this one a landscape. The top half is white sky, the bottom half is the calm sea reflecting the white sky, sea and sky so of a piece, though one is reality to the other's reflection, that but for the almost unreal demarcation of the horizon, they can be called one, and the painting, instead of *Sea and Sky*, is an allegorical landscape entitled *Yearning for Unity*. But by now anyone will be able to fill a gallery of indiscernible works, belonging to as many genres as one has patience and imagination enough to imagine exemplifications of. What I cannot imagine is one of these being called *Fate*, for I can see no identification that might sustain that interpretation; a reading would be wanted, as with *Old Man Planting Spring Cactuses*. Or I can imagine a painting like ours which will be called one of these things, only I cannot imagine what it would be like to see it transfigured that way. It would be like asking a child to pretend that the stick is a blue smudge or a blocked sneeze. I don't see what the child could *do* with the stick, except perhaps point to it the while saying "There is a blue smudge" or "Here is a

blocked sneeze," which would be more an instance of pretending to pretend than of pretending *tout court*. You can call a painting anything you choose, but you cannot interpret it any way you choose, not if the argument holds that the limits of knowledge are the limits of interpretation. Knowing as much (or as little) as we know about fate or the planting of spring cactuses by old men, we can see there is no way to interpret them as such. To be sure, there are paintings where the interpretation escapes us, like *La Tempesta*, but I wish to defer consideration of these in order to meet an objection from the avant-garde.

It may be argued that consideration of interpretation will have carried us no great distance in establishing a definition of artworks. It is possible to see an ordinary line drawing as simply a pattern; and then, once having seen it as a drawing, say of a cube, to see it with distinct and non-coobtainable spatial axes, like Necker cubes, where what we see first as a front face is then seen as a rear face. Or one may see the lines resolve first into a duck and then into a rabbit. Are these paltry things artworks? They require interpretation, as does any map or diagram. This objection must be met, since it questions interpretationality as a sufficient condition for art. But I have first to meet an objection that questions even its necessity. Why interpret? Why not leave the work alone? To be sure, there may be, J assures us, works that require interpretation, and my sly insertion of this fact into a provisional definitional formula a few pages back was perhaps precipitous. Of all people I should be wary of erecting a parochial consideration into a universal condition. And he draws my attention to works that, much like his own insolent bed, are so much what they are that interpretation seems inane, such as "interpreting" a stick as a stick or, for the matter, pretending that a stick is what it is. These works, J continues, are what they are, can only be identified with themselves, and yet they are artworks.

Think of the plain man, J says. Overhearing us in front of his painting—or for the matter K's—the plain man might think we were insane. To be sure, it is his own fault, J admits, to have created something so involved with interpretation as his recent work is, a compromise with everything he believes in—which, he adds, is also what the plain man believes, that things are what they are and not some other thing. That, the plain man says, is just a black line on a white piece of canvas, that and nothing more. Now I am unpersuaded that sophisticates have much authority when it comes to identifying what the plain man would say about anything, but let us grant the conceit, and proceed as though the

plain man were defined by a kind of artistic aphasia and sees only what a chapter back we ourselves supposed the barbarian sees: only the material counterpart that underdetermines a set of artworks, things as they would be before we learned to make interpretations and identifications. Now let us address some works of which J approves.

Consider, first, a work exhibited some years back by an artist named Kuriloff. It was called *Laundry Bag* and consisted in a laundry bag indeed, mounted on a board with a label underneath reading "Laundry Bag," in case anyone should seek for an interpretation. To be sure, the allegorical mind is always primed to see this humble repository of soiled linen as something more than it is; the label is, I gather, meant to nail down all such flights. The work is what it says it is, what the plain man, pointing to it, would say it was: a laundry bag and nothing more. The other artist might be any of the physicalists of paint impaled by Lichtenstein's wry *Brushstroke* discussed above: "olefactory artists," as Duchamp disparaged them, meaning those who were in love with the smell of paint. For the artists in the 1950s, their world was made of paint in something like the way in which Fromentin says of Van Eyck that his world was made of gold. Paint, since the beginning of art, was always transformed into something—martyred saints, arranged apples, mountains, maidens—as though it were a magical substance that was anything the skilled painter wanted it to be. And spectators always disregarded it, looking past and through it to whatever the artist may have made of it. The olefactory artist wants to render it opaque, giving it forms too recalcitrantly eccentric to be identified and interpreted. With these works, to miss the paint, to seek to see through it, is to miss the work entirely, which is, as the plain man himself would say, the paint itself. That, the plain man is supposed to say, is black and white paint, and nothing more. And this is just what the olefactory artist himself wants to say: black and white paint, and nothing more. This Taoist celebration of the no-theory theory of the plain man marks, then, two powerful impulses in the recent avant-garde. And though the artworld has swept on to other things in recent years, the philosophical challenge of separating the plain man from his artistic celebrants remains to be effected, and merits some scrutiny from those of us who wish to say that nothing is an artwork without an interpretation.

The first thing to notice is that Kuriloff's work is not quite so radical as it appears to be at first. To say, for example, that it is only a laundry bag and nothing else is to have forgotten or to have looked past certain obvious things. One of these is that the laundry bag is only part of the work he has exhibited. There is, in addition, the board upon which the laundry bag is mounted and the rather conspicuous label, mounted on

the same board, reading "Laundry Bag." Laundry bags, in our society, are not mounted on boards; they are hung in closets or on the backs of doors. Second, laundry bags are among the homely familiar objects of ordinary life and do not require labels. The work looks as if it were part of an exhibit for people from outer space: there might be a sign reading "Toothpick" under a mounted toothpick, "False Teeth" under mounted dentures, and the like. To label an object so banal and familiar is to dislocate it, to distort the environment. Kuriloff then, by virtue of a sweet irony, is part of the very tradition he doubtless set out to repudiate. But the analysis is somewhat *ad hominem*, inasmuch as a more radical possibility remains, a logical opening seized upon by J himself when he constituted his bed as *Bed* and transfigured it into art. No boards, no labels, he did not in the Rauschenberg manner hang it on the wall. The best we were able to say was that at least the question of what it was about could legitimately arise, knowing that J would say that it was about nothing, had no interpretation. We may deal with such an object, I believe, in much the manner in which we shall deal with the olefactory artist, clearing the field at last of these theoretic siblings.

When the olefactory artist says of his work that it is black and white paint, and nothing more, that the painting is the painting, that it is not about anything, it may seem to the superficial observer that he is saying what the plain man is saying. But if we have learned to establish differences between optically indiscernible objects, differences so deep that pairs of these may lie on opposing sides of an ontological boundary, we ought not to hesitate to apply the same strategies to *sentences* which as such seem indiscernible but which may be used to make quite different statements, and to have accordingly very different forces. "That is black and white paint" can itself be an interpretation, and is so in the mouth of the reductionist of art, though not in the mouth of the plain man. What I am now interested in emphasizing is that a person will be using the same sentence to make different statements depending upon a variety of contextual factors. The sentence "That is black and white paint" can be used to reject artistic statements, or it can *be itself* an artistic statement.

What I wish to suggest is that the olefactory artist has returned to the physicality of paint through an atmosphere compounded of artistic theories and the history of art (which he knows), and that he is in an artistic way rejecting a whole class of statements, a whole class of attitudes, which are attitudes taken toward art objects. I like to think of the return to *paint as art* as a rather Buddhist thing. For a long time, people appreciated art as revealing a certain reality. Instead of seeing paint they saw a girl in the window, the rape of the Sabine women, the

Agony in the garden, the ascension of the Virgin. And so it would be like seeing the objects of this world as essentially unreal and merely as things to be put behind one as one moved to higher things, to a world beyond, which would be a certain kind of religious attitude toward the world. The Samsara world, as it is called, contrasts with Nirvana, and we are taught to see the world itself as something to be sublated. But in the higher teaching of radical Buddhism—the teaching of the Diamond Sutra—the distinction between Nirvana and Samsara collapses: the world is not to be sublated in favor of a higher world, but is to be charged itself with the qualities of the higher world. We find this magnificently expressed in the passage from Ch'ing Yuan:

Before I had studied Zen for thirty years, I saw mountains as mountains and waters as waters. When I arrived at a more intimate knowledge, I came to the point where I saw that mountains are not mountains, and waters are not waters. But now that I have got the very substance, I am at rest. For it is just that I see mountains once again as mountains, and waters once again as waters.

He sees mountains as mountains, but it does not follow that he sees them as mountains just as he saw them before. For he has returned to them as mountains by the route of a complex set of spiritual exercises and a remarkable metaphysics and epistemology. When Ch'ing Yuan says a mountain is a mountain, he is making a religious statement: the contrast between a mountain and a religious object has disappeared through making the mountain into a religious object. Consider, again, the celebrated defense of commonsense by G. E. Moore. Certain philosophers, he maintained, had denied the existence of material objects. If, by material objects, they had in mind such things as these—and here Moore held up his two hands—then they were wrong, for here certainly were two material objects. And surely this was a proof, indeed the only sort of proof, that there are at least some material objects. And surely, Moore went on, these philosophers would not be denying that these two *hands* exist. How on earth could they? And, in case they should mean by "material object" something different from the sort of thing these hands of his happened to be, well, Moore continued, he no longer could be sure what they were denying. Now Moore's statement "This hand exists" is hardly a "commonsense" statement. Who but a philosopher would deny it, and who but a philosopher would affirm it? A man might have a nightmare in which his hands were cut off and wake to find that it was only a nightmare, and he might say "My two hands exist!" But he would not be making a philosophical statement; his would be strictly a cry of relief. The relief we get from Moore's account

is a metaphysical relief: in some not very clear way, we come to feel that the world does not depend upon our thoughts, much less consist of our thoughts. The plain man, so called, never entertained any such idea, and if it were proposed to him, he might say "Nonsense!" and walk off. But his would not be a contribution to philosophy or a refutation of idealism. Philosophical usage is virtually at right angles to ordinary usage, which is why, since so many of the words are the same, philosophical claims strike the common mind as either banal or absurd.

It is in this regard that I want to say that the claim of the physicalist of pigment, the man who has found in paint per se the point of art, is not saying what the philistine is saying when he says "This is black and white paint, and nothing more." He is not even uttering a tautology when he says that this black paint is black paint. Rather, he is making an artistic identification by means of this "is"—he is remaining within the idiom of art. He is saying, in effect, that a whole other class of identifications is wrong, relative to a *theory* of what art is. To see something as art at all demands nothing less than this, an atmosphere of artistic theory, a knowledge of the history of art. Art is the kind of thing that depends for its existence upon theories; without theories of art, black paint *is* just black paint and nothing more. Perhaps one *can* speak of what the world is like independently of any theories we may have regarding the world, though I am not sure that it is even meaningful to raise such a question, since our divisions and articulations of things into orbits and constellations presupposes a theory of some sort. But it is plain that there could not be an artworld without theory, for the artworld is logically dependant upon theory. So it is essential to our study that we understand the nature of an art theory, which is so powerful a thing as to detach objects from the real world and make them part of a different world, an *art* world, a world of *interpreted things*. What these considerations show is that there is an internal connection between the status of an artwork and the language with which artworks are identified as such, inasmuch as nothing is an artwork without an interpretation that constitutes it as such. But then the question of when is a thing an artwork becomes one with the question of when is an interpretation of a thing an *artistic* interpretation. For it is a characterizing feature of the entire class of objects of which artworks compose a subpopulation that they are what they are because interpreted as they are. But since not all members of this class are artworks, not all these interpretations are artistic interpretations.

Works of Art and Mere Representations

6 Although it may be thought that the methods so far used in this book have a special and perhaps a unique application to what was once called the "visual arts," it is not difficult to show that all the same problems may be forced to arise throughout the domain of art. Material objects may be selected which not only underdetermine a class of distinct artworks within a given genre, but, thanks to the options exploited by our avant-garde, it is even possible to conceive of artworks belonging to distinct genres—as distinct as painting or music or fiction—sharing a common material counterpart. Imagine an entity that, without benefit of interpretation or artistic identification, one would suppose to be a simple exemplar of the Manhattan Telephone Directory for 1980. It is like in every particular those heavy volumes sent to subscribers throughout the borough. Nevertheless it is an artwork, and my purpose in elevating it thus is to emphasize that it is not clear to what genre it might belong, and that different criteria for appreciating it will come into play depending upon how we resolve the question of genre: it could be a piece of paper sculpture, a folio of prints, a novel, a poem, or perhaps, in the spirit of novel notation, the score for a musical composition—by Luciano Berio?—in which the names are to be chanted. If it is a novel, we may deplore the exiguities of plot, but hardly if it is sculpture, since sculptures have no plots. We can applaud the poet's achievement in having used not a single verb throughout his opus (it would be like praising a painter for using only reds), but such credit as the poet may derive from this is unavailable to the printmaker. Yet the printmaker may be praised for having eschewed fancy paper in favor of pulp stock, and for having foregone the richness of etched lines in favor of the studied banality of coldtype—a crossgeneric appraisal, as it also might apply to concrete poetry. And so on, from genre to genre.

It is tempting to say that the fact that there should be such a novel (or sculpture or whatever) may have a certain modest philosophical interest without its following that it is an interesting novel (or sculpture or whatever): that its sole interest lies in the fact that it could have been done. And it is true that the purpose of such works is often intimately connected with what interest the very idea of them may philosophically possess. But let us just consider the novel, whose title is *Metropolis*

Eighty. As a novel, we have observed, it has little by way of plot, far too many characters in search of whatever plot it does have, and scant suspense of the sort appropriate to the conventional novel. Yet it certainly can be read. Bishop James Pike, according to Joan Didion, is reported by his third wife Diane to have "read both the dictionary and the phone book from cover to cover by the time he was five (and a whole set of the Encyclopaedia Britannica before he was ten)." This was offered in illustration of the Bishop's early thirst for knowledge, but still he read the phonebook from cover to cover, even if it is difficult to imagine his saying he "could not put it down." The sole motive I could suppose the novel's reader having—if there were a reader—for cheating by looking at the last page "to see how it all comes out" would be to determine whether the novelist adhered to what his intention may be conjectured to have been by ending his epic with a ladder of Zs. So we would be surprised, in just the way we are if the gardener rather than the butler did it, or if the feminist heroine opts after all for marriage rather than self-fulfillment through pottery, should the last page give us some Ms. Or some Ms and some Rs, just in case we think we have simply come to the end of volume one (A–M). And we would want an explanation of why the Rs, the form of which, as an explanation, would be determined by the generic identification of the object as a novel, that is, with some reference to narrative ordering. For just to class it as a novel is to make this form of explanation appropriate, however little success we may have in getting the explanations we seek. We at least know what they would look like. Let it end, however, conventionally enough with the anticipated Zs. This gives it a kind of classic form. As the *auteur* points out, it has a beginning in the As and a middle in the Ms and an ending in the Zs. And it has suspense of an alphabetical sort, for by time we get to the Ms we have built up a sense of fatality so great as to bear comparison with Hardy, and we marvel at the author's relentless narrative will in driving with an iron necessity on to the Ns and thence through the Os to the Ps. It is true, he concedes, that the book lacks romantic interest and eschews description—but these are bourgeois excrescences he is anyway delighted to sacrifice in the interests of producing a piece of pure art: an Absolute Novel of Abstract Narrativity. Alas, a colleague from political science tells him, he remains infected with a certain *esprit conservateur* in retaining so classical a format, and he is still slave to narrative time and—who knows?—a kind of bourgeois linearity of historical conception. Who knows but whether the structure of Past, Present, and Future, whose literary correlate is Beginning, Middle, and End, does not have deep economic determinates? Stung by this, our author responds by rewriting the work in such a way that the pages are

de-alphabetized, destroying, he says, the last remnants of a rotten artistic culture. "Read it any way you want," he says. "The beginning is where *you* begin, the ending is wherever *you* stop." He has invented participatory fiction, and at the moment is de-alphabetizing Dun and Bradstreet.

All of this can happen, perhaps it all does happen, but it is of less interest to protract these little conversations with our current authors and to draw attention to the fact that their experiments are defined by the rules of the genre they are working in. "Beginning and end," for example, remain as attributes of the work, even if they coincide with the act of reading. Whereas if we turn from novel to paper sculpture, "beginning and end" surrender to "front and back," and an entirely different set of artistic experiments becomes possible. Of course it will be acknowledged that in some sense narrative sculpture exists, and the question of what story is being told has crossgeneric application, even if rejected by the Abstract Novelist and the Abstract Sculptor alike, indignant at the stigma of narrativeness. Still, the way in which their respective works lack stories differs from the way in which the Manhattan Telephone Directory lacks one, for the novel and the sculpture are defined through the fact that each belongs to a genre within which such questions have application.

It would be pendantry to spell out the differential structures of the distinct artistic genres. I refer to them simply to specify the logical boundaries that set the horizons for possible artistic experimentations, and because the avant-gardist is committed to probe these boundaries to see to what extent she or he can produce something that remains within boundaries though lacking one or another of the traits believed to define the genre. Thus we have abstract painting, plotless novels, unrhymed verse, atonal music, to mention some of the monuments to this mode of categorial exploration. Think, finally, of the musical work that, because of its resemblance to the Manhattan Telephone Directory, resembles artworks in quite alien genres. The composer, whose pretensions are Wagnerian in virtue of the insupportable length of his composition, may be told by a friendly critic that his work cannot be performed. Well, it could have been one of his intentions to produce an unperformable work ("Heard melodies are sweet . . ."), but even so it is unperformable only if it is relevantly first classed as music. There is an irrelevant sense in which the Manhattan Telephone Directory is not performable, namely because it is not music. Most of the world is made up of things that logically cannot be played.

I offer the speculation that the phenomenon of confusable counterparts belonging to distinct ontological orders arises only when at least

one of the confusable things bears a representational property: where at least one of the counterparts is *about* something, or has a content, or a subject, or a meaning. A good example of what I mean will be two sets of shapes, one of which is an inscription; the other set of shapes arrived on its surface in a manner inconsistent with its having a meaning. The two sets may be superimposable, but only one of them can be read, since only one of them qualifies as a piece of writing. The inscription will obviously possess properties that cannot belong to its uninscribed counterpart: it may be in Latin, have faulty syntax, contain a misspelled word, or simply be a sentential fragment. It is not just false to ascribe these properties to mere marks; it is categorially false. One may be moved, stirred, warned, or chastened by what one reads in an inscription, but these are wrong responses to mere marks, etched, to put it metaphorically, by the elements. It is because one set is representational that it has, as we saw, structural properties lacking its nonrepresentational counterpart. If we have two mere things that differ though they look in every outward particular the same, I suppose the difference must be looked for in their infrastructures: to say they are the same is to claim their infrastructures are the same, as in two samples of water or in two bits of gold. But when we have two sets of marks, one of which is an inscription and can be read, while the other is simply a set of marks, this is certainly not to be explained on the basis of infrastructure; it is not by descending to a microscopic level that we are to find the basis for the differences. Rather, the structures virtually supervene from the location of the inscription in a representational system. It is something imposed by whatever are the rules and conventions of the relevant representational system, and does not emerge, as it were, from below. Then different sets of rules and conventions assign different structures to otherwise indiscernible counterparts when these are regarded as representational to begin with.

This, however, whether sound as a speculation or not—and the testing of it belongs to a quite different work—returns us to a question we left standing two chapters back: how do we distinguish works of art from other representations? What must we add to the concept of representationality which will make the difference between ordinary representations and works of art? The method of finding indiscernible counterparts is certain to have application here as well. We are bound to find two (at least) representations, indiscernible in any merely visual sense, only one of which will be an artwork. The question then will be what makes it one.

L ate in *Languages of Art,* Nelson Goodman effects a strik-
ing juxtaposition. He asks us to compare the curve shown in an electro-
cardiogram, the gradiants of which may be intuited from the fact that it
is supposed to be indiscernible from the curve in a drawing by Hiro-
shige of Mount Fujiyama. One of these is certainly a work of art and the
other merely a vehicle of representation, inasmuch as graphs represent
relationships between sets of numbers through sets of points having co-
ordinates defined by that relationship, and the electrocardiogram is just
a graph. It is certainly no aim of mine to say that there cannot be art-
works consisting of graphs. But I take it as noncontroversial that not
every graph is an artwork, and let us suppose the wiry jag congruent
with Hiroshige's drawing simply is not one. And for the sake of neat-
ness, let us vary the example, allowing the graph instead of an electro-
cardiogram, to represent the gradiants of Fuji's slope itself, so that nei-
ther form nor content varies between our pair of curves. Goodman
observes that all that is relevant to the determination of points on a
graph is the assignment of numerical values for the x and y variables in
the pertinent equation, and it may be admitted that Hiroshige did not
arrive at his curve by overt calculation. How many Fourier series his
highly developed brain may have to resolve in order to make the subtle
changes in direction registered here is not to the point. These stand to
draftsmanly motion as retinal images do to perception, and Hiroshige is
doubtless as unaware of what goes on in his brain as we are in general as
to what goes on in our eyes: "I draw what I see," we may suppose him
to say, in the blunt idiom of the artistic mystic. We may applaud
Goodman's own spontaneous effort to enlist historical considerations in
differentiating the curves, but this still does not answer the philosophi-
cal question of why one of them is an artwork.

This problem is exacerbated by the possibility of an artist who sets
out to expunge just those factors of dexterity, synaptic wiring, *maniera,*
and sensitivity which set Hiroshige apart as a master, and to work out a
scheme of art that "anyone can follow." Enlisting the aid of analytical
geometry, he plots the locus of points that describe the slopes of Fuji
and connects them up in a drawing, the mechanicality of which is just
what he is after, part of his aim being to purge art "of all that hand-
and-eye crap." I am willing to admit that he has produced a drawing,
even if by nonacademic or counteracademic devices, and will go on to
admit that it is an artwork, though perhaps I would withhold that ac-
colade from a drawn curve generated by the principles he ideologizes,
commissioned, let us suppose, by The Japanese Bureau for the Preserva-
tion of the Ancient Profile of Mount Fujiyama.

Goodman is not especially helpful in eliciting differentia, though he

introduces a special term, "repleteness," and speaks of the Hiroshige as being "relatively replete." I am not wholly certain I understand what either repleteness or its antonym "attenuation" means, but Goodman at least sketches the difference between the diagram and the drawing this way: "some features that are constitutive in the pictorial scheme are dismissed as contingent in the diagrammatic scheme." And this summarizes the somewhat more extended gloss which I quote in its entirety:

The only relevant features of the diagram are the ordinate and abscissa of each of the points the center of the line passes through. The thickness of the line, its color and intensity, the absolute size of the diagram, etc. do not matter . . . For the sketch, this is not true. Any thickening or thinning of the line, its color, its contrast with the background, its size, even the qualities of the paper—none of this is ruled out. (*Languages of Art*, p. 229)

Relevant to *what*, one would like to know? For Goodman, as nearly as I can tell, the issues have to do with synonymy, so that any line specified coordinately is synonymous with the diagram, all other features notwithstanding, whereas this is not true for the picture, where, I suppose, some decision has to be made as to what features of the object are constitutive and what contingent—not an easy decision in contemporary art when we have to reckon with such works as a legendary one of Rauschenberg's, in which the passing shadows on a canvas contributed to its repletion. But then the differences in any case are matters of degree, so that the diagram is not fully "attenuated," and attenuation, I should surmise, would characterize only real things—which happen to satisfy no representational predicate or which conform, in Goodman's idiom, to no "character." For just that reason, however, reference to repleteness leaves our problem just where we took it up, all the more so in view of the fact that we have succeeded in imagining a *drawing* in which all that matters is the locations of the points that the curve passes through, and which in point of repleteness would be indiscernible from Goodman's graph. Accordingly, Goodman's observation serves less to mark the difference between drawing and diagram than to identify two styles of drawing. But then it may very well be under the concept of style itself that we might look at our various visually indiscernible curves: the graph itself lacks any stylistic characterizations just because it is a graph, whereas the analytically generated drawing might be stylistically characterized as mechanical—which is almost an aesthetic appraisal—while the drawing by Hiroshige is perhaps just disciplined and controlled, like a swordsweep by a samurai. To be sure, it may be objected that it is only because we know the histories of these curves that

we ascribe stylistic predicates to works that are perceptually not to be told apart. But if it is in terms of differential histories that we discriminate between those things in principle susceptible to stylistic acription but not to be told apart by immediate perception, it is far from plain that differential histories may not be the sort of tool we are seeking. Let me begin to bring this out by examining an actual case.

In a quite respectable book called *Cezanne's Composition,* the critic Erle Loran worked out some of the deeper formal structures of the master's paintings, and the book itself is illustrated with some helpful diagrams. One in particular has become notorious. It diagrams a painting of Cezanne's wife, itself a celebrated portrait. It is just what a diagram should be, with arrows, dotted lines, labeled areas; and it reveals just the variations in direction and proportion it was Loran's intention to make explicit. The notoriety of the diagram is due to the fact that some years after the book appeared, Roy Lichtenstein produced a canvas, entitled *Portrait of Madame Cezanne* (1963), differing in scale and substance from Loran's diagram, but so like it by criteria of optical indiscrimability as between, say, photographs of the two, that Loran brought charges of plagiarism and a minor controversy swept the art journals of the time. Now, of course, at that period Lichtenstein was "plagiarizing" from all over: a picture of a bathing beauty from an advertisement that still appears for a resort in the Catskills; various Picassos; and a number of things often so familiar that the charge of plagiarism is almost laughably irrelevant. The Campbell Soup can, to cite an artifact that has a parallel artistic correlate, is simply incapable of being plagiarized in the relevant way; an irrelevant way is that in which a soupmaker pastes Campbell labels on his product, exploiting familiarity and induction to save the expense of marketing his own mulligatawny under an unknown name. Moreover, Loran's book was so widely discussed in the artworld of the fifties that the possibility of plagiarism could hardly arise. The issues, however, are really not interestingly moral, but concern the serious philosophical difference between the diagram of an artwork and an artwork that consists in what looks like a diagram, and in at least these cases the point is pretty clear. Loran's diagram is about a specific painting and concerns the volumes and vectors of it. Lichtenstein's painting is about the way Cezanne painted his wife: it is *about* the wife, as seen by Cezanne. It is fitting and interesting to show the world as it appeared to Cezanne as so many labeled areas, as so many arrows, rectangles, and dotted lines: we have the famous conversations with Emile Bernard, in which Cezanne speaks

of nature as so many cubes, cones, and spheres, a kind of Pythagorean vision of the ultimate forms of reality, never mind what the senses say and conventional paintings show. Not many years after these geometrical speculations, the Cubists were painting the world in much those terms. But then how singularly apt to apply this geometrizing vision to Cezanne's *wife*, treated as though she were a Euclidean problem! For we know the sexual side of this man, in whom prude and satyr warred, and we know the passion and violence of his relationship with this woman, with whom he lived out of wedlock and by whom he had a son. And if the source and focus of all this feeling should be reduced to a kind of formula, how much this must tell us of the final triumph of the artistic impulse in his soul, even if it entailed a certain dehumanizing transfiguration of the subject; as if the person were so many planes, treated with no more and no less intensity and analytical subversion than a wax apple. One is reminded of Monet's anguished discovery that, sitting by the body of his late wife Camille, his model, love, support, angel, he had, instead of grieving, been studying the purple on her eyelids. He wondered what manner of monster he had become. Lichtenstein shows us the sort of monster Cezanne had become, if the parallel is allowed, but his in any case is a work of depth and wit, concerned with the way the world was perceived by the greatest painter of modern times. Loran's is not a work of art at all, but just, after all, the diagram of a painting. The issue of plagiarism is silly, inasmuch as the objects belong to disjoint categories, though both may be allowed to stand classification as vehicles of representation.

Yet this hardly can be said to have been proved, and the fact that the one has been accepted as an artwork and the other regarded merely as a diagram may all by itself only *seem* to have established a case that in philosophical honesty we must recognize remains to be made. For all that the analysis up to this point has established is that the two representations have different contents: the one concerns a painting by Cezanne and the other the vision and attitude someone who painted in that way may be conjectured to have had. One content may then be deeper than the other, without this difference in depth amounting to the sort of difference we are seeking. And we have known from the beginning that it is possible to have two works of art with different contents and which do nevertheless look perfectly alike. So unless we wished to claim that artworks have some special content, or some special kind of content, which sets them off from other representations altogether, the appeal to content would get us nowhere. And then we would have to demonstrate that Lichtenstein's work had that special kind of content and Loran's work did not (note the ambiguity on the

word "work"). But I would hesitate to suppose even then that something having the same content as Lichtenstein's painting would *ipso facto* be an artwork (think of my own description of Cezanne's way of seeing). But if not in content, and not again in what meets the eye, wherein is the difference to be found? The example, interesting enough no doubt, only reproduces the problem it was to illuminate.

T he failure of the example to reveal the differences we are seeking nevertheless suggests a reasonable next move. Suppose we can find a pair of things which not only resemble one another outwardly to whatever required degree, and have moreover the identical content, but where one of them is a work of art and the other not. Then the differences between works of art and mere representations should be discernible in whatever makes the difference in the pair. Of course, we may be unable to come up with the required example, in which case the arbitrariness of the concept of art is going to appear remarkably tantamount to mere injustice, just as J supposes at the beginning, where the relevant principle of justice requires that equals be treated equally. Either both or neither of such a pair will have to be art in virtue of congruity of shape and identity of content. But beyond that, it is going to seem hardly less arbitrary to call one of a pair of things which differs in content while retaining congruity of shape an artwork. And so on: we will systematically be forced into the worst caricatured formulations of the Institutional Theory of Art; that is art which is so designated by the effete snobs of the artworld. So a great deal turns, it seems to me, on whether or not the required example can be located.

Happily, the opening discussion in this chapter lends us license to draw our examples from whichever artistic genre is most convenient. So let us this time consider a text. Let us, for the matter, reflect upon the animating motive of Truman Capote's *In Cold Blood,* a text proclaimed when it appeared some years back as the first nonfiction novel: a philosophically innovative creation in that it demonstrated by counterexample that "All novels are fiction" is nonanalytical. The writer, apart from this stunning piece of philosophical imagination, invented nothing, or at least intended to invent nothing, in contrast with the typical novelist who invents characters, episodes, situations, and plots. Capote used the technologies of what today is called investigative journalism, and by constant digging came to know everything he could find out about the murder that was the subject of the book. It had the content of a very thorough forensic report written by someone in the district at-

torney's office. Or a newspaper article where the reporter had been as enterprising as Capote. Certainly, Capote could have made mistakes, but the appearance of these in his account would not make it a work of fiction, for then errors in the forensic report or in the newspaper article would constitute their authors as creative writers. What sets fiction apart from nonfiction is as subtle as what sets prose apart from poetry, and as there can be historical truth in fiction, there can be historical falsehood in nonfiction, without these transforming the texts into their opposites in either case. However, I am not interested in doing more than pointing out what may be left to the enterprising reader to elaborate. What counts is that we have three texts which, let us suppose, represent all and only the same facts. As they nevertheless differ in the manner in which they are written, they fail to satisfy one main condition for the example we need. They have only their content in common. Thereafter they diverge, as suits their differing purposes. Capote's book reads like a novel, as would be expected, given his mastery of the literary skills and his Edwardian Gothic sensibility, which is his cachet. But need a nonfiction novel in fact read that way? Is there any special way a novel, fiction or nonfiction, must read?

Imagine, now that the possibility is before us, a nonfiction story, where the term "story" is meant to carry the connotation of a work of literary art. The imagined writer is considerably in advance of Capote as an artistic experimenter and, like many of the artists who have darkened these pages, is ideologically antiart. Call him M. Now M eschews anything one might identify as literary. He despises Capote, whom he grudgingly allows to have had a good idea, which he spoiled. M prizes texts of a sort beneath the scrutiny of literati and hardly ever used as such by writers pretending to art: telegrams, stock-market printouts, want ads, newspaper boiler plate, laundry lists, and the like. One of his major achievements is a Marilyn Monroe calendar. However, in the present instance he has chosen the format of a newspaper story, with place, date, byline, headline, subheadings, columns, and the rest. Well, let him investigate, in the manner of his predecessor, the suicide of a man in Patchogue after he killed the owner of a service station and several other customers. And now we have the form and the content of his nonfiction story—which differs, let us suppose, in no particular from a newspaper account of the same *fait divers* written by the provincial crime reporter for *Newsday*, whose name might as well also be M, to assure congruity of bylines. He is just doing his job. But M says he too is just doing his job, which is "to make art." The products of course match utterly. More elaborate and less credible examples could be furnished,

but this one has the advantages of possibility. The question before us is fairly put: wherein do they differ, and what makes one a work of art if the other is not?

It seems to me now not difficult to see where they may differ. The nonfiction story uses the form of a newspaper story to make a point. The newspaper story, by contrast, uses that form because that is the way newspaper stories are; the writer is not making any special point by using that form. The newspaper story contrasts globally with literary stories, not being literature. The nonfiction story that happens to use the form of the newspaper story is a species of the class the newspaper story is excluded from. The author M's reasoning, as we may reconstruct it, is not without interest. He wants to make the point that the format of the newspaper story is the proper way facts of this sordid sort are commonly presented to a world steeped in media. So there is a nice relationship between content and form, twisted in the event by Capote in the interests of decadence. So M has repudiated the usual form of fictional presentation because this is, he says, nonfiction. It is nonfiction, but by no means nonliterature (like the newspaper story itself). We have already noted the way in which the Pop artist has preempted the screens and rasters of mass communication to present the charged images of our history and to underscore the violence of the times: chiaroscuro, scumbling, the glazing technique of the Old Masters, would be at odds with the depiction of the Kennedy assassinations, the Watergate confessionals, Vietnam (the wire-service photo suits these as the newsreel clip renders World War II, rotogravure the soggy realities of World War I, and the woodengraving the events of the Franco-Prussian War). The medium is not the message, but the form in which the message is given, and this is taken as a stylistic device by the artists who have become conscious of the structure of the media. The form of the newspaper story, which we pay little attention to because it is so commonplace in our culture, is chosen because of its commonplaceness by M—it is not commonplace in literature (yet).

There may be a question whether this difference makes the difference we want it to make. But it is a difference beyond visual congruity and identity of content. And the principle by which the example was generated may be extended and generalized. Any representation not an artwork can be matched by one that is one, the difference lying in the fact that the artwork uses the way the nonartwork presents its content to make a point about how that content is presented. Of course not all artworks take their flight from matching nonartworks, and those that do may almost be defined as modernist. Nevertheless, if the way the content is presented in relationship to the content itself is something that

must always be taken into consideration in analyzing a work of art, we may be on the threshold of having our definition. One observes, meanwhile, that this may serve to show in what way a copy of an artwork may not be an artwork in its own right: the copy merely shows the way the artwork presents its content, without itself especially presenting this in a way to make a point of it; a copy aims at a state of pure transparency, like an idealized performer. But a photograph of a work of art may very well be an artwork in its own right, if it presents content in a way that shows something about the content presented.

The Lichtenstein painting has many properties the Loran diagram lacks, but it is difficult to suppose the difference between them can simply be found there. It is, for instance, much larger than its counterpart. But then the counterpart is much smaller than it. It is painted on canvas. But its counterpart is printed on paper. And so on. There is nothing about any of this which shows that one of each pair of inverse properties must make something an artwork; we can imagine cases in which the opposite works as readily. But I have tried to identify a property of an essentially different sort, a property to the appreciation of which I intend to devote the remainder of this book. The Lichtenstein self-consciously exploits the format of the diagram to make a point, and of course it itself is not a diagram. To the degree that we can speak at all of diagrammatic styles, Lichtenstein's *Portrait of Madame Cezanne* has none of these: its style consists in the fact that it uses a diagram, whatever the latter's style (if it can be said to have a style); the style in question is consistent with other works of Lichtenstein which happen not to use diagrams at all. Here, Lichtenstein uses the diagrammatic idiom *rhetorically*. Loran does not use the idiom of diagrams; he simply uses diagrams (which happen, since they are diagrams, to be in that idiom). Whatever Lichtenstein is doing, he is not diagramming. The activity of diagramming has criteria of success and failure and infelicity. In the case of Loran's work, indeed, the diagram can be false to the degree that further empirical work can show that it has the eye movements all wrong. His is a contribution to the psychology of art, not art, which has criteria of an altogether different sort that have to be worked out case by case as we open up the structures of individual works.

From case to case. But it would be evasion of philosophical responsibility not to press past this concession and see what general principles may be involved. The principle cannot yield formulas for art appreciation, which requires us to work through each artwork in its own terms. It at best will specify the sorts of terms the analysis of the artwork will have to contain. So I shall offer a thesis.

The thesis is that works of art, in categorical contrast with mere rep-

resentations, use the means of representation in a way that is not exhaustively specified when one has exhaustively specified what is being represented. This is a use that transcends semantic considerations (considerations of *Sinn* and *Bedeutung*). Whatever Lichtenstein's work finally represents, it *expresses* something about that content. It manages to do this in part because of the connotations diagrams themselves have in our culture, belonging to the domain of economics, statistics, mechanical engineering, descriptive geometry, and *modes d'emplois*. By virtue of these connotations, the diagram is virtually a metaphor for whatever it shows. And it is this double role of representation and expression which has to be worked out in the final analysis of the work. Diagrams as diagrams typically express nothing about whatever it is they show. It is not that they are inexpressive, but that for such representations there is no place for the concept of expression. So it is not as if we use *zero* for the expression variable; there is no expression variable in the imagined equation to assign even zero to.

Expression, I admit, is too ill-defined a concept for us to pretend that we have probed deeply by its means into the metaphysical structure of the artwork. It must also be noted that no more than the concept of expression are the concepts of style, rhetoric, or metaphor altogether well-understood concepts. I have brought them in casually, but the fact that each comes naturally to hand, at the same crucial point in the analysis, suggests that they may have a common structure. And this, if true, means that we might be able to find out a great deal about each by taking them all together, rather than seeking to study metaphor or expression on its own.

I shall address myself in the next chapter to the ambitious program just announced, but I feel I must first clear the air of an objection that may have occurred to the reader. Recall the polemical context in which these concepts were introduced. I was seeking to differentiate artworks from other vehicles of representation by constructing pairs of representations formally congruent and having the same content. I then proposed that an artwork expresses something about its content, in contrast with an ordinary representation. But how do I know that what I have called expression is not after all part of the content of the work, so that in the end Lichtenstein's work has a somewhat richer and somewhat different content than the Loran diagram, and the nonfiction story contains some information about the cultural place of the newspaper idiom in addition to whatever criminal facts it also records? So in the end must I seek my definition in a place I rejected, namely that works of art are distinctive through their contents? Suppose that in addition to being about whatever they are about, they are about the way they are

about that—having, as it were, first- and second-order contents. They are complex, semantically speaking, incorporating into themselves a subtle piece of self-reference. It would be no accident, thus, if works of art were always such through the fact that they are about art and hence about themselves—and require for their existence, as I have argued, the concept of art. Well, suppose something like this is the case. Must I not then go on to ask whether every representation that is at least partially self-referential an artwork? And then will the task before us go on forever?

However this deep objection is to be met, it is some comfort to recognize that we must have made some progress, inasmuch as the question in this form has not, to my knowledge, been raised before in the entire history of the philosophy of art. That it has not been raised can in part be brought out by considering that whatever are the qualities that are picked out by the concepts of expression and the rest, whether they are representational categories or simply qualities of representations, there is no room for treating them under the conventional framework of the *imitation theory of art*. This I believe to be the defect of the theory, which has a certain philosophical nobility, and I want to show the incapacity to deal with these newly introduced concepts is what spells its doom. It was after all an insight of Socrates that the imitation theory could not effect the distinction between representations that were not works of art (allowing mirror images to be representations) and representations that were. So what an irony after all that Plato is identified as someone who believed in the imitation theory of art.

I now want to begin to meet the Socratic challenge seriously. This will bring out something worth knowing about these qualities and will prepare us somewhat to meet the objection. The issue is not to kill a theory, but to identify those elements in the atmosphere of art it would have needed to survive. I leave unanswered the historical question of how much was known about these elements in ancient or other times.

The imitation theory of art gets its best paradigms from painting, and its ideal formulation is expressed in a famous instruction of Leonardo Da Vinci. Imagine, Leonardo proposes, a pane of glass interposed between artist and motif. Then the outline of the motif, as traced on the glass, will exactly reproduce the outline of the motif as presented to the eye; and if we additionally reproduce on the glass whatever the object itself is seen through the glass to possess by way of qualities, the eye should in the end be unable to discriminate between perceiving the object or perceiving the replication of the object on the

interposed glass pane. Indeed, the eye will discriminate *on* the glass exactly what it would have discriminated *through* the glass had it not been for the intervention of the skilled painterly hand. The visual data exactly underdetermine the distinction between motif and image, exactly the same information reaching the eye from what in reality are altogether diverse sources. Of course Leonardo had the stationary eye in mind: parallax induces immediate distortions. And he had stationary motifs in mind as well. There is no way to fix on glass the movements an object makes; at that point the artist is required either to take for granted the viewers' antecedent beliefs about moving objects or to introduce various conventions to be read as indicators of movement. Until the advent of motion-picture technology, movement itself could only be indicated, not replicated. But it will not be profitable in this place to discuss the complexities raised by properties incapable of duplication on intervening panes of glass. There are problems enough with those properties that can be duplicated.

There is a temptation to suppose that with the image on the glass we are dealing with a kind of direct representation, as where a curve is used to represent a curve of the same gradiant as itself. It is direct representation, in this sense, when the representing property is an instance of the property represented. In fact this is very seldom the case with the Da Vincian image. Thus what turns up on the glass may be a trapezoid where the corresponding surface in the motif is a square. Where the motif is red the image may be brown. It is just that actual square and actual trapezoids elicit the same visual experience as might actual red and actual brown. The trapezoid and brown are *of* a square and *of* red, without being square or red as such. Indeed, it is only under a special artistic ideology that the representation must *be* what it is also *of.* Thus the Impressionists, noticing that shadows, though in fact not black were traditionally represented by black, felt this to be a failure in observation rather than a mere convention. Because shadows were colored, the representations of shadows should be colored. And that is the mark of the Impressionist painting. But of course a price was paid. Very few viewers were found, I am certain, for whom the Impressionist painting of *The Harbor of Honfleur* looked like the harbor at Honfleur or *The Seine at Pontoise* like the Seine at Pontoise. In demanding that representer and represented instantiate the same predicates—that what was of red should in fact be red—the Impressionists violated rather than enhanced the actual strategies of representational art, which is to elicit equivalent experiences through inequivalent stimuli. Strictly speaking, the viewer will not be perceiving, in perceiving the image, what he would have perceived in perceiving the motif. It will only seem that

way. That distinct sets of causes can elicit indiscernible experiences has been the secret of illusionists down the ages. But as it is the experience that underdetermines its causes, illusion occurs when the viewer believes it is the motif he is perceiving when instead it is the image. The issue is not what in reality marks the difference between motif and representation, but how they strike the eye and seduce the mind.

If illusion is to occur, the viewer cannot be conscious of any properties that really belong to the medium, for to the degree that we perceive that it is medium, illusion is effectively aborted. So the medium must, as it were, be invisible, and this requirement is perfectly symbolized by the pane of glass which is presumed transparent, something we cannot see but only see through (as consciousness is transparent in the respect that we are not conscious of it but only of its objects). If the pane of glass were not a means, it would be a metaphor for mimetic representation, and accordingly I take the logical invisibility of the medium to be the chief feature of imitation theory. The successful imitator does not merely reproduce the motif; he sublates the medium in which the reproduction occurs. And this is a necessary condition for the possibility of the desired illusion: that one is in the presence of the reality when in fact one is in the presence of an eidolon, to a woman if one is Pygmalion or some grapes if one is a bird. So conceived, it is the aim of imitation to conceal from the viewer the fact that it is an imitation, which is conspicuously at odds with Aristotle's thought that the knowledge of imitation accounts for our pleasure. But imitation evidently did not entail illusion in Aristotle's scheme. In Plato's it evidently did, and it is this form of the theory I am working with now. Taken as a theory of art, what the imitation theory amounts to is a reduction of the artwork to its content, everything else being supposedly invisible—or if visible, then an excrescence, to be overcome by further illusionistic technology. My aim is to show that this is part of the reason the imitation theory cannot serve to differentiate artworks from the pertinent class of representations which are just like them in the sense of having the same content. As I have shown, content alone cannot do the trick. And if art is only its content, we have no way of accommodating the concepts introduced early in this chapter. (I note incidentally that it is a defect in Marxist theories of art that they virtually identify art with the content of artworks.)

The theory just sketched has an exact philosophical analogue in Bishop Berkeley's theory of mind. What the mind contains are ideas, and ideas *are* just their contents, so the difference between a cow and the idea of a cow is not there to be drawn by Berkeley, who is after all eager to identify cows with the idea of cows. Nothing is left over when

you subtract the content from the idea. So you are never aware that what you are aware of is an idea; you are only aware of what it is an idea of, namely a cow. It is that which makes Berkeley's theory so surprising, and why it is so difficult to convince people that they are only aware of ideas.

There is also, as I mentioned, a philosophical analogue to the concept of medium. It is the concept of consciousness, which is at times described as a pure diaphanousness, never opaque enough to be an object for itself. Thus the medium is a kind of metaphysical effigy for consciousness, in that it is never part of the picture but sacrifices itself as it were, in an act of total withdrawal and self-effacement, leaving only content. So the artwork is the message and the medium is nothingness, much in the way in which consciousness is held, by Sartre for instance, to be a kind of nothingness. It is not part of the world but that through which the world is given, not being given itself.

In addition to making visible the degree to which the imitation theory has always been deeply metaphysical, these analogies enable us to discern a number of other transparencies in the other genres of art. There are, for example, parallel ideologies in the performative arts, as when the performer, in the fullest realization of her art, seeks to disappear as herself, to become a pane of glass on which the image of Phèdre is so tellingly projected that the audience believes, allowing for the parallaxes of language, that it is seeing just what it would have seen in Thebes on the actual, but also disappearing, stage of the Comédie. And again in the performance of music, it is the goal of certain players to evacuate themselves from the space between audience and sound; to the extent that the audience is conscious of the musician it is distracted from the music.

Music is not generally regarded as an imitative art, though both Aristotle and Plato regarded it that way, and there have been those who supposed that if it did not merely express the emotions, it in some way mimed them. But from the perspective of the concept of medium, the intermediary substance and avenue of transmission from subject to spectator, music shares crucial features with painting and sculpture and drama. And so might literature to the degree that we regard writing as a medium we are not supposed to be conscious of when we read, but to have the sense that Levin and Kitty are as vividly before the mind's direct gaze as the objects of our fantasies and dreams. The ideal style is, to pun on a portentous title, the zero degree of *écriture*, as though writing itself were a kind of pis aller, an expedient resort for those unable more immediately to present the images and episodes of fiction. It is as if the motion picture came as a solution to the problem that writing consisted

in, making it a natural thing to say that one has seen the picture but not read the book. The medium is the glass we see darkly through, a metaphysical cataract, a prosthetic of vision we would like to be able to throw away and see face to face what there is to see. The imitation theory, so considered, is after all virtually a synonym for Platonism, since media are those pools and puddles in which the forms we are unable to perceive directly and with absolute intimacy, are gotten at obliquely and through their reflections. Small wonder that Plato hated art. And small wonder that art would be required to hate itself if it heeded Platonism, since at best the artist clotted the space its greatest aspiration was to vanish from in an achievement of utter diaphanization. It is the medium that sunders reality from art. And what in the end recommends the imitation theory is less the notion of duplication as such than the promise that the right sort of duplication can transcend the medium.

It is a clear consequence of this theory that whatever response an audience has to an artwork must *ipso facto* be a response to the content of the artwork. Less pragmatically, whatever properties the artwork has are simply the properties of what the artwork shows—media being ideally empty, and having properties of their own only to the extent that they fail in their transparent ambitions. Consider aesthetic properties alone. The theory may not have solved the problem of the correct analysis of "is beautiful," but it would have solved the problem of "is a beautiful artwork." The analysis is simple: x is a beautiful artwork if and only if x is of y and y is beautiful. The task then of making artworks of beauty was in turn simple: find something beautiful and render it as on a pane of glass. "The wise Greek," wrote Lessing, "confined painting strictly to the imitation of beauty: the Greek artist imitated nothing that was not beautiful." Such a view may be found even today, in explaining, for example, why a given painting is not beautiful. Monroe Beardsley writes in "Beauty and Aesthetic Values," "since the Crucifixion as depicted by Grunewald is not beautiful, the painting is not beautiful." There may be beautiful paintings of crucifixions, Beardsley allows. But then these have to be of beautiful crucifixions—"Or bring into the picture other areas than those that depict a crucifixion" (in *Journal of Philosophy*, 1962, p. 621). I don't know quite how the latter in fact could be achieved. I don't know what could have been brought into Grunewald's painting to mitigate the green-splotched anguished Christ in such a way that the overall painting is made beautiful. One might bring in dancing lords and ladies with garlands in the manner of Watteau or Lancret—but that horrendous Jesus would eat through like acid, and the pretty areas would suddenly transfigure the painting into something of an even greater horrendousness—like the bowknots the

lady anchorite embellishes her hairshirt with to "give it a feminine touch." These added areas merely deepen the horror and constitute acts of artistic sadism, however well-intentioned. But as far as "beautiful crucifixions" themselves go, I am at an even greater loss: crucifixions are pretty monstrous events. Artists often went to some pains to conceal the gore in religious paintings in the Renaissance—Christ might have been a pretty athlete in his loincloth and muscles, suspended gymnastically—and there are numberless cruciform personages in the history of art to which suffering can hardly be attached. It would have been the theological aestheticians of the Council of Trent who demanded, in the interests of heightening faith, a little more fidelity to the anguish of suffering saints and martyrs, and Jesus henceforth appears torn and bloody as he would have been at Golgotha. So what Beardsley must have in mind is less the crucifixion than *representations* of crucifixions, which indeed can be beautiful—but only because they are not imitations. Little matter: the formula is much the same as Lessing's, and we may put it perhaps thus. Letting w = artwork and c = content, and forgetting just for the moment the relationship between c and what c may imitate,

$$beautiful(w) \rightarrow (beautiful(c)),$$

There are two main difficulties with this theory. The first is that strictly speaking, the antecedent in the conditional never is really satisfied, for the moment we seek to attack an aesthetic predicate to the work, we find we have attached instead to the content of the work, since the work itself is what it is of; so in responding to the work we are responding to what the work is of. And this seems somehow false of our experience in the galleries. Even if a pair of artists should indeed have depicted beautiful madonnas, it is the Raphael and the Murillo to which we respond and not just to the madonnas, beautiful as they are. And the theory, by giving us nothing save content for the work to consist in, cannot account for this experience. But second, the theory works best for such routine aesthetic predicates as "is beautiful" or perhaps "is pretty," in the respect that a pretty picture *is* often a picture of something pretty. But if we generalize upon the formula thus:

$$(F) \ (F(w) \rightarrow (F(c))),$$

then we get an inferential pattern quite inconsistent with the wider class of aesthetic predicates which rise spontaneously to out lips the moment we begin to express our responses to pictures. The range of aesthetic predicates is enormously wide—so wide, indeed, that there hardly can be an adjective of the language that cannot be pressed into the service of aesthetic utterance. But the moment we see the extent of

this range, we have to appreciate that few of these predicates attach to the content of the work in anything like the way in which they attach to the works themselves. I shall now seek to establish these claims. We shall uncover a portion of the anatomy of artworks simultaneously with uncovering a portion of the logic of the language with which we speak of artworks.

Here is a list of terms I have taken from a critical review of an exhibition of drawings by André Racz. These were, as it happens, drawings of flowers, and it is worth keeping in mind that few of the predicates I am about to list could easily be applied to flowers: "powerful," "swift," "fluid," "have depth," "have solidity," "sharp," "eloquent," "delicate." A comparable list could be culled from the columns of any art magazine, any volume of art criticism; and their peers and counterparts could be found in music magazines, architectural journals, literary periodicals, or would be heard at intermission time at concerts, murmured in galleries and museums, spoken if not declaimed in lectures and seminars. These words are the currency of the artworld.

The terms are not, of course, exclusively descriptive, as may be seen by imagining a collection of drawings that satisfied the antonyms of these terms: "weak," "halting," "stiff," "shallow," "hollow," "dull," "clumsy." I hesitate to identify a specific antonym for "eloquent." "Plain," for example, goes with "honest," and connotes commendatory attributes, so I shall merely use the convenient "lacks eloquence." These terms echo terms of praise in common life; it is difficult to imagine a context in which it is discommendatory to speak of something as "powerful." Power, speed, sureness, fluidity, are qualities we prize in things, or at least things we rely upon, and it is useful here to consider them, not least of all because, as examples, they are markedly less shopworn than the commonplace vocabulary of aesthetic discourse, at least as this is represented in philosophy.

It seems clear that members of the language community one may refer to as the artworld not merely tend to share the values these words express, but would seldom disagree among themselves as to whether a given term applies to a given work. To be sure, what one finds powerful another, more astute artworlder may find bombastic. But bombast lies on the same scale with powerful and weak—it is weakness masquerading as strength—and we would not understand someone who were to say, "Not powerful, really, but perhaps fluid, don't you think?" This is not to correct, but to change the aesthetic subject ("runny" might be to fluidity what bombast is to power). The rules for applying these terms

within the artworld must be pretty well understood in practice, though they may be difficult to raise to consciousness. They must be well understood because we understand one another easily when we use these terms. Not merely are there terms you cannot apply to these drawings if in fact all the terms in the above list truly apply—it is difficult to see how drawings could be all those things and at the same time pompous, febrile, childlike, or mechanical—but there are also words without aesthetic use, at least in connection with drawings. We might agree there are such words, but find it difficult to think of examples, since any word one might think of—ragged, compressed, hypertensive, baggy—puts an easily met challenge to imagine works to which these terms would effortlessly apply. Indeed, we understand them as immediately as we understand jokes or metaphors, to which I am certain they bear the closest of semantic relationships. To explain why a work is powerful is like explaining why something is funny. It can be done; the explanation very possibly recapitulates the mental processes we went through in identifying the work as powerful or the joke as funny; and we must beware of supposing that because we commonly see such things instantly, we are dealing with simple properties or terms with simple semantics.

The language of art stands to ordinary discourse in a relationship not unlike that in which artworks stand to real things. One can almost think of it as an imitation of real speech. There are terms that apply to artworks that do not apply to real things, or do so only by metaphoric extension: terms like chiaroscuro, triforium, cantabile, and the like. These are technical terms, for the use of professionals to mark the distinctions they require. They are remarkable for the fact that they are pretty much value-free in their primary use, as "joist" is, or "carburetor." This, I have suggested, is not true of the terms I am seeking to identify. They all express values, and I find it a striking thought that we cannot characterize works of art without in the same breath evaluating them. The language of aesthetic description and the language of aesthetic appreciation are of a piece.

The question immediately before us is how the theory of transparent media might handle such predicates, inasmuch as nothing is allowed as subject of a relevant predication except the content of the work. Inasmuch as the image is to be ideally indiscernible from the motif, the predicates, though they may attach to the image, in fact must be of a kind that normally attach to motifs as such. Thus nothing will be true of the representation of flowers that will not be true of flowers as flowers. Of course, the image embodied in the medium is, strictly speaking, supposed to have no properties of its own. Thus, if the flowers represented are yellow, the most we may be entitled to say of that in the

image which shows this feature of them is that it is "of yellow." There indeed may be a tacit *of* in front of every predicate we may wish to use, and this would be consistent with that feature of representational art we touched upon before entering into the mysteries of transparent media: a brown patch may be "of red" without needing to be red itself. There need be no inference regarding what a representation itself may have as a property from information regarding what it is *of:* a patch that is "of red" may itself be brown, but it can also be red. But in the ideal and impossible case of the perfectly transparent medium, the medium has only such properties as those whose linguistic representation requires the inseparable *of*. As Berkeley's ideas were always of cows, or of flowers, but because states of pure diaphaneity—what Berkeley spoke of as spirits—none of the properties an idea would be of could be properties of the ideas themselves.

It takes scant reflection to see how impossible this account must be, discounting any philosophical repugnance the concept of transparency itself may elicit. To begin with, these predicates do not yield sensibly to the analysis that would require them to be prefixed by the contentual "of," which then exports the predicate to the content of the work. We cannot proceed from "are powerful drawings of flowers" to "are drawings of powerful flowers." We cannot because there are none, or at least these flowers are not powerful. So in cases where it seems licit, some essential grammatical or lexical structure is concealed—as "are powerful drawings of athletes" to "are drawings of powerful athletes," or in Beardsley's case "is a beautiful painting of *x*" to "is a painting of a beautiful *x*." One difficulty with the traditional range of aesthetic predicates as studied by philosophers—conspicuously "is beautiful"—is that they seem without jarring our verbal sensibilities to apply equally to works of art and mere real things: there are beautiful paintings and beautiful sunsets. But it is verging on nonsense to speak of flowers as powerful, though it is straightforward to speak of drawings that way. Someone conversant with the language of the artworld, and of course with the ordinary language it trasmutes, would be absolutely puzzled to hear someone refer to actual flowers as fluid or powerful or wistful. There is no way in which actual flowers can be any of these things. And though indeed flowers have solidity—as what material objects do not in some degree?—it would violate the intuitions activated by what Grice speaks of as "conversational implicature" to observe of flowers that they have solidity. What could be the point of that? So we cannot, after all, so easily proceed from powerful drawings of flowers to drawings of powerful flowers. I do not mean, of course, to deny that a context can be eked out in which it literally makes sense to say that flowers are

powerful. We may think of them as pushing through the earth. Dickens, in *Great Expectations*, speaks of Mr. Jagger's "powerful handkerchief," but he also gives us a context for appreciating this characterization of so essentially flimsy an accessory. But no special context is required—or the fact that it is the artworld gives all that is needed by way of context—for applying the predicate "powerful" to drawings of flowers without implying anything about the flowers serving as motifs for Racz's drawings. Of course someone alien to the lexical usages of the artworld would be as much puzzled by such language as the member of the artworld would be by the exportation of an artworld predicate to a real thing. In Chapter 4 I proposed that we often cannot perceive the aesthetic qualities of artworks, as distinct from the aesthetic qualities of their material counterparts, until the concept of art is available to us. But I have now taken this point a step further. There is a whole range of predicates beyond the standard aesthetic predicates which have application to artworks and not to real things, nor, for the matter, to the material counterparts of the artworks. For if it would be strange to speak of flowers as powerful, it would be equally strange to speak of scribbled and splotched paper as powerful.

These considerations lead to one further argument, which is that although according to the transparency theory, art seeks to achieve an illusion, the language of illusion has nothing to do with these predicates. Under the standard terms of praise for ocular trumpery, we exalt a picture of x as: it looks just like x. "Looks good enough to eat" or "looks sweet enough to taste" are descriptions the birds of Zeuxis would have applied to simulacra of grapes had they known they were simulacra. So the aim of the transparency artist is to make it seem not that "looks F" is true of painted grapes but that "is F" is believed to be true of real ones, the belief in this instance being false in consequence of the stunning illusionist technique of the artist. But nothing remotely of this sort would work with the class of artistic predicates we are examining. Such terms as "powerful," applied to drawings, has no application to what drawings are of, except in quite special cases and then by different criteria of meaning. And so, though illusion may indeed work in such a way that someone may believe he is seeing flowers when in fact he is seeing only paint, he cannot falsely believe of *those flowers* that they are powerful. Since this is generally true of these predicates as a class, it would be worth pausing to meditate on the concept of illusion, on *trompe l'oeil*, which has, despite the prominence given it, little after all to do with the concept of art. The entire language of the artworld falls into inapplication the moment illusion arises. For none of the characteristic terms of the language of art apply to the content of an illusion

believed to be a real thing, but only (falsely as it happens) the predicates that apply to real things. But perhaps the most useful observation to make is that the terms used so interestingly (and as it happens, so intelligently) of Racz's work do not entail that the drawings are in fact of anything at all. In a way, told that there was a set of powerful, fluid, energetic drawings being shown at the Ruth White Gallery, I could hardly tell what they were of, or if they were of anything.

The medium, toward which the transparency theory has taken so prudish a stance as to pretend that it does not exist and to hope for an illusion through which it will be rendered invisible, is of course never really eliminible. There is always going to be a residuum of matter that cannot be vaporized into pure content. Yet, even so, a distinction must be made between medium and matter, as may be seen from the fact that although the predicates in question may apply to drawings without content, they cannot apply to the mere matter from which the drawings are fashioned: they do not straightforwardly apply to real objects; neither do they apply to paper and ink, which are also real objects. The predicates true of artworks are not true of the material counterparts of artworks. There is, in the current artworld, a tendency as reductionist as the transparency theory ever was. We might call it the Opaque Theory, to preserve symmetry. It is the theory that the artwork is only the material it is made from; it is canvas and paper, ink and paint, words and noise, sounds and movements. There *is* painting that aspires to become identical with its own material counterpart, what Joseph Mashek calls hardcore painting. But hardcore painting would have to go with hardcore language as well; none of the predicates characteristically used of painting can be used of hardcore painting, but only the predicates that apply to real things. Of a hardcore painting we can only give such descriptions as we could give of the material counterpart it seeks to be, and succeeds in being identical with. So all the critic can do is describe these paintings in the vocabulary of real discourse. The moment an artistic predicate is applied—such as "has depth"—we have left the material correlate behind and are dealing with the work of art, which can no more be identified with matter than with content. It is because medium cannot be identified with matter that the question of content cannot be logically rejected of an artwork, even if it has none.

As always, I am struck by the possibility of a speculative mapping of these distinctions onto quite another philosophical subject. I have remarked already the analogy between that theory which seeks to reduce artworks to their contents and Berkeley's theory that things are only the content of ideas. Berkeley subscribed to what to him was a felicitous theory of mind, which made it so transparent that Hume found he was

unprepared to countenance its existence. But Hume also felt uncomfortable in collapsing the self onto its contents, though of course if the self was the way in which those contents were given, it could hardly be part of what it gave, and hence would be logically invisible in relation to its data. We are all familiar with the ultimate reductions of materialism, which would identify what Berkeley called "spirit" and Hume called "self," with our material embodiment, with some state of our nervous system perhaps. And though this is a good theory, if the self has any analogy to the medium, the relationship between it and the nervous system is not a simple matter of identity. For as there are predicates true of the medium which are not true of the canvas, so are their predicates true of the nervous system only insofar as it has the characteristics the self is supposed to have had. Perhaps, again, it consists in the way the world is given to the one whose nervous system it is. Briefly, what would be missing from a description of the self in the descriptions of neurophysiology unaugmented with the language of moral psychology would be all those features of personality and character which come closest to those qualities of style and expression in the world of art. It is the qualities of character and personality which make us so interesting to one another as individuals, which arouse in us those feelings of love and hatred, fascination and revulsion, and which escape classification in terms of the regimented distinctions that have defined the mind-body problem in the philosophical tradition. It is possible to suppose that what is important to us in art, in view of these parallel structures, is of a piece with what is important to us in one another—as if the work of art were the externalization of the artist who made it, as if to appreciate the work is to see the world through the artist's sensibility and not just to see the world.

It would be dangerous to carry these speculations further at this point, but they have returned us to concepts of central interest. We still have some way to go before addressing ourselves either to them or their counterparts in moral psychology, though perhaps we can prepare the way by pondering yet another difficulty with the transparency theory.

That something is an imitation does not require that there exist something of which it is an imitation: "i is an O-imitation" can be true though the world be O-less. All that is required is that from i we should be able to recognize O, if O's exist and i is a good O-imitation, where goodness has to do with perspicuity, clarity, resolution, and the like. Nothing very different is required of O-descriptions. One can describe what is not, and all that is required of such descriptions is that

from them we should be able to tell what is the case with O were it to exist, provided again that it is a good description. Like imitations, descriptions fall away from goodness by syntactic criteria and by various other criteria of clarity and distinctness. In general, supposing these criteria satisfied, to understand a representation R, be it picture or proposition, is to know how the subject of R must be in case R is true. The *goodness* of R only facilitates cognition when R is applied to the world. To the degree that understanding is compromised by murk, recognition is compromised by uncertainty. Such, loosely, are the sorts of connections among meaning, understanding, knowledge, truth, representation, and reality. Such, loosely, is philosophy itself, in a nutshell.

For the moment I am concerned with imitations alone, that class of representations we understand would have to match reality when true, or at least elicit experiences equivalent to those a correspondent reality might elicit. If *i* is an O-imitation and O does not appear as *i* would lead us to expect it to appear, then *i* is either false or bad. False or bad: tradeoffs are always possible and sometimes necessary, and we can count certain imitations true if they are so bad as to be false if they were good. In visual mimesis, the Da Vincian pane defines goodness for still imitations of still objects—"still" in both senses of the word, immobile and silent. Philosophers of language not long ago were concerned with the parallel question of what would define descriptive goodness; they despaired of finding sentences in any natural language sufficiently clear to serve, and so had recourse to artificial ones. Both searches ran concurrently in the *Tractatus*, inasmuch as Wittgenstein supposed in the ideal case that sentences would be pictures. The philosophical search for the transparently clear sentence more or less ended when Wittgenstein ventured the thought that natural languages are fine as they are, and questions of pictorial accuracy were abandoned to the psychology of perception. In any case, given the criterion for mimetic goodness, there would always be a problem of deciding whether we have a good likeness of a strange thing or a bad likeness of a familiar one. Picasso's women, depicted flounder-fashion with eyes on the same side of the head: are they good imitations of women whose existence requires revision of our physiognomic notions or bad images of plain women? Supposing our physiognomic notions sound, then those images are true only if bad. To be sure, there are always surprises. It comes as a shock to those patronizing of the mountainscapes of the southern Sung to recognize that in fact there are mountains like those in China, thrust like skinny fingers up through the plain. At least the decision as to whether, against a constant conception of the world, a given image is good or bad, true or false, faces the transparency theorist at every turn,

for he has no other way to evaluate pictures. When it seems to him that imitation is so bad that major revisions of our conception of the world would be required even to imagine them true and good, special explanations of the artist seemed demanded, with the favored sorts being that the artist is inhibited by ineptitude, motivated by chicanery, or simply is insane. And it would have been the clear inadequacy of these explanations in modern times that finally recommended another possibility, that the artists in question were really not concerned to imitate a reality that they were representing badly, but to express certain things about a reality which they were doing rather well. A whole different way of looking at art was enjoined, to which Da Vinci's pane no longer seemed pertinent.

But of course it was always pertinent, even in the new dispensation. Expression could be measured by deviations from the Da Vincian projection when these deviations were not intended representationally. Inevitably, expression induced distortions of the image. And how speak of distortions save against a model of perspicuous mimesis? But there was truth in the fact that the transparency theorists could not account for components and properties of representations which were not intended to have a representational function. On the other hand, it is not as if one is spared some decision parallel to the one imposed on the transparency theorist: one must decide which distortions are due to representational ineptitude and which to expressive force. (There is a benign inane theory that every deviation is expressively relevant.) All this is true, but it is possible to suppose that the place in which the concepts we are after, of style and expression and even metaphor, are to be found in those discrepancies between image and motif which the transparency theorists can only give a negative value to, and attribute to failure of mimesis.

It may be worthy of note at this point that discrepancies can be invisible at a given time, simply because there is a contract between artist and spectator that a given representation is indiscernible from any correspondent motif. Giotto's contemporaries were astonished at the realism he was able to achieve, and even Vasari, between Giotto and whom the entire Renaissance occurred, chose to praise one of Giotto's paintings, of a man drinking water, as "portrayed with such marvelous effect, that one would believe him to be a living person drinking." This would have been a conventional form of praise, but it is not one to which we could be tempted upon gazing at Giotto. What would have been transparent to Giotto's contemporaries, almost like a glass they were seeing through to a sacred reality, has become opaque to us, and we are instantly conscious of something invisible to them but precious

to us—Giotto's style—which the transparency theorist might explain away as due to the fact that Giotto lived at a time when exact delineation of outward things was undeveloped. What I call "style" must have been less what Giotto saw than the way he saw it, and invisible for that reason. It must have been a way of seeing shared by a sufficiently large group of citizens of the artworld of his time, or they could not have praised Giotto in terms of the sort Vasari employs. The point seems general. Proust describes the great actress Berma as being transparent in something like the same way; he never was able to see what he came to see, namely great acting. Instead he found himself beholding Phèdre herself, suffering her hopeless love: Berma made herself into a kind of glass to reveal a character, and Marcel was not aware of the revelation of the character, but only the character herself. We shall never see Berma act. But I am certain, were we by some miracle of temporal transportation to do so, that the acting would have none of the stunning effect on us it had on Proust. She would be an opaque performing artifact of the theatrical world of the Belle Epoque, as distinguishable in style as the furniture of Nancy or the posters of Toulouse-Lautrec. We are likely to be convinced only by our own actors, those who, like Elliot Gould, are seen as natural because their audiences have been transformed into imitations of them. But Gould, transported to the stage of Berma's time, would be so opaque that he could not even be perceived as acting.

The allusions throughout this discussion express the extent to which I am concerned by structural analogies between periods and persons. Each has a kind of interior and an exterior, a *pour soi* and a *pour autrui*. The interior is simply the way the world is given. The exterior is simply the way the former becomes an object to a later or another consciousness. While we see the world as we do, we do not see *it* as a way of seeing the world: we simply see the world. Our consciousness of the world is not part of what we are conscious of. Later perhaps, when we have changed, we come to see the way we saw the world as having an identity separate from what we saw, giving a kind of global coloration to the contents of consciousness. Frege, in speaking of the vehicles of meaning, distinguishes what he speaks of as their *Farbung*. It is this notion I am seeking to capture. Consider a well-known engraving of Dickens, which often embellishes editions of his works. It was doubtless made so that his many admirers could have a portrait of the great man. "There is Mr. Dickens," they might say, "supposed to look just like him." But it could not, by transparency criteria, look just like him, and to believe that it did so is to be unconscious of the way one's consciousness colors one's reality. We see it as an early Victorian artifact. The

dimensions and proportions date it; no one, unless he were trying deliberately for archaism, could depict someone with those proportions and dimensions today. Not and say: "That is Mr. Kuhns, looking just as he does." No: the eyes are too large, the hair too wavy, the lips are fuller than lips ever are: someone who actually looked that way would be a freak. It is a romantic head, and an opulent one, looking back in one direction to Ossian and *The Cenci*, looking forward in the other direction to overstuffed furniture and heavy Edwardian port. It expresses the age—which means that the beliefs and attitudes that define the world as lived by those whose period it was, are somehow expressed, because presupposed in the way Mr. Dickens is shown. When those beliefs and attitudes change, the period is over, and one no longer sees Mr. Dickens—or anything—quite that way. And when one is conscious of that fact, one is seeing the consciousness of the period from without. It is to this coloration that the attributes of style and expression attach, and it is again this coloration that the transparency theory cannot account for. It is part of the representation without being part of the reality, and the transparency theory has no positive room for that difference. To say that the features through which I have sought to distinguish the Lichtenstein from the Loran representation are not part of the content is of course to make an appeal to the presuppositions of the transparency theory: by content I have in mind whatever would elicit equivalent stimuli with the object represented.

What I now propose to do is to give some intense analytical scrutiny to those features of coloration I have invoked in this chapter, and which I have sought to locate by examining the shortcomings of the transparency theory. And one particularly attractive byproduct of my extended analogy between ways of representing and ways of showing may be this: if the analogy holds, we may get our best logical insights into the concepts of style and expression from pondering the logical peculiarities of the language of mind. It is as if a work of art were like an externalization of the artist's consciousness, as if we could see his way of seeing and not merely what he saw. Canaletto made souvenirs of Venice, and we can see in them what we would have seen in Venice; that is why the lordling tourists bought them. But there is more to the paintings than gondolas and the Saluta. There is Canaletto's way of seeing the world, a way of seeing that must have not always been so remarkably different from that of his consumers, if they saw them just as souvenirs of the way Venice looked. In its own way they are as magical as the city, perhaps because they *are* the city, raised to self-consciousness, perhaps because the city itself was a work of art in its own right. But let us return to logical matters.

Metaphor, Expression, and Style

7 In seeking to differentiate artworks from other vehicles of representation which happen to resemble them and yet fail to enjoy their status, I introduced rhetoric, style, and expression as concepts that might bring us closer than we might otherwise come to a definition of art. Of the three, I believe that the concept of expression is the most pertinent to the concept of art—that art *is* expression has after all passed for an intended definition of art—and this would be all the more true were it the case that artworks, in addition to representing, express something about their subjects, when they have them. So it would not be an artwork if it failed to express. But in view of the fact that style and rhetoric serve almost the same differentiating function in our previous discussion, it is possible that these too, though less enshrined in the textbooks as theories of art, have certain features in common with the concept of expression which it would be to our advantage to identify. For the concept of expression itself spills over into so many domains that a philosopher, convinced that expression is importantly an aspect of art, might spend his entire time examining a portion of the concept which has quite peripheral bearing on the philosophy of art. I shall suppose that the point of intersection between style, expression, and rhetoric must be close to what we are in pursuit of, and that by keeping it in mind we may have a protective charm against getting too widely involved in concepts that are at once fascinating and difficult, and each of which has generated libraries of elucidation.

Discussing Lichtenstein's *Portrait of Madame Cezanne,* I said that he made a rhetorical use of the diagrammatic format, and I want now to clarify this claim by bringing forward some commonly recognized features in the practice of rhetoric. As a practice, it is the function of rhetoric to cause the audience of a discourse to take a certain attitude toward the subject of that discourse: to be caused to see that subject in a certain light. It is this increment of activity in excess of merely communicating the facts that doubtless makes rhetoric seem manipulative and the rhetorician insincere and "rhetorical" almost standardly abusive. Certainly the rhetorician—and any of us when we

engage in rhetorical strategy—is not merely asserting facts; he is suggesting them but in a way intended to transform the way in which an audience receive these facts (it is of no logical interest that the rhetorician may lie at the level of communicating facts; we may assume that the facts, to which we are often encouraged to stick, are there as stated, rhetoric beginning only after that is taken as assumed).

Loran's diagram has roughly the function of mapping the eye movements the *Portrait of Madame Cezanne* elicits in viewers of it, and it exhausts its function in charting those movements of the entranced eye. As a diagram it is true or false, and tests may be performed to determine which of the two it is. It is consistent with this admirable function that the diagram itself should be clear and clean, even pretty—that it should have certain aesthetic qualities—without being a work of art. At least it does not use the diagrammatic format rhetorically. A great deal of discourse is of the same order of intention, say the whole of scientific discourse. The discourse aims at nothing beyond apprising an audience of certain facts, toward which unquestionably a certain attitude may be predicted, but where the facts alone suffice to cause that attitude without any interventions from the writer or speaker who is content to let the facts speak for themselves. And so no "art" beyond the cognitive and discursive skills of routine rapportage are enlisted to cause any attitude. This, to be sure, may be ideal. It may in fact be that, even in the most objective sort of writing, rhetoric is unavoidable. It may be that the very use of objective sorts of writing is rhetorical in its own right, its rhetorical purpose being to assure the reader that these are but the facts, speaking for themselves. Nevertheless, let the distinction rest: we need the ideal case for philosophical purposes.

I am supposing that the characterization of rhetoric I am sketching cuts across a distinction between words and pictures. And I am supposing in both cases that the causation of an attitude toward what is represented is intentional. A picture of a bottle of beer may arouse thirst, a picture of a female garment may arouse a prurient desire, even though each is used to illustrate only how certain things look. But when the bottle is shown in such a way as to cause the viewer to infer that it is chilled, or the garment in such as way as to lead him to infer lubricity in the wearer, he may perceive the beer as good to drink and the garment good to buy, and it is the provocation of such perceptions that the commercial artist's rhetorical skills are exercised. Indeed, the pictures are painted in such a way as to require these inferences in order to be understood, and to arouse feelings of a sort it may be predicted the viewer will have toward the object as inferred. The distinction between the depicted frost, intended to move the viewer to imagine thirst and

its surcease, and the depicted lacrimation of enlarged eyes in the paintings of Carlo Dolci, intended to move the viewer to a pious sadness, is not so great that we must suppose ourselves, in treating of rhetoric, to be treating solely of its most meritricious examples. I am concerned only with the logical consideration that it is the intention of rhetoric to cause attitudes, irrespective of the goodness or badness of the motives in question. To be sure, Dolci's big-eyed saints and martyrs are too sentimental for current taste, and his motives too visible to move us to the desired attitude, which may mean that awareness of the means of arousal can abort the intended effect. But it is not at all difficult to find rhetorical aspects in the most exalted art, and it may just be one of the main offices of art less to represent the world than to represent it in such a way as to cause us to view it with a certain attitude and with a special vision. This had been the explicit aim in the period of the High Baroque in Italy, where artists were mandated to cause feelings in viewers in order to heighten and confirm faith; and it remains the clear aim of Socialist Realist and political art generally in the world today. But it is difficult to imagine an art that does not aim at some effect and insofar at some transformation in or some affirmation of the way the world is viewed by those who experience it fully. Let us consider some examples.

When Napoleon is represented as a Roman emperor, the sculptor is not just representing Napoleon in an antiquated get-up, the costumes believed to have been worn by the Roman emperors. Rather the sculptor is anxious to get the viewer to take toward the subject—Napoleon—the attitudes appropriate to the more exalted Roman emperors—Caesar or Augustus (if it were Marcus Aurelius, a somewhat different attitude would be intended). That figure, so garbed, is a metaphor of dignity, authority, grandeur, power, and political utterness. Indeed, the description or depiction of a as b always has this metaphoric structure: Saskia as Flora, Marie Antoinette as Shepherdess, Mrs. Siddons as the Muse of Tragedy—Gregor Samsa as Bug—as if the painting resolved into a kind of imperative to see a under the attributes of b (with the implication, not of course necessarily sound, that a is not b: the concept of artistic identification, introduced earlier, may be seen as possessing this much of metaphoric structure). There is an interesting distinction to be drawn between the cases just cited and those in which the individual who *happens to be* Napoleon or Sarah Siddons or Marie Antoinette is used as a model for a Roman emperor, the muse of tragedy, a simple *bergère*. For models are representational vehicles in their own right and merely stand for what they are models for; the identity of the model is swamped with the identity of its designatum. Ideally, the

model is intended to be transparent, and we are not supposed to perceive the model so much as what she or he is a model of—even though, of course, it is the model that is painted, photographed, or whatever. When the model is too familiar a figure for this submergence of identity to occur, the model is badly chosen: Elizabeth Taylor, Jackie Kennedy, or Richard Nixon would make bad models, having too strong an identity to go evanescent. A model may achieve a certain identity as a model, like Kiki in Montparnasse or Gabrielle in the Renoir household. But even here the artist will not see these *as* whatever they are used as models for when they are in fact used as models and not as motifs, not standing for nudes on the beaches but in fact being nudes on the beaches. Saskia is sometimes a model, sometimes a motif—as when Rembrandt draws Saskia in a summer hat or Saskia dying—and sometimes as the subject of a metaphor, Saskia-as-Flower-Goddess. It is part of the structure of a metaphoric transfiguration that the subject retains its identity throughout and is recognized as such. Thus transfiguration rather than transformation: Napoleon does not turn into a Roman emperor, merely bears the attributes of one—which is why Gregor Samsa is the hero of a piece of science fiction, metamorphosed rather than metaphored.

Metaphor is only the most familiar of the rhetorical tropes, each of which may with ingenuity be found to have a counterpart in pictorial representation. But rather than seek exhaustive illustration it will better serve our purposes to ask why metaphor is a device of rhetoric, and why in consequence a portrait of Napoleon as Roman emperor is more than simply a representation of a Roman emperor using Napoleon as model, or why it is more than a depiction of Napoleon simply in classical togs. The answer to this question will, I believe contribute to our understanding of another problem, reviewed in the preceding chapter: why is the difference between an artwork (Lichtenstein's portrait) and a mere representation (Loran's diagram) not just a difference in content? Here the question can be put this way: why is not the difference between a picture of Napoleon-as-Roman-emperor and a picture in which Napoleon stands as a model for a Roman emperor, why is this not *just* a difference in content? And if it is just a difference in content, why use a metaphor that shows Napoleon as a figure of imperial grandeur instead of simply showing Napoleon amid the appurtenances of imperial grandeur, of which there were, as we know, plenty: Why not "let the facts speak for themselves," all the more so if the metaphor itself brings forward no new facts? And this returns us to the question of why metaphor at all.

The *Rhetoric* of Aristotle is above all things a treatise in moral psy-

chology. Book II gives us an analysis of the emotions beyond which, I think it fair of Heidegger to have said, hardly a step has been taken since. Aristotle is concerned with the emotions primarily as the effects of rhetoric as seeking to arouse certain attitudes toward whatever is being described—describing it in such a way as to cause the appropriate emotions to arise. Rhetoricians must accordingly have sufficient conceptual purchase on the emotions that, if it be anger they intend to arouse, they will know how to characterize the intended object of the anger in such a way that anger toward that object is the only justifiable response. Thus one is not simply supposed to take note of the fact that someone has insulted one in a certain way; to have the concept of an insult is to respond to the fact with a suitable sort of wrath. So more is involved than getting a certain description accepted as true. It is to get taken toward that object so described the sort of attitude that would spontaneously have been taken toward the object originally, had it been seen in the light it required the rhetorician to put it in. Indeed, just as a practical syllogism is intended to terminate in an action and a theoretical syllogism to terminate in a belief, it is not implausible to see Aristotle in the *Rhetoric* working out the structures of a pathetic syllogism which are supposed to terminate in a certain sort of emotion. After all, like beliefs and actions—in contrast with bare perceptions and mere bodily movements—emotions—in contrast with perhaps bare feelings—are embedded in structures of justification. There are things we know we ought to feel given a certain characterization of the conditions we are under. And there are things we feel we know we ought not to feel, just as there are things we know we ought to believe or be doing, or not believe and not be doing, under conditions everyone in our communities will understand. Belief, action, and emotion are states of a person rather than stages in arguments, and so causal as well as logical considerations have a place in the Aristotelian structures. It is not enough for a rhetorician to demonstrate that a certain feeling ought to be felt, or that you—his audience—would be justified were you to feel it and perhaps unjustified in not feeling it: he is only worth his salt if he *gets you to have that emotion* and does not just tell you what you should be feeling. He must in some marvelous way engage the mind and make it move into the state he intends it to be in. He is not dealing with automata or mere rational beings. And that is why rhetoric as the art of persuasion and logic, when psychologized as the art of demonstration, must engage an audience as well as characterize facts and their interrelations.

In one of the most interesting of his observations in psychological logic, Aristotle cites the enthymeme as the most suitable logical form

for rhetorical purposes. This can seem puzzling at first, but it holds a key to something crucial. An enthymeme is a truncated syllogism, with a missing premiss or a missing conclusion, and it yields a valid syllogism when, in addition to meeting the usual conditions of syllogistic validity, the missing line is an obvious truth, or taken to be an obvious truth: something anybody can be expected to accept without special further effort: a banality. But the enthymeme then does more than demonstrate its conclusion given the truth, and in the pertinent case the obvious truth, of its premises. It involves a complex interrelation between the framer and the reader of the enthymeme. The latter must himself fill the gap deliberately left open by the former: he must supply what is missing and draw his own conclusions ("his own conclusions" are those "anyone" would draw). He is not, as a passive auditor, told what to put there; he must find that out and put it there himself, participating in the common procedure of reason, which operates the way responsive prayer is supposed to do, where a congregation is not prayed at, or in front of, but with. In a small way, the audience for the enthymeme acts as all readers ideally should, participating in a process rather than just being encoded with information as a tabula rasa. Explicitness is the enemy of this sort of seductive cooptation the enthymematic forms ideally exemplify. And something like this is true of all rhetorical usages. Consider only the most familiar occurrence of the adjective "rhetorical" in common usage: its occurrence in the label "rhetorical question." H. W. Fowler, with his muted irascibility, puts it thus: "A question is often put not to elicit information, but as a more striking substitute for a statement. The assumption is that only one answer is possible, and that if the hearer is compelled to make it mentally himself it will impress him more than the speaker's statement." The dialogue, as an instrument of maieutic art as used by Socrates, where his partner was supposed himself to bring forward a theory Socrates claimed himself impotent to furnish, thus shares a set of deep assumptions with the system of rhetorical tropes his enemies, the Sophists, were working out to effect the same ends. They have a common psychology of persuasion, and it is not surprising that the composition of Socratic dialogues was a standard rhetorician's exercise. So the enthymematic gap but exemplifies the ellipses that rhetoric exploits, on the plausible psychological assumption that the auditor will span the gap himself and, by an almost inevitable movement of mind, persuade himself more effectively than he could be persuaded by others, the rhetorician himself simply exploiting the auditor's own momentum. It is instructive to observe how little Iago says when he skillfully clears a space for Othello to drive himself mad with jealousy in.

Now something of the same dynamism is to be found in metaphor as well. Even if true, this would not yet explain how we do understand metaphors, but only that some particular action of the mind is engaged, a matter that Aristotle perhaps too narrowly from the perspective of logic but accurately enough from the perspective of understanding, explained as finding a middle term t so that if a is metaphorically b, there must be some t such that a is to t what t is to b. A metaphor would then be a kind of elliptical syllogism with a missing term and hence an enthymematic conclusion. Perhaps for any pair of terms a third can be found which mediates them into a metaphor, however originally distant they might seem initially to stand from one another on a possible lexical map: so perhaps, as with enthymemes, some presumption of truism governs the choice of a suitable middle, a fact which would by itself seriously call in question the thought that metaphor constitutes the *living edge* of language. The important observation here, however, has less to do with whether Aristotle has successfully found the logical form of the metaphor than with the fact that he has pragmatically identified something crucial: the middle term has to be found, the gap has to be filled in, the mind moved to action.

The provocation to participation is powerless against or merely puzzling to a person with insufficient knowledge: Napoleon as Roman emperor is a visual metaphor only for those who know how in general Napoleon would have dressed, know that it was historically wrong for Napoleon to have dressed that way, know that Roman emperors were supposed to have dressed that way, and so on. Beyond this the viewer must perceive the metaphor as answer to a question of why *that* man has been put by the artist in *those* clothes—a different question entirely from that which asks why Napoleon is dressed that way, the answer to which might not be metaphorical at all. In brief—and this is a point with enough logical promise that we must return to it—the locus of metaphoric expression is in the representation—in Napoleon-as-Roman-emperor—rather than in the reality represented, namely Napoleon wearing those clothes. Of course it is no secret that Napoleon was a very powerful figure. The purpose of the rhetorical portrait was to have that piece of common knowledge put in the light of Roman power, with all the benign connotations of that classical concept. Indeed that concept would have been a powerful and rich concept, difficult to exhaust. If Napoleon were merely wearing roman togs, there would be little to understand except why he did so—unless the clothes *themselves* had a metaphorical significance for him which a literal portrait of him wearing them would miss; a picture of a metaphor need not be, almost certainly will not be, a metaphoric picture. That is why, or

partly why, it is crucial to distinguish the form of a representation from the content of the representation.

In the light of these cursory reflections, we might now return to our juxtuposed exemplars of the previous chapter. Once more, it will be instructive to somewhat refract the different structures of Loran's diagram of Cezanne's portrait of his wife and Lichtenstein's takeover of that diagram as an exercise in logical crystallography. The same painting, that very portrait, is the subject of the two representations. In the one case the diagram maps the eye's trajectory, more or less. In the other, as we saw, the intention is wholly different. We may interpret it as a metaphor in this sense: it is, as it were, the *Portrait of Madame Cezanne* as a diagram. It is a transfiguration of the portrait, in which the portrait—like Napoleon—retains its identity through a substitution which is meant to illuminate it under novel attributes: to see that portrait as a diagram is to see that artist as seeing the world as a schematized structure. In order for the viewer to collaborate in the transfiguration, he must of course know the portrait, know the diagram of Loran, and accept certain connotations of the concept of the diagram, and then he must infuse that portrait with those connotations. So the artwork is constituted as a transfigurative representation rather than a representation *tout court,* and I think this is true of artworks, when representations, in general, whether this is achieved self-consciously, as in the arch work I have been discussing, or naively, when the artist simply happens to vest his subject with surprising yet penetrating attributes. To understand the artwork is to grasp the metaphor that is, I think, always there. Thus, to vary the example, consider Gainsborough's painting of St. James's Mall. It is indeed a picture of Regency ladies promenading. But the women are also transfigured into flowers and the *allée* into a stream they float along, and the painting is more than a document of leisure and fashion, becoming a metaphor on time and beauty. But every artwork is an example of the theory if it is correct: Rembrandt as prophet, Parmigianino as convex mirror image, Diocletian as Hercules, Christ as Lamb. But the greatest metaphors of art I believe to be those in which the spectator identifies himself with the attributes of the represented character: and sees his or her life in terms of the life depicted: it is oneself as Anna Karenina, or Isabelle Archer, or Elizabeth Bennett, or O: oneself sipping limetea; in the Marabar Caves; in the waters off East Egg; in the Red Chamber . . . where the artwork becomes a metaphor for life and life is transfigured. The structure of such transfigurations may indeed be like the structures of making believe— of pretending for whatever pleasure that brings and not for the purposes of deceit. But in such pretending one must always know that one

is not what one is pretending to be, and pretending, like a game, ceases when done. But artistic metaphors are different to the extent that they are in some way true: to see oneself as Anna is in some way to *be* Anna, and to see one's life as *her* life, so as to be changed by experience of being her. So the thought that art is a mirror (a convex mirror!) has after all some substance, for, as we saw at the beginning of our inquiry, mirrors tell us what we would not know about ourselves without them, and are instruments of self-revelation. One has learned something about oneself if one can see oneself as Anna, knowing of course that one is not a Fine Woman or necessarily a woman at all, let alone a Russian and a nineteenth-century person. You cannot altogether separate from your identity your beliefs about what that identity is: to believe yourself to be Anna is to be Anna for the time you believe it, to see your life as a sexual trap and yourself as a victim of duty and passion. Art, if a metaphor at times on life, entails that the not unfamiliar experience of being taken out of oneself by art—the familiar artistic illusion—is virtually the enactment of a metaphoric transformation with oneself as subject: you are what the work ultimately is about, a commonplace person transfigured into an amazing woman.

These are exalted reflections to be sure. But, to be sure again, one must at some point touch upon whatever it is that makes art itself an exalted activity in terms of the almost universal respect in which it is held. Making beautiful things is of course an exalted activity, as beauty is an exalted quality: but aesthetics, as we have so often seen, hardly touches the heart of art and certainly not of great art, which is certainly not the art that happens to be most beautiful. And so much of our discussion has been based upon such minimal exemplars, on squares of bare canvas and rude boxes and single lines, that it is intoxicating, if but for a moment, to ponder the masterpieces. But for the moment we must descend from heights on which it is difficult not to sound portentous, and point out one or two more obvious features and implications of artworks construed in terms of rhetoric.

The first is that if the structure of artworks is, or is very close to the structure of metaphors, then no paraphrase or summary of an artwork can engage the participatory mind in at all the ways that it can; and no critical account of the internal metaphor of the work can substitute for the work inasmuch as a description of a metaphor simply does not have the power of the metaphor it describes, just as a description of a cry of anguish does not activate the same responses as the cry of anguish itself. It is always a danger, in connection with an artwork one admires, to put into words what the painting means, for it is always available to anyone to say "is that all?" meaning that they can see very little recommenda-

tory in *that*. To try then to respond to this deflationary response by add-
ing more to one's description leaves it always a possibility to rerespond
with the same question. And this is because what more there always is is
not merely a quantitative overcharge one may hope with more words to
redeem; it is rather the power of the work which is implicated in the
metaphor, and power is something that must be *felt*. Metaphors do not
simply have rather wider connotations than can be specified—perhaps
one can in this sense "unpack" the metaphor into the full array of its
connotative elements. But once more the power the metaphor has is
simply not carried by its connotative equivalent which, as a list of at-
tributes, is of a different logical sort altogether than the metaphor. Crit-
icism then, which consists in interpreting metaphor in this extended
sense, cannot be intended as a substitute for the work. It function rather
is to equip the reader or viewer with the information needed to respond
to the work's power which, after all, can be lost as concepts change or
be inaccessible because of the outward difficulties of the work, which
the received cultural equipment is insufficient to accommodate. It is
not just, as is so often said, that metaphors go stale; they go dead in a
way that sometimes requires scholarly resurrection. And it is the great
value of such disciplines as the history of art and of literature to make
such works approachable again.

There is, then, a measure of truth to the claim that we ought to "pay
attention to the work itself," that there is and can be no substitute for
direct experience. It is a suggestion that has its analogue in certain very
familiar empiricist theories, and it may be countered, on a shallow
reading, that the analogy in some degree undermines something hoped
to be distinctive of artworks. For there is no possible substitute for the
direct experience of simple such qualities as red if one is to understand
such predicates as "red," and no description, however protracted, can
be equivalent to such primitive experiences. No doubt one could pro-
pose, on the basis of this analogy, that there is something as unique and
irreducible about artworks as there is about the primitive qualities cele-
brated by empiricism, that in its own way the unique quality of *The
Night Watch* is as much part of the basic stuff of the universe as is the
simple quality of red. And so one would have an explanation of the
uniqueness of art! This is an attractive theory, but not a finally persua-
sive one. It is not because, once more, the structure of artworks is like
the structure of metaphors and *artistic* experience is internally related
to this structure. Because of this it is a cognitive response and involves
an act of understanding of a complexity wholly different from those
basic encounters between simple properties and us: learning the mean-
ing by acquaintance with its denotation may enable us to apply the

name "The Night Watch" as the parallel encounter with red enables us to apply "red." But responding to that or any painting is considerably more than being able to identify it. Exactly this complexity of responsive understanding must, in many cases explicitly, be abetted by the mediation of criticism. But as the impugning of secondary works is part of what those have in mind who direct us to "the work itself," it is they who are open to the analogy from primitive experience—and characteristically they do treat artistic experience as a kind of aesthetic blur or blow whose only verbal correlative is an expletive—overlooking the complexity of structure the possibility of receiving the work involves, as well as the intricate interrelationship between the language we use to describe the work and the experience of the work itself.

There is a further point. I have inveighed against the isolation of artworks from the historical and generally causal matrices from which they derive their identities and structures. The "work itself" thus presupposes so many causal connections with its artistic environment that an ahistorical theory of art can have no philosophical defense. But this is more strongly than ever supported by the references of rhetorical force just brought forward. The rhetoric of the work presupposes accessibility to the concepts out of which enthymemes, rhetorical questions, and the tropes themselves are completed, and without this the power of the work and hence the work cannot be felt. But beyond this, I think it an analytical truth that rhetoric itself is an intentional activity, and that beings only of a certain sort are capable of it. If true this implies an important relationship between work and artist. That is, there is an implicit reference to the fact that someone is trying to move one rhetorically to the extent that one responds (perhaps mistakenly) to the work. "Intentional" does not entail "consciously," of course, and there may be room for a theory that refers art to the unconscious of the artist without this in any way changing the conceptual relationships between art and its intentions: metaphors have to be *made*. So the psychology, which I shall not further pursue, is certain to be exceedingly intricate.

Finally, I have observed in passing that the structure of the metaphor has to do with some features of the representation other than content. It was this that would explain why the difference between artworks and mere representations is not a simple matter of differences of content. And it would moreover explain why another representation with the same content would not substitute for the work at all, inasmuch as part of the power of the work is internally connected with features of *that* representation. This cannot be easily clarified without heeding some more logical features of metaphors than I have so far dealt with, and while metaphor is a vast topic, I cannot slip the responsibility here of

giving some sort of an account, at least an account sufficient to redeem these claims.

I have deliberately and tendentiously emphasized *visual* metaphors in this discussion, for if indeed there are visual metaphors, then a good theory of metaphorical expression and understanding must be able to account for the appearance of metaphor in both the main systems of representation, that of language and that of pictures, and accordingly what makes metaphor possible cannot be something peculiar to either of them: it must rest, one would think, upon features the two systems share. There are, for example, theories that characterize metaphors simply as grammatically or semantically deviate sentences or expressions. Indeed, linguistic metaphors may be that, but I doubt that being a metaphor can in any way depend upon being a grammatically or semantically deviant sentence or expression. For what then are we to say of pictorial metaphors? Is there a "grammar" of pictures which can be a touchstone for standard or deviant pictures? And is there something, call it pictorial competence, which bears comparison with linguistic competence? Then what is the relationship between these two systems of competency? Is, if it exists, pictorial competence perhaps parasitic upon grammatical competence, so that pictorial metaphors are ultimately to be explained with reference to grammatical competence, clearing the way for a single grammatical theory of metaphors as, say, grammatically deviant? Or could it be the other way round? Or are there just two independent systems? These are not questions to be answered here, in the philosophy of art. I take them up elsewhere, and regard them as deeply central questions of philosophy as such. I raise them here solely as a warning against conceptual provincialism—just because we find a good theory of linguistic metaphor may not mean that we have a good theory of *metaphor*. It will meanwhile serve the ends of perspicuity to track our discussion through rather more grammatical, or at least linguistic, domains. Let me begin with just a few dogmatically urged observations.

(1) It is often averred that ordinary language is a graveyard for defunct metaphors, as though literal discourse were simply metaphors gone dead, turned, as it were, to wood, while metaphors are the growthbuds of language. This seems to me altogether wrong. Ordinary speech is certainly full of clichés, and clichés doubtless are dead, or at least pretty stale metaphors (but how still apt it is to speak of death as the big sleep, of time as a river, of life as a dream, of passion as flame, of men as swine). But clichés enter speech virtually as phrases, distillates

of received wisdom to be brought out, like Christmas ornaments, to embellish an occasion—they are utterances of the moment, like "Happy Birthday" or "Here's looking at you"—and to understand them is more or less to understand where and when it is appropriate to say them, which has nothing to do with linguistic competence but with something more like cultural competence. As such they must be distinguished from *literal* sentences such as "The water is boiling," which is true of given waters at given temperatures and has nothing to do with the ceremonial aspects of cultural competence. "The water is boiling" was never a bright trope and is not now a tired one. No one ever invented it. Contrast this with "His blood was boiling." This may be a middle-aged metaphor, en route to banality: the person who says it did not invent it, but it was invented by some writer, I dare say. It is striking that "His lymph was boiling" has even now no metaphorical praise, lymph not being, like blood, the sort of thing metaphors are made on. It may be objected that "His blood was boiling" is the literal and "The water is boiling" the metaphorical spinoff which has become, like literal discourse generally, cliché. This is certainly wrong, however, for reasons I shall specify below. For the moment I shall merely observe that "The water is boiling" may be precisified as "The water has reached 100 degrees"—but we cannot substitute a comparable precisification for "His blood is boiling"; the subject of the discourse would be dead through internal cooking. It is the mark of metaphors in general to resist such substitutions and precisifications, the explanation of which must, I think, give us the key to this concept. Now it may be almost intuitively clear that there are pictorial clichés if there are pictorial metaphors, but not every picture is one or the other. Someone invented showing the stars and curved lines over a character's head as a metaphor for having sustained a blow—is "seeing stars" a verbal equivalent or the other a pictorial equivalent?—which has become a cliché of comicstrip notation. But a picture of a man with stars over his head can be just a picture of a man with stars over his head.

(2) The theory that metaphors are deviant utterances acknowledges, I think, what I have just sought to argue: some distinction must be available for setting metaphors young *and* old apart from literal utterances—which do not have quite that sort of lifetime—and the elegant concept of deviance does this superby and structurally. Deviance is to be distinguished from ill-formedness or ungrammaticality, and has nothing to do with any mere statistical considerations. The cliché about a stitch in time, which is a metaphor, is almost certain to be more frequently used than a sentence about a stitch in brine, which may be literal until we find out better. But when a man speaks of a stitch in brine,

is he speaking of a preserved stitch, an ineffective one, an underwater one or what? There is no obvious metaphor in "A stitch in brine is fine," but is this because the sentence itself is nondeviant? How can we tell? Clearly the theory is on a right track in view of the fact that it seeks metaphoricality as some property of a sentence rather than of a word, which was the limitation on such theories as Nietzsche's or Derrida's. But the problem remains as to how deviance is to be identified, and it may prove useful to consider the matter initially from the perspective of pictures.

Consider a picture of Napoleon as Madame Récamier. It shows Napoleon improbably got up in the lovely Empire robes we associate with Madame Récamier from David's portrait, his podgy frame extended along a chaise longue. Perhaps it is intended as a slur on his manhood, perhaps as an insinuation that Récamier is the power behind the throne: who knows? Let it simply be a bright conceit by a clever painter, who leaves it to his viewers to eke the meaning out. In whatever way it is deviant, it is at least not so in the respect that Napoleon had just never been depicted that way before. But let us try to put pressure on the deviance concept by imagining that Napoleon and his friends were in fact transvestites, as so many Nazis were alleged to have been. In the privacy of his chambers he drew on the lovely Empire gowns of his female contemporaries, and arrayed his podgy body along a chaise longue, the way he saw it done in David's painting. Indeed, his perversity may be supposed to have gone so far as to want himself painted in those robes on that chaise, and so he commissions a portrait of himself in sexually alien garments—perhaps to present to one of his lovers. Imagine the portrait executed. It is irresistible, as the reader will recognize, to imagine this portrait indiscernible from the one just described, of Napoleon *as* Récamier. There are the two of them side by side, each a picture of that man in lady's weeds. One is a metaphor, the other not. One, if metaphor be deviant, is a deviant portrait; the other a portrait, nondeviant itself, of deviancy (perversion). How are we to tell which is which? Truth, clearly, has nothing to do with it. The metaphorical truth of the one is consistent with the nonmetaphorical truth of the other, and indeed the latter may blind Napoleon himself to the metaphoricity of the other portrait, which *he* sees, perhaps, as an attempt at blackmail ("How could they have found out?"). Since the paintings, as they always do when we need them to, look exactly alike, as artworks may look exactly like other representations or like no representations at all, nothing that meets the eye is going to help. I don't say the question is unanswerable, but I shall not protract the agony further by raising tiny perplexities for deviance theorists. Instead I shall talk a

bit about some routine logical features of metaphors and argue that these can entail nothing about deviance inasmuch as some standard sorts of grammatical exemplars share these logical features without in any very recognizable sense being deviant. Or if they are, then we shall have a good logical criterion of deviance.

(3) That we can replace "boiled" with "attained 100 degrees" in "His water boiled" but not in "His blood boiled" could merely be evidence that the word "boiled" in English is ambiguous. I should think, however, that ambiguity cuts cross the distinction between literal and metaphorical uses of predicates, and there are deep reasons why this failure of substitutivity occurs in the case of "His blood boiled." They have to do with the fact that metaphors have an *intensional* structure, it being one of the marks of such structures that they resist substitution of equivalent expressions. Substitutions patterned as above may reveal ambiguities, but they are possible. If T is an ambiguous expression, then indeed there will be at least two expressions more or less available, either of which might be interchangeable with T without being interchangeable with one another—and this is what it is for T to be ambiguous. But when a context is intensional, no substitution is licit. To the best of my knowledge, the discovery that metaphors are resistant to substitution comes from my student, Josef Stern, who illustrates this with the familiar metaphoric cry of Romeo that Juliet is the sun. The sun, indeed, is the body of hot gases at the center of the solar system, but it would be false to say that Juliet is the body of hot gases at the center of the solar system, and it would be hysterically funny were someone to suppose the incongruity to be due to some ambiguity of the expression "the sun." It may be ambiguous in other ways, but Romeo hardly could have been indulging ambiguity when he identified his love with the sun. To be sure, it is possible to argue that it is unclear whether "His blood boiled" is a metaphor (or better, a cliché) or a literal sentence employing an ambiguous predicate. I suppose this is not difficult to decide because the sentence does not so much predicate "boiled" of the subject's blood as "boiling blood" of the subject himself, who is picturesquely being described as very angry. But I think it very little profitable to ponder particular cases. Rather, I shall proceed by assuming that metaphorical contexts are in fact intensional, roughly as Stern has claimed, and that the first philosophical step to be taken in understanding metaphorical construction is to find out why. I am not certain I have the answer, but I have some surmises.

Philosophers in recent times have identified a number of contexts, none of which is especially deviant grammatically, as intensional through the fact that coreferential expressions—or coextensive ones—

are not interchangeable within such contexts *salve veritate*, and, as may be expected inasmuch as quantification is the obverse of substitution, through the fact that one cannot really quantify into these contexts. Of these contexts, the most heavily canvassed has perhaps been that in which someone *m* is said to believe that *s*. Let *s* be the sentence "*a* is F." Then it will not follow from the fact that *a* is identical with *b*, that *m* believes that *b* is F, nor will it follow that (Ex)(*m* believes that *x* is F)—though it is accepted that either of these operations will sustain truth when performed upon the sentence *s* alone. These seeming anomalies of belief contexts have been very widely found throughout the domain of mental discourse, discourse in which someone is said to be in some mental state, let it be fear or desire or hope, so long as the attribution admits the "that-*s*" mode of construction. Whenever this is the case, the embedded *s* is demonstrably intensional, and on the basis of this logical consideration, intensionality has been advanced as "the mark of the mental." So it may be; but it would be hasty to conclude that we are dealing here with something peculiarly true of minds. For an impressive variety of contexts are clearly intensional without being clearly mental—modal contexts, for one, and all contexts that bear structural analogies to modal contexts (including structures in epistemic logic in which "believes" itself is used as a sentence-forming operation on sentences); contexts in which a person is quoted or said to have said-that something (where "said that . . ." may be specified as any of a wide class of speech acts such as warning, promising, asserting, and the like); and, not surprising if metaphors are intensional, similes. Indeed similes give a good example, for though all of them seem to involve comparisons and some relationship of likeness, not all sentences in which something is said to be like something else is *ipso facto* a simile. Tip is like Xerxes, these being dogs, and this is hardly a simile, in contrast with a farfetched one in which Tip is said to be like Fafnir or like Cerberus. And it may be questioned whether we yet have an exhaustive inventory of all the intensional contexts there are. I wish only to have given enough cases to block the easy explanation of intensionality through some feature supposed special to mind or consciousness.

Now I believe there must be some general explanation of why these various contexts are intensional: some sort of special truth condition that all and only intensional contexts share. And until this truth condition has been isolated, explanations of intensionality which cannot be generalized must be regarded as *ad hoc*, however brilliant they may be in suggestiveness and power. Thus a most elaborate apparatus has been evolved for dealing with modal contexts—and for a great many other contexts seeming to share structure with these—using the exceedingly

artificial concept of sets of possible worlds. Thus we replace the thought that something is possibly true (of the actual world) with the thought that something is actually true (of some possible world). No doubt a great deal of interest will continue to be generated by this approach, not least of all because philosophers like technical apparatuses of the sort reference to possible worlds has come to require, and I have every reason to believe that if it has not already been proposed, it very soon will be suggested that instead of being metaphorically true for this world, we will say of some sentence that it is literally true of a possible world, and so map a semantics for metaphors onto a semantics for modal logics. But as I believe that a *general* explanation of intensionality is demanded, I find it difficult to believe that a possible-worlds analysis will survive, for all its brilliance and its exceedingly occasional insights. Apart from its extreme artificiality—which is never, I suppose, a persuasive philosophical reason for rejecting an analysis—I find it hard to see how a possible-world structure will convincingly resolve contexts of direct discourse, cases in which it is true that m said "a is F" and false that he said "b is F," for all that a is identical with b. The theory I wish to propose has nothing of the architectural dash of the semantic theories evolved along the lines of reference to possible worlds. But it is more natural, it does in fact account for *how we understand* such contexts, and it can, so far as I can tell, be generalized to cover even the easily dismissed case of direct discourse. I shall only sketch the outlines of the theory and indicate the rough modes of its application.

Briefly the theory is this: the explanation of the logical peculiarity of intensional contexts is that the words these sentence make use of do not refer to what they ordinarily refer to in routine nonintensional discourse. They refer, rather, to the form in which the things ordinarily referred to by those words are represented: they include among their truth conditions some reference to a representation. Thus when we say that m believes that Frege is a great philosopher, this will not be the same as saying that m believes that the author of the *Begriffschrifft* is a great philosopher, though Frege is he. This is not simply because he may not know that Frege wrote that thing, for he may know that and in fact he may believe that the author of the *Begriffschrifft* is a great philosopher. It is that *we* are referring neither to Frege nor to the author of the *Begriffschrifft*, but to a constituent of the way m happens to be representing something. The sentence we assert is about that fragment of a representation, about (in this instance) the way the world is taken to be by m. Since intensional contexts are about something quite different from what expressions using the words they use would be about, it is small wonder that substitution and quantification seem blocked. They

are only because they have no business being used with reference to the same things they would be used with reference to in nonintensional contexts. But the semantics are apt to be fairly complex, and I shall review some contexts in order to prepare the reader to see how nicely this theory fits the case of metaphor. Nonphilosophers may wish to skip directly to that discussion.

Quotations. Let us consider a perhaps excessively complex case: someone in the course of conversation makes an allusive quotation. The rhetorical use of such quotations is perhaps to flatter the audience, which is supposed to recognize the quotation, simply because allusion here presupposes familiarity since the quotation itself is presupposed familiar. The radius of familiarity describes a circle or a class of persons which forms a community, whether it be Mr. Daubeny (in *Phineas Finn*) citing Virgil in Latin, or Mark Rudd quoting Bob Dylan to his cogenerationists. Such quotations have always a metaphoric pragmatics in excess of any metaphor the quotation itself may have if it is already a metaphor; and commonly the quotation is made to establish a recognized parallel between the situation it is applied to currently and the situation intended by the source of the expression quoted. Mr. Daubeny simply says, as the distillate of relevant wisdom, "Graia pandetur ab urbe," as Rudd says "You don't have to ask the weatherman which way the wind is blowing." And everyone feels edified. Let us suppose now that the complicated transactions of semantic and general metaphoric fit have been achieved: the quotation is recognized, the situation epitomized, the speaker is taken to have voiced a very deep truth, the parallels are indeed there or thought to be there. None of this need be altered if the speaker in fact has gotten his words slightly wrong. Mr. Daubeny, say, has used the word *Hellenica* instead of *Graia*, and Rudd *meteorologist* instead of *weatherman*. Now in the linguistic communities in which the original source of the utterance was situated (Virgil, Dylan), a choice may be supposed to have existed, and the writer could have used the words in fact wrongly used by the quoter: "weatherman" and "meteorologist" may be said to mark off pretty much the same extensions currently, and "Greece" and "Hellas" codesignate much the same geographical place. So we may imagine they would have been able to justify choosing the word they did choose on some basis in prosody. (They had the choice even if in fact they did not choose—even if it had not so much as occurred to Dylan to use the word "meteorologist," though the whole style of the radical underground might have been different had he in fact chosen the alternative term.) The point is that whatever choice defined the situation of Virgil and Dylan, it is not a choice available to their quoters. As quoters, they must get the words

right, whatever further rhetorical purposes they may have in bringing the words forward when they do bring them forward, implying parallels, stating poetic truths, cementing the communal bonds, and such.

I shall now put this somewhat formally. Let Q be a quotation, and let F be a function from Q onto some proposition P when the speaker means for his audience to recognize that when he utters Q he means P. Thus Mr. Daubeny is not talking about a small town in Greece; he is talking about a small town in England in which, in a political speech, he broached the topic of the disestablishment of the Church of England. In any case, the audience has grasped the function and replaced, as it were, Q with P, and it has been a rhetorical success to that extent. Suppose further that Q-as-P is true, whatever that means in such contexts. In any case, if it is true, its truth ought not to be altered if in fact a term *t* in Q happens to be replaced with a term *t* that would ordinarily interchange with it *salve veritate*.

In acts of quotation there is always an implicit reference to a sayer, a citation of sources which may be omitted in the interests of collusion. The members of the House of Commons may be presumed to know it was Virgil who said "Graia pandetur ab urbe." And the function from Q may be fairly simple when the sentence it sends us to is Q itself. Thus "Dad said 'Dinner is ready' " sends the pertinent audience to 'Dinner is ready.' In such cases rhetoric is minimal or absent, save in this instance for the citation of authority, the speaker presumably having none of his own to summon anyone to table. In general, the P to which the hearer is taken by the function may be any of a set of largely equivalent sentences as paraphrases on Q; nothing is much altered if, when *a* says "Dad said 'Dinner is on the table' " to *b*, *b* simply says "Supper is on the table" to *c*. In quotation generally, the quoter utters a sentence and means a sentence, and when the intentions are rhetorical he means the audience to find the function with which to find the sentence that he means them to find. The audience has a choice, usually, of the sentence it finds when it rises to the rhetorical bait; each completes the rhetorical act in perhaps different but roughly equivalent ways when successful communication indeed has taken place. But, as said, the quoter himself has no such liberties. He is obliged to replicate the words he is quoting, within, to be sure, the elastic boundaries afforded by translation, where the translated sentence may, in Carnap's terms, be intentionally isomorphic with the original sentence. Whatever the case, Mr. Daubeny, in quoting Virgil, is making a very complex claim, some of the truth conditions of which are satisfied by Virgil's words themselves, some of which are satisfied by whatever will have satisfied what Virgil's words will have been about, and some of which must be satisfied by

that, whatever it is, which the sentence into which Q is taken are about—and then there are truth conditions having to do with the relationship between the last two sets of truth conditions. The complexity is due to the various levels upon which Mr. Daubeny's utterance must be taken. His words refer to some words, to what those words were meant to refer to, to what he means for them to refer to, and so on. So his allusive quotation, as must any, plays a very complex role in the discourse it facilitates. But my claim here is that what makes quotational contexts intensional has to do with the fact that part of what makes his statement true, if it is true, are certain features of the *words* he must replicate—those words and not some others that may, outside quotational contexts, readily enough be interchanged with them. His utterance is not fully intensional, inasmuch as part of what it is about is also what the words he replicates are about. Those words, as it were, occur both opaquely and transparently in the single act of speech, and this in part is because, in addition to making a quotation, Mr. Daubeny is asserting the sentence the rhetorical function maps the quotation onto; and that requires that the quotation itself be in position to be interchanged with it. The semantics of mere quotation is much simpler, of course; it merely requires that one replicate a set of words, intending to replicate them, and intending that one's audience know this to be one's intention. Then all that is necessary is that the words one uses replicate the words one mentions. But I wanted the more complex case, the case in which the words themselves compose only some of what is needed to satisfy the truth conditions for the whole.

Modalities. Quotational contexts seem most clearly of all the intensional contexts to yield an explanation of why one word cannot be replaced with a mere synonym for it: it would have been that first word, and not the second word, which was actually *said*. So the constraints on quotational contexts seem to be exacting. I have therefore begun with quotational contexts, simply because the parallels between them and the other intensional contexts are much closer than one might have believed. In brief, I mean quotational contexts to stand as my model for the others I want to discuss. I turn next to consider modal contexts. It should be a trivial observation that the modalities are logically represented as operations upon sentences, and that the sentences which result from attaching a modal operator to an embedded sentence is true just when the sentence embedded satisfies the conditions of the attached modality—and hence that such sentences are about a property of the embedded sentence, true if it has the property, false if it does not. It is about *that* sentence, and not about some other which may be obtained from the embedded sentence by interchange of one term with

another term coreferential with it. And so it is not, as such, about whatever that sentence may itself be about. Reflect for a moment on the celebrated Fregian sentence "The Morning Star is identical with the Evening Star" and its mate "The Morning Star is identical with the Morning Star." Only the latter is commonly deemed necessary, but its necessity derives from no astronomical fact, but from the instantiation it makes of the schema *a* equals *a* where it is a condition for the instantiation that the flanking terms be the same. But the first sentence is "possible" just because the sentence that it instantiates is neither that schema nor the schema *a* does not equal *a*. The sentences that instantiate neither of these schema are "possible" not in virtue of any feature of the world, but in virtue solely of the terms they use, and "It is possible that the Morning Star is identical with the Evening Star" is made true solely with reference to these facts concerning the terms, and not with reference to whatever may make the embedded sentence itself true or false. So it is quite independent of any considerations of the sort that will enable one to establish identities in the world. That modalized sentences have solely to do with the terms which compose them will explain why they are intensional if, indeed, intensional sentences are in fact made true or false by certain features of the language they are about. And there seems little more to be said on this aspect of the topic, whatever considerably more there may be said about other aspects of the modalities. And it is solely this aspect I am concerned with.

Of course there may be uses of "necessary" and "possible" and "impossible" that do not intensionalize the sentences on which they furnish some quantification. Thus when I say that it is possible I shall marry, it is far from plain that the sentence here is intensional, simply because it is far from plain that the occurrence of the word "possible" is a modality whose logical representation is as an operation upon a sentence. But, at the same time, the analysis of such sentences is likely to be somewhat complex. Just consider, "It is possible that Smith is married." Smith, let us suppose, is the chief accountant, so if it is possible that Smith is married, it seems equally the case that the chief accountant is married, since they are the same man. But Smith may also be the same as Mrs. Smith's husband, and while it should be possible that Mrs. Smith's husband should be married, since this will be Smith himself, and while there seems grammatical parity with "It is possible that the chief accountant is married," it seems odd to *say* it. This may be because it has less to do with Smith under whatever description than with the way the term "possible" is viewed. Thus it is these days, in a quaint throwback to medievalisms, sometimes urged that "possible" is to be appreciated as meaning "not inconsistent with the essence of . . ." And while this

may be a deep way of understanding this expression, there are splendid analyses of the concept of essences which refer us instead to definitions. So it would seem that "It is possible that" is to be read as "It is not a matter of definition that not," and this rings false when we address Smith as Mrs. Smith's husband, for it *does* seem a matter of definition that Mrs. Smith's husband is married. But in any case, if "it is possible that" is so read, it refers us to definitions, and definitions are very much a matter of words. Again, it is sometimes urged that "it is possible that" be taken as an epistemic qualification, so that "It is possible that Smith is married" may be treated as "For all one can tell, Smith is married," or "It is consistent with what we know of Smith that Smith is married." But "telling" and "knowing" refer us more or less to states of cognitivity—of belief, for example—and descriptions of such states are paradigmatically intensional. But here again the penumbra of ignorance implied by "For all one can tell" or comparable expressions of cognitive modesty is difficult to imagine surviving the illumination that the man referred to is referred to as a *husband*. For then there hardly can be doubt that he is married, unless the latter is taken in some quite special or restricted sense. In general I would surmise that nonmodal use of terms that also have a modal use may be worked out in such a way that their intensionality is parasitic upon some element in the specification of their truth conditions having to do with contexts which are quite clearly intensional. But it is not my business here to pursue a catalogue or to exhaust the different cases.

Psychological ascriptions. With sentences in which some characteristic mental predicate, such as "believes" or "hopes" or "fears" or "thinks," where this is followed by a sentential fragment "that *s*" and the *s* is itself a sentence, the intensionalities with regard to the embedded sentence have been conspicuous since the discovery of the phenomenon. It is possible to treat these all as yielding to the same analysis as "*m* says '*s*'" and hence as subject to much the same constraints as direct quotation. To be sure, the "that" suggests a closer grammatical connection with "*m* says that *s*," where the latter, as an instance of *oratio obliqua*, does not entail that in fact *m* said "*s*." He may have said words that to all intents and purposes *amount* to *s*; he may have said no words at all but communicated in some way which to all intents and purposes amounted to saying *s*, and so forth. Whatever the case, if *m* said that *s*, there has to be some specific sentence, uttered or written or signaled in whatever way, and ultimately it is with this sentence and its specific vocabulary and grammar that the sentence attributing the saying of such a sentence is about; and we saw that quotational contexts are intensional in virtue of this. So we may treat "*m* believes that *s*" as standing

in the relationship exemplified by *oratio obliqua* to "*m* believes '*s*'"—
and take this to imply that there is some specific sentence *s* such that *s*
is what *m* believes. To be sure, it may be countered that when it is true
that *m* says something, there is an actual occurrence of a sentence,
which comes out of his mouth or onto the paper he is writing on: a sen-
tence is produced. But what can be said of a sentence merely believed?
Where is the sentence? Clever theories are available whereby to write
down what *m* believes is to produce a sentence and to comply with the
demand. But to say that *m* believes *that*—pointing to the sentence—is
an exceedingly unnatural account of what I think is wanted. The objec-
tion is in good faith.

My own theory is that if *m* believes that *s* is true, there is a sentential
state of *m* which *s* individuates. To believe that *s* is to represent the
world in a way which *s* itself exemplifies, and to ascribe a belief is in
part to characterize a representation. This is true for all such mental
characterizations as hope and fear and the rest. This leaves the problem
of differentiating belief from hope from fear, but I am interested here
only in the representational character of these cases. Briefly, I would
argue for the view that the mind is a medium in which sentential repre-
sentations occur as literally as written sentences occur on paper or spo-
ken ones in the ether. And as psychological inscriptions thus compass
among their truth conditions references to a representation (and one
may accept this while rejecting my own perhaps too abrupt theory), the
explanation of their intensionality follows if what accounts for inten-
sionality is finally reference to a representation.

Texts. If we may generalize from these rough analyses, intensional
contexts are such because the sentences in whose formation they enter
are about specific sentences—or about specific representations—and
not about whatever those sentences or representations would be about
were they to occur outside those contexts. As noted in discussing quo-
tational contexts, intensional contexts may have a certain complexity
through the fact that the sentences, whose properties figure among the
truth conditions for the entire sentence, may play more than one role.
Thus in quoting, one may, in addition to citing the words, express
agreement with them; the embedded sentence is both mentioned and
used in a single act of speech. Or again, one may not simply record the
fact that someone believes that *s*: one may in addition want to say that
what he believes is true, and this in effect is to assert the sentence one
also cites as the content of the belief. This is certainly the case when
one claims of someone that he knows that *s*: for this implies that one
knows that *s* oneself, and it is recognized as a performative assertion of
a sentence to claim one knows it to be the case. So, to preempt current

terminology to our own ends, a sentence may have an opaque *as well as* a transparent occurrence in a single act of speech, it being in its opaque role or position that the phenomenon of intensionality arises. We may see this perhaps nowhere more clearly than in those literary texts where, in addition to stating whatever facts the author means to state, he or she *chooses the words* with which they are stated for other purposes: to make an allusion, to sustain a cadence, to frame a pun, to mock a character, to impose a lietmotif—literary intentions that would fail if other words were used instead.

It is these textual features that are lost when the texts themselves are translated, which under criteria of transparency raises no comparable problem, inasmuch as whatever can be said in one language can be equivalently said in the translating language. It is these features of texts taken as *things* with a certain density, and conforming to certain principles of textuality, which put fragments into relationships with other fragments in ways having little to do with stating facts or giving the truth; which explain, or explain in part, why we prefer the original to the translation and the translation to the paraphrase or condensation. We do so because authorial subtlety and, let us say, *art* are contained in just the verbal materials from which the text is built. Of course the verbal material carries its meaning as well. It is, I should suppose, with reference to the conditions of opacity that we would mark out what belongs to the form and, with reference to the conditions of transparency, that we would mark out what belongs to the content of a text. Because each text has both, it is not difficult to explain in what way form and content are inseparable and in what way they are different. But as a thing, a text cannot be translated, just because things cannot be. (It is, incidentally, this innocuous logical fact regarding texts which has provoked, on the Continent, an astonishing flood of rhapsodic textolatry.)

Metaphors. It is now not difficult to see what in general must be said about metaphors, which are true or false in at least the sense that their interpretations are true or false, and which have in addition certain properties connected with the conditions of opacity. Consider the abusive metaphor, "Men are pigs." Pigs are the exclusive provenance of pork, but pork itself is remote from the defining center of militancy in those women who stigmatize males as pigs. Pigs indeed are useful, benign animals, but it is certain qualities believed possessed by pigs, and which when possessed by humans is morally repugnant, which are intended in the metaphor. But this means that part of the truth conditions of the metaphor will be constituted by certain features of the predicate itself. The metaphor is about men and not so much about pigs as

"pigs"—about *that expression*, with its received connotations in the idiom of the day—and, because it is *that expression* which is crucial, there is no assurance that any other word or expression will carry the pejorative venom the metaphor exudes, however otherwise interchangeable "pigs" may be with such expressions in the frameworks of transparency. Thus a metaphor presents its subject and presents the way in which it does present it. And it is true if the subject can be presented that way, though it may be false or flat if presented in a different form.

The "form of presentation" is of course, in metaphors, one that has what meanings and associations it does have in the cultural frameworks of the times. There may be other times and cultures in which "Men are pigs" might be taken as a metaphor without its being abusive, perhaps because of the current rarity or value of pigs. After all, Juliet as the sun might in Shakespeare's time have meant that she was immaculate, a connotation that would not survive the discovery of sunspots and the demotion of heavenly bodies to plain bodies subject to the laws of mechanics. For these reasons, though they can be translated, metaphors will lose or gain something by translation because of the cultural differences with which the two languages go. There is nothing then deviant about metaphors, any more than there is about quotations, modalities, propositional attitudes, or texts. As there is in the end no difference in deviance when we shift logical attention from the use to the mention of an expression.

It would not, I think, be prudent to press past this point. It would be an agreeable distraction to work out the semantics of the various rhetorical tropes, but this may better be left as an exercise for those who may become enthusiasts—or enemies—of the theory. From my perspective it will have sufficed to have shown that metaphors embody some of the structures I have supposed artworks to have: they do not merely represent subjects, but properties of the mode of representation itself must be a constituent in understanding them. It is, after all, a commonplace that every metaphor is a little poem. By dint of the features we have identified, metaphors are minor works of art.

It might be possible to work our way concentrically outward from the concept of rhetoric, through the concept of expression, to the comprehensive concept of style, if Meyer Shapiro is right that *style* makes reference to "an overall quality which we may call 'expression,'" and if Nelson Goodman is right that expression is metaphorical exemplification. For then metaphor will be what the three concepts

have as a common core, and in having come to terms with it, we will have become clear on the concept of art itself, in the analysis of which, after all, rhetoric, style, and expression have played so great a role. But of course these three concepts are not equivalent, nor exhausted by their common element, and something of profit may turn up in exploring the areas in which they do not altogether overlap. No excuse ought to be required for doing this, inasmuch as expression and style have a traditional, if perhaps misapprehended, connection with the philosophy of art. And since expression seems to lie midway between rhetoric and style, I shall address myself first to it, and pursue Nelson Goodman's fascinating suggestion that it may be reduced, as it were, to metaphoric exemplification. For then, having said what we can on the topic of metaphor, the treatment of expression should be quickly done, as nothing much can remain to ponder save the concept of exemplification itself, and that can hardly be a taxing notion to elaborate.

Exemplification is one of the simplest cases of representation, consisting in drawing a sample from a class and then using it to stand for the class from which it is drawn, with whose membership it is almost guaranteed to share whatever properties go to make the class up. Examples so conceived do not give rise to certain questions that the wider sorts of representations do, inasmuch as it must follow from the fact that e is an example of k that k must have members: for otherwise e would not be an example. So each example constitutes a sort of ontological argument in favor of its own designation; and there are no false examples, in consequence, only things falsely believed to be examples. Exemplification can be extended to cover any case in which the vehicle of representation is an instance of what it is supposed to represent: a line represents and is a line; a color a color; a shape a shape; a sound a sound; and movement movement, as in a representational dance or in a motion picture. Indeed, exemplification is pretty much what Plato had in mind by mimesis, his best example of that being the case in which a dramatist uses speech to represent speech, the words coming out of the actor's mouth being the very words the character is being represented as speaking. So amplified, exemplifications compose one main class of representations, the other being those which do allow questions of a correspondent ulterior reality to arise. But these matters to one side, it is enough to analyze exemplicatory representation thus: a exemplicatorily represents b if (i) a and b instantiate the same predicate and (ii) a denotes b (iii) because (i) is true.

The fact that artworks often appear to instantiate some of the same predicates that other things do gives rise to certain problems when the artworks appear to be of the wrong sort to instantiate those predicates.

This has been the case especially when, to cite instances traditionally associated with the concept of expression, the predicate in question comes from the vocabulary of emotion. It has been thought strange that a piece of music or a poem should instantiate the predicate "is sad." Or that it should instantiate the same predicate as the one who remembers a lost love and wasted opportunities: for how can something that lacks a soul be sad? And failing to make sense of this, standard philosophical proposals have been that "The music is sad" is elliptical for some causal claim, either to the effect that the composer expressed his sadness by the music, as the less gifted express theirs by tears and faraway looks, or that the music arouses sadness in the breast of those who hear it. Though very nice theories, these hardly can survive musicological and phenomenological discoveries to the effect that the composer was not sad when he wrote the music and that, though sad itself, the music elicits no great or any melancholy in its auditors. Indeed, a piece of music may elicit sadness, as one may feel sad because it reminds one that one's kindergarten teacher used to play it, without being at all sad: it may be *Country Gardens*. And this is perfectly general. An artist may express his friendship for a man by painting a portrait of that man's favorite dog; the painting is an expression of friendship, but it does not in consequence express friendship. The artist might have expressed that very friendship, for example, by mowing that man's lawn, and the mown lawn would be an expression of friendship in just the way the portrait of the dog would be. But as it is not a work of art, one supposes, *it* hardly can express friendship or anything. For the concept of expression we are after applies only to things that first are representations, and the mown lawn is not that, though in the causal sense it is an expression in the same sense in which the portrait of the dog is. So if the latter expresses friendship, it must do so for some reason other than its causal provenance. But this would be true equally of sad music if it should express the composer's sadness in lieu of but in the same way that tears would. To just the degree that they admit the same sort of explanation, each is an expression, but there had better be something else to the music beyond this fact or we shall have to wonder why tears are not works of art in their own right. Beyond that we recognize music as sad, we recognize most expressive properties of artworks, without necessarily knowing anything much about the artist, and there is nothing to withdraw in our characterization of the work which in any way depends upon having that lacked knowledge. But this leaves us back with the problem of whence the sadness of the music, and how it can instantiate "is sad" in the way a person does. It would certainly be useful to know the answer to this, all the more so if, once we had the answer, we

could say that the music *exemplifies* sadness. Then, by the analysis just given, it would denote the class of sad things, and since denotation is a mode of representation, music would be representational to the degree that it was *expressive*. And as the representational character of music has been much disputed, while the expressivity of music has been widely accepted, it would be agreeable to demonstrate the inconsistency of these two attitudes. Much turns on the question, then, of how exemplification is to be construed, and Goodman's theory, that it is to be construed as a metaphor—that a painting exemplifies "is sad" metaphorically—is a genuinely interesting theory. I shall explore it briefly.

It would be unfortunate to conclude that expressive predicates are never literally true of works of art. Every statue has weight, every painting has space; but not every statue expresses weight nor every painting space, though some of each certainly do. The inference from "metaphorically exemplified" to "not literally exemplified" is no more a warranted one than its parallel from "metaphorically true" to "literally false." Here, I think, the bad inference is encouraged by the narrow fixation of philosophers on those expressive predicates which seem on their surfaces to be almost categorically false of statues and paintings, inasmuch as the predicates themselves are drawn from our psychological vocabulary, and vesting paintings with these is an instance of the pathetic fallacy. Nevertheless, even in the case of individuals of whom or which the predications are *not* categorically false, the inference itself is bad. An actor, a performer of music, may express sadness—or express happiness (perhaps because the director or the notation instructed him so) and be in fact literally sad or happy without its being his sadness or happiness he expresses, for he could express these things in the required ways despite what his inner state at the time might be. But the important thing is that emotional predicates do not exhaust the range of expressive predicates, and it would be extraordinary to suppose that anything like the causal theses that go with emotional predicates, when used also as expressive predicates, could remotely be true for other expressive predicates. When a painting expresses weight, it is not caused to do so by its *own* weight. And yet it may literally exemplify what it also metaphorically exemplifies. The cathedral of Beauvais is (happily) a vertical structure. But in some deep way, to be explained in part through the proportion between the distance separating the piers to the height of the vault that springs from them, the cathedral also expresses verticality. And indeed the verticality of Beauvais, taken expressively, is a metaphor. Taken literally it is one of the facts of life for architectural structures, to be accounted for in terms merely of gravity, friction, stress and strain, and the like.

It is possible to class such predicates as "is sad" among the artistic predicates, the logic of which was sketched a chapter back, and in truth there is perhaps no predicate in the language that may not on occasion be pressed into such a use. There are nevertheless at least two arguments that count against this assimilation. The first may be brought forward through consideration of a more perspicuous example: a painting may *express* power without being a powerful painting in the straightforward artistic sense. A drawing may express swiftness without being a swift drawing (which when true need not entail that it was swiftly drawn). And these examples could be indefinitely extended: a work may after all express whatever it does express poorly or ineptly or obscurely, while the artistic predicates do not admit these modulations. The second argument is that artistic predicates imply evaluations, so that it is a bit of praise to describe a painting as powerful. But that is not in the same logical sense true of expressive predicates. One may say that the cathedral of Beauvais expresses verticality, leaving it a question to be asked whether this is good or bad. But apart from all this, my claim would be that calling a painting powerful is making a literal application of an artworld predicate, while saying that it expresses power is to make, if Goodman is right, a metaphorical use of an ordinary predicate. Someone who praises Beauvais for its verticality, or uses "verticality" to praise it, is of course not praising it for standing erect. But using verticality as an artworld predicate—some buildings exemplify it, some do not—leaves open the question of whether Beauvais expresses verticality, which may be one with asking whether its artworld verticality carries a metaphoric connotation. Here we may have begun to broach the conceptual boundaries of style, all the more so if there is truth to Meyer Shapiro's suggestion that the study of style involves the correlation of form and expression. Perhaps indeed we cannot avoid broaching this boundary since we cannot readily separate what a work expresses from how it does so.

This may yield a third argument, and perhaps the best argument we can get, against assimilation of the expressive to the artistic vocabulary: it is that the artistic predicates themselves enter in as part of the explanation of the expression. "Diagrammatic" is an artistic predicate as applied to Lichtenstein, but a literal one as applied to Loran, but the diagrammicity of the former enters into any account of the metaphor in which its expression consists. So, returning to Beauvais, its great verticality may be felt as an artistic property. But perhaps it is felt as an expressive property only when grasped as a metaphor for the ascent of the soul. Of course this may be understood without being felt, and conversely. Whether this would be accepted by Goodman is doubtless in

question. I have transformed insidiously the suggestion of metaphorical exemplification into the thought that what a work expresses is what it is a metaphor for—but it is to his great credit that he has sought to de-psychologize the entire concept of expression by reducing it to two essentially semantical notions, exemplification and instantiation. Rather than square accounts with another writer, let us return to our key example and work out our theory by it.

The metaphoric interchange of the *Portrait of Madame Cezanne* with a diagram of itself serves, I have argued, to make explicit what the painting expresses about what it shows. In order then to grasp what is expressed, we should have to seek the metaphor at the heart of Cezanne's painting itself, which may be said to use his wife as a motif, as if she were a mountain, or a Provençal *mas*, or an apple, an object for pictorial exploration, even *she*, who induced such crosstides of passion in this violent, emotional man. Lichtenstein's study is a cartoon of this attitude, but the painting itself might express, in a partially self-referential way: this is how objects, even objects of love, should be painted. It is as if one were born with eyes but no feelings. Giacometti once told me that he tried to depict the world as it would appear in a purely visual way, say to someone who had been born without hands, who had no sense of touch. The painting may not, probably does not (save by benefit of a theory), express Cezanne's feelings toward the subject of the work; those do not enter into it, except in the oblique way I have suggested. The painting gives us a way of showing and may be taken as a metaphor for painting as well as an instance (this would be a marvelous example of something literally exemplifying what it also metaphorically exemplifies).

Madame Cezanne as Motif (as we might thus title the celebrated portrait) may be interestingly compared with the great portrait by Rembrandt of Hendrijke Stoeffels as Bathsheba, for Rembrandt stood to this woman in a way not markedly different from that in which Cezanne stood to his wife. I assume that the subject of the painting is Hendrijke-as-Bathsheba rather than Bathsheba as such, for whom Hendrijke happened to be used as model, and that there is accordingly already a metaphoric structure at the heart of this representation. Regarding the work, Kenneth Clark has written: "One looks at the unflinching modelling of her round, solid body, which is seen with such love that it becomes beautiful" (*Rembrandt: An Introduction*, p. 101). That we are dealing with a work of art and with nothing else must be immediately clear to the reader who tries to think of what *except* a work of art such a statement can meaningfully be made. If I am right— if nothing but a work of art can satisfy this description—we ought to be

able to learn something about art and the languages of art by examining it closely. "Unflinchingly modelled" implies that there is something in the body depicted before which a painter might flinch. We flinch only at truth which it is hard to accept. There would be nothing the portraitist of Brigitte Bardot in the prime of her great beauty need flinch from, unless we attribute certain perversities to him. So however we might describe his modeling of her, "unflinchingly" would not be an appropriate qualification. But neither is there anything to flinch or not to flinch at in the portrayal of a subject undertaken dispassionately and disinterestedly, as with Madame Cezanne, say, treated as a complex geometric surface. So just the logical applicability of such an adverb as "unflinchingly" in the one case, and its logical inapplicability in the other, almost by itself suffices to show how differently these two artists were as artists, viewing those two women. Rembrandt had to have been seeing her as a man sees a woman. He depicted a great many things—flayed carcasses, cadavers, old and sick and blind persons, objects of pity— from which sensitive persons, those not separated by a kind of distance from these things, such as butchers or anatomists or geriatricians or Buddhists, might flinch. That he depicts each of these things unflinchingly is a mark of his deep humanity and his catholic compassion as a man. It is almost as if he chose things he had to depict unflinchingly to express this compassion and this humanity. The carcasses are not depicted the way a butcher would depict them or want them depicted, nor his cadavers the way anatomists could learn much from; he is painting anatomy lessons, but the paintings are not themselves anatomy lessons. In the case of Hendrijke, what there is to flinch from are the signs of age and use in her body. A man could paint a middle-aged woman in a humiliating way—but not unflinchingly (the photographs of Diane Arbus are in this sense unflinching), just because a man bent upon humiliation is not a man to flinch: he paints those folds and wrinkles and those fallen breasts in order to make her look like an old bag, he gives them prominence. But Rembrandt does not give them prominence, he simply leaves them there because they are part of the woman he loves. And *that woman*, with just those marks of life upon her, *is* Bathsheba, a woman of beauty enough to tempt a king to murder for the possession of her. And that is the metaphor of the work: to show that plain dumpy Amsterdam woman as the apple of a king's eye *has to be an expression of love*, just as a depiction of a plain dumpy Amsterdam woman as a plain dumpy Amsterdam woman pretty nearly has to be an example of contempt (why not leave her alone?). The case is exactly comparable with showing a cadaver as Christ, by showing that cadaver in the position in which Mantegna showed Christ in such a

strong way that henceforward anyone who painted a figure in that way had to be viewed in Mantegnesque perspective. So the painting must express the boundlessness of grace and the truth of redemption and the power of divine love. We know as an independent fact about his life that Rembrandt loved Hendrijke, and we know as an independent fact of Cezanne's life that he had a Provençal passion for his wife. But what these paintings respectively express has nothing to do with this knowledge. Hendrijke is shown as flesh, Madame Cezanne is certainly not. She is shown as something to which the predicates of age and youth have no application, and there is in the way she is shown no way in which we can speak of her character or inner life or cast of mind.

Consider her in the context of another motif of Cezanne's: the series of cardplayers. It is a curious subject for a geometrizing eye. Cardplaying is an exciting activity, it often involves serious stakes, it can be played with skill, it can be played dishonestly. The gaming table is a metaphor for a kind of life, the turned card a moment of truth. Saint Matthew is shown with cardsharks in Caravaggio's painting. Jan Steen shows cardplayers raking hell, with a free hand grasping a tankard or a breast while the other one slams a trump. His cardplayers are dissolute and merry. But the cardplayers of Cezanne are none of these: they are like eggplants in their cloaks and under their melon hats; they are devoid of any psychological interest, they have no interiors, the paintings cannot be "rich explorations of the human character." By contrast with them Mont Sainte-Victoire is almost alive. Cezanne we know to have used waxfruit for his still lives; it would be consistent with the way he painted that he should have used dummies for his cardplayers. It is no accident that Roger Fry, for whom Cezanne was the paradigm artist, should have taken this absense of psychological content as a positive trait of painting as pure. So he cannot help lamenting the fact that Rembrandt's paintings are polluted by psychology, even suggesting that Rembrandt would have been a better painter had he reserved his psychological preoccupations for novels and kept his paintings pure. But my claim is that these are simply differences in metaphors and that Cezanne's paintings are no less expressive than Rembrandt's.

Much the same connection between form and content—much the same matter of style—may be found in novels as well. Hemingway's characters are like Cezanne's cardplayers, simple and geometrical, and they hardly can be otherwise, given the simple declarative sentences by which they are described. Proust, by contrast, employs sentences that have a length and inflectedness, counterposed qualifications, thoroughly consistent with his effort to show characters with nuanced, subtle, involuted, and often neurotic interiors, where each gesture is freighted

with meaning (the dialogue of the narrator's sisters, who seek to pay an oblique compliment to Swann, is a metonymy of the Proustian style). Try writing about Proustian jealousy with Hemingway sentences. Or think of James, whose dense and gelatinous prose is perfectly suited to exemplify what he is interested in, the field of feelings, in which the individual characters are more or less points of condensation. He identifies this perfectly in *The Awkward Age* when he writes, "The unanimous occupants of Lady Brookingham's drawing room were almost more concerned for each other's vibrations than for anything else." All James's characters communicate by means of vibrations, and the prose shows this; try to think of this being done with Rabelaisian syntax or Johnsonian symmetries or Shakespearean fustian. But there is nothing to be gained by further elaboration of examples. The philosophical point is that the concept of expression can be reduced to the concept of metaphor, when the *way* in which something is represented is taken in connection with the subject represented.

The term *style* derives etymologically from the Latin term *stilus*—a pointed instrument for writing—its specific inscriptional use redeeming it from its near of kin *stimulus* (point, goad) and *instigare* (to goad or prick). Indeed the overtones that its shape and its less exalted functions connote have occasioned a certain sexual hilarity on the part of the arch, naughty, grammatological fantasists of the moment. Nevertheless, it is as an instrument of representation that the *stilus* has an interest for us and, beyond that, its interesting property of depositing something of its own character on the surfaces it scores. I am referring to the palpable qualities of differing lines made with differing orders of stiluses: the toothed quality of pencil against paper, the granular quality of crayon against stone, the furred line thrown up as the drypoint needle leaves its wake of metal shavings, the variegated lines left by brushes, the churned lines made by sticks through viscous pigment, the cast lines made by paint dripped violently off the end of another stick. It is as if, in addition to representing whatever it does represent, the instrument of representation imparts and impresses something of its own character in the act of representing it, so that in addition to knowing what it is of, the practiced eye will know how it was done.

We may thus reserve the term style for this *how*, as what remains of a representation when we subtract its content—an algorith licensed by the contrast between style and substance enshrined in usage. In actual execution, I should think, it is difficult to separate style from substance, since they arise together in a single impulse. The Chinese, for whom the

brush did not leave the paper until a form was executed, necessarily re-
stricted themselves to forms that allowed this virtuosity of execution:
fish, leaves, bamboo segments, and the like. It would be a misspent vir-
tuosity which executed a Last Judgment or a Massacre of the Innocents
in a single stroke—a perversion—and when such subjects are chosen, a
different stilus and a different style are mandated. With the Chinese,
substance would be an occasion for stylistic bravura, but this is a matter
of focus. The point is that the same substance may be variously stylisti-
cally embodied, and synonomous vehicles may have marked stylistic
differences. On the other hand, within a single stylistic tradition, the
stilus, broadly speaking, will deposit not only its own character but the
character of the hand that drives it, and style may then become a mat-
ter of autography, Rembrandt's line becoming his signature. After the
first *Pietà*, Michelangelo never signed another work, there being no
need, since the work was what his hand alone could do. But then we are
led naturally to Buffon's profound observation that style is the man
himself: it is the way he represents the world, minus the world, and
taking man, portentously, as the enfleshment of the word. But now we
have broadened the concept, making a metonymy of the stilus.

Of the three concepts I have been elaborating, rhetoric concerns the
relationship between representation and audience, and style the rela-
tionship between representation and the one who makes the represen-
tation; in both cases, as indeed in the case of expression, the qualities of
the representation do not penetrate the content. With those qualities
referred to as style, the artist, in addition to representing the world, ex-
presses himself, himself in relation to the content of the representation
when, realistically, we recognize that only in an act of ruthless but nec-
essary abstraction can we sunder style from substance. It is in any case
this relationship I wish to anatomize, and we can make a good begin-
ning by pondering the case of Ion the Rhapsodist, and, in our own style,
turn from rhapsody to logic.

Ion is an interpretative artist, with a singular gift for reciting Homer.
It is singular both in being outstanding and in being exclusive, for Ion is
unable to recite the other poets with equal power and conviction, a fact
which puzzles Ion (who is not bright). He might perhaps bear compari-
son with a pianist remarkable for her interpretations of Bach, but who
has no particular powers for interpreting Fauré or, let us say, Alban
Berg. Socrates says that the explanation is that Ion lacks "knowledge or
art" though he is, in compensation, inspired, literally possessed, by
some external power, communicated to and through him in a way simi-
lar to that in which, to use his famous illustration, a lodestone transfers
its power to and through an iron ring. And indeed Ion does have the

power of a great orator almost to magnetize his audience. It is this upon which his income depends, and I suppose he wishes he could, for crass reasons, do it for any poet at all, in the way an actor gifted for comedy would like to be able to play Hamlet or Lear and wonders why he cannot. But it is just this inability to generalize the skills that Socrates means by lacking knowledge or art.

And surely something like this generalizability *is* a mark of "knowledge or art." A child will sometimes say that she can read a certain book, but not any others. But of course she cannot really then read; she has probably had a book read to her so often that she has memorized a text that she may recite with it before her, not perhaps realizing that, however much this resembles the way reading looks from outside, it is not reading at all. To be able to read is to be able to read each and every text in the language, though of course not with the same degree of comprehension—but comprehension calls upon knowledge other than that of reading. Someone, again, may be able to pick out a certain tune on the piano, but to be able to play the piano is to be able to play anything at all on the piano, though once more with the obvious limitations on dexterity and depth. And something like this will again be true of drawing: to be able to draw at all is to be able to draw anything drawable, though one's lions will not look like Delacroix's nor one's nudes like those of Boucher. In this sense, though, Ion does have knowledge or art: he can recite whatever is recitable; his complaint is that he cannot recite it all at the same high level at which he recites Homer. And the question is whether there could indeed be knowledge or art, comparable to reading, playing, drawing, or reciting, whereby one could perform everything at the highest possible level. Is what separates Ion's performance here from the rest of his performances and the performances of Homer by other rhapsodes something that could be closed by knowledge or art? If there were, then Ion could learn it, or we could learn it and do as well as Ion. Knowledge or art is the very opposite of what one might speak of as a *gift*, where a gift is something that logically has to be given, for if it were acquired in any other way it would not be—a gift. And of course Socrates is not denying that there are gifts in this sense. His question, put this way, is whether what is *de facto* a gift, a certain power of execution, is logically foredoomed to be a gift—whether the same power of execution could not be acquired, through teaching and learning, once we had the knowledge. Then we would not be dependent on the inegalities of nature. Anyone prepared to undergo the appropriate education could be a Rubinstein or a Bernhardt—or an Ion—with the difference that he not only would be able to do the thing in question, but would do it as an exercise of knowledge

and not be dependent upon some forces outside himself, as poor Ion evidently is. "Knowledge or art" implies a kind of radical egalitarianism, an overcoming of the unfairnesses of what Kant speaks of as "the niggardliness of a stepmotherly nature." We might choose our artists and poets by lot, if only the knowledge were available.

It is not difficult to sympathize with Socrates' posture here. Apart from the sly thrust at poets, regarded as moral teachers in his culture, now shown to lack knowledge or art at just the point at which their excellence as poets is to be located, and who must be curious teachers inasmuch as they lack knowledge exactly there: what then qualified them to teach? Why not persons with extremely long noses, that being a kind of gift too? But Socrates had been through serious polemics against the entire idea of moral authorities or specialists. In the *Euthyphro* he asks, good being defined as what the gods admire, whether it is good because they admire it or they admire it because it is good. If the former, what possible authority could the gods have except where we all are authorities, namely on the matter of what things we admire? And if the latter, we might then suppose it is a matter of art or knowledge, admittedly a knowledge the gods might have and we lack, but one that in principle we could acquire and then be as good judges of what is good as the gods are. Either way, we could dispense ultimately with the gods for moral guidance. And again in the *Republic*, he tried to show that justice was not exactly something there could be specialists in (for when exactly would we then use a just man?). So it was central to Socratic thinking that whatever could be known could be known to anyone, in principle, so if it could not be known by anyone in principle, it could not be knowledge. Well, perhaps what Ion had was not knowledge. Perhaps it was an ineluctable gift. Nevertheless, there is a profound difference, supposing it was in principle knowledge, between Ion's relationship to his performances and the relationship to outwardly similar performances on the part of someone for whom it *was* knowledge. It is in the difference between these two relationships that I would want to ground the difference, say, between style and manner. A style is a gift; a manner can be learned, though from the outside there may be no particular difference to be observed.

I have elsewhere explored in some depth a distinction between basic actions and nonbasic ones, and between basic and nonbasic cognitions. The difference itself is crudely this. A cognition is nonbasic if the person who knows something knows it through something else that he knows. And an action is nonbasic if, when the person in question does *a*, there is something else, distinct from *a*, which he does and through the doing of which *a* is done. Then basic cognitions and basic actions are

defined through the absence of the mediating cognition and action. It is exceedingly difficult to say whether whatever is in fact done basically could have been done nonbasically, and conversely; and similarly with cognitions. Galileo argued that we could know whatever can be known, say by God, but whereas God knows whatever he does know immediately and intuitively, we have to proceed in most cases by inference. So might God know the temperature of the distant planets as we know that we are in pain. Still, though it takes work and the mediation of instruments, we can know what God himself knows. Such was Galileo's cognitive faith. But so whatever God does he must do directly: all his actions must be basic actions. However, we can perhaps, by an analogous practical faith, do whatever God does, providing we acquire the requisite technology. That we can both know and do whatever can be known or done in principle is perhaps close to what Socrates would have had in mind by knowledge or art. Ion does what he does without knowledge or art; it is a kind of basic performance in that regard. Still, it does not follow that what he does could not have been done nonbasically, providing that art or knowledge were there to mediate. Then the sort of relationship I have in mind in speaking of style is what is done without the mediation of art or knowledge. That is what one might mean by saying that style is the man himself. It is the way he is made, as it were, without the benefit of having acquired something else. But we do draw an invidious distinction between style, so construed, and manner, which would be a nonbasic performance. And it is unquestionably worth concluding this essay by asking why. I believe that something of deep human importance resides in the answer, but I also suspect that something like the difference between what is art and what is not may reside here as well.

W e have grown used to the possibility of two objects outwardly indiscernible, one of them an artwork and the other not. It would be fascinating if the differences, which we have supposed to lie in the mode of production of these two objects, were finally a difference between the one's being basic and the other done through the mediation of "knowledge or art." Of course there is no art without knowledge, without skill, without training. Art is something in connection with which the possibility of being a master is an analytical component. Only when one can draw or play do questions of style arise, or do those qualities we identify as matters of style come to importance. The question of their being such is what I have in mind when I make reference to basic and nonbasic executions, for I believe that a master of drawing

can draw in Rembrandt's *style*—that whatever Rembrandt could do might as a matter of knowledge or art in principle be mastered by another, and that he might therefore draw that way exactly as a matter of knowledge or art. And so with any set of qualities of a performance or representation. Whether these are matters of style, hence of *l'homme même*, depends upon whether they were put there as a matter of knowledge or art. And the question before us is what difference their being put there that way or not makes in the judgment of the object, in its being an imitation, or in the style of, or whatever. That the question has some importance may be seen from the fact that analogous questions have importance in the sphere of moral judgment.

It is Aristotle who makes the fine distinction between doing temperate things and being a temperate person, arguing that an action has a truly moral quality when it issues from a person's character and does not merely satisfy the criteria of temperance. So one is not a temperate person, for example, when one works from a list of things temperate people do, and then does them because they are on the list. The very use of a list puts a distance between oneself and the quality to which one aspires; the having of the list is inconsistent with being that sort of person. And the same thing may be said for a variety of moral qualities: kindness, tact, or considerateness are cases in which it is inconsistent with being kind, tactful, or considerate to do kind things because they are on a list. It is not merely that there is this entailment to the nonmediation of a list; it is that there can be no exhaustive list, no finite set of actions such that each and every kind action is on the list and what is not on the list is not kind. To be kind is to be creative, to be able in novel situations to do what everyone will recognize as a kind thing. A moral person is an intuitive person, able to make the right judgments and perform the appropriate actions in situations in which he or she has perhaps never been before. Moral competence is almost like linguistic competence, in the sense that the mark of the latter is the ability to produce and to understand novel sentences in the language. And no more than having linguistic competence can consist in having mastered a list of the sentences in a language can morality consist in mastering a list of the right things to do. In the *Republic*, Socrates sees, regarding the little urgencies of daily life, "Small wisdom in legislating about such matters, nor are there any precise written enactments about them likely to be lasting." One teaches through examples, but in the end one does this in order to direct the development of judgment, which is to carry its possessor through unstructured moral and legal spaces. "Examples are thus the go-cart of the understanding," Kant writes—and the distinction be-

tween acting from and merely acting in conformity with principles is the cornerstone of his moral system—and he adds, in a wry footnote to *The Critique of Pure Reason:*

Deficiency in judgment is just what is ordinarily called stupidity, and for such a failing there is no remedy. An obtuse or narrow-minded person to whom nothing is wanting save a proper degree of understanding . . . may indeed be trained through study, even to the extent of becoming learned. But as such people are commonly still lacking in judgment . . . it is not unusual to meet learned men who in their application of their scientific knowledge betray that original want, which can never be made good. (Smith edition, p. 178)

This concept of judgment has something in common with what Kant would call the faculty of taste. For taste does not consist, say, simply in arranging things in a tasteful way, for one may have simply mastered a set of rules, a recipe of sorts, which yields what happens to be a tasteful arrangement without the arranger's having taste at all. And indeed the mediation of a recipe of that sort is precisely what makes the action not an exercise of taste, but rather is evidence for its lack. It has been said of certain peoples that, though there is a remarkable national taste, the taste itself is deeply ritualized and in such a way that, in situations deviating significantly from what they have been taught, they have no aesthetic discrimination. So, like judgment in Kant and like wit, taste is again something for which there can be no knowledge or art. There can perhaps be a knowledge or art which will assure that whatever is executed in conformity with it will *be* in good taste—in the sense of being found to be in good taste by someone with good taste. But the knowledge or art in question is quite inconsistent with the person having taste who arranged it, if he used the knowledge or art.

And something, finally, like this is true of the fine arts as well. Bach was accused of having a secret fugue-writing machine, something that ground fugues out like sausages. Of course there would in one sense be no point in patenting such a machine. It would be like the goose who laid the golden egg, in that now anyone could turn out all the fugues he wanted to. That would be true but essentially uninteresting. What would be interesting is not some proof that such a machine did not or could not exist, but that if it did exist, the person who used it would stand in a very different relationship to the generated fugues from Bach's, and the mechanical fugues would be *logically styleless* because of the failure of that relationship defined exactly by the absense of mediational devices—rules, lists, codes—which the fugue-writing machine would exemplify. Anyone could make a painted tie like the one Picasso

made, but it would have no style, however exactly it resembled Picasso's. And Picasso once slyly told Kahnweiler that he now was a rich man because he had sold his license for painting guitars.

There is one recipe that brings out precisely the point I wish to make: to replicate, exactly, a given work. Let the work have what style it does have. Its replication will be logically styleless—it will perhaps *show* but not *have* a style—just because of the formula used to generate it. Of course it is possible for two things exactly to resemble one another and have the same style. David Pears told me that J. L. Austin improvised his lectures, but they came out the same each time—which is a far cry from repeating oneself. The artist Ad Reinhardt produced black square paintings that were very much alike but, as they came from the same impulse, they were not duplicates of one another and each stood in the same relationship to the artist himself. So with Morandi, whose paintings of bottles look, or could be imagined to look, exactly alike; each comes out of the same artistic source, and interresemblance leaves their style intact. We might contrast it with Chagall, who perhaps had a style but now has a manner, and whom we often accuse of self-plagiarization, at best of repeating himself—though his paintings might resemble one another less than those of Morandi or Reinhardt do. The question, then, is why repetition of this sort is considered so damaging to the status of an artist and of a work, so damaging, indeed, as to rob the work of style.

I want indeed to return to the intuition that style is the man, that while there may be various external and transient properties of a person, style at least comprises those of his qualities which are essentially his. Thus there would be a contrast between style and fashion, fashion being by definition transient and ephemeral, as there is between style and manner, manner being what appears to be style but is in fact separated from the man himself by a gap it is the function of knowledge or art to bridge. So when someone paints in the style of Rembrandt, *he* has adopted a manner, and to at least that degree he is not immanent in the painting in the way Rembrandt is. The language of immanence is made licit by the identity of the man himself and his style—he is his style—and by transitivity of identity Rembrandt *is* his paintings considered in the perspective of style. I want to begin the exploration of these notions, and I shall be ruthlessly speculative as I do so, for the argumentation I require here belongs to another topic, and I can only allude to it now.

What, really, is "the man himself"? I have argued a theory to the effect that we are systems of representations, ways of seeing the world, representations incarnate. Obviously, any such theory, however philo-

sophically interesting, is in the end empirical, but the *sorts* of conceptual evidence I have relied on, are certain phenomena in the domain of intensionality. Thus I have argued that for such characteristically psychological sentences as *"m* believes that *s"* to be true, *m* must be in a sentential state which the sentence *s* pictures, and the belief is true if the sentential state pictured by *s* is true. Two sorts of evidence are available in support of a theory of sentential states. The first comes from psycholinguistics, where it has been argued that there must be a language of thought if certain elementary human competences are to be understood; thoughts must have the structures of sentences if anything like reasoning is to occur, as there must be if there is to be such a thing as justified belief and hence knowledge, or justified conduct, and hence action; states of mind must relate to one another causally and logically at once. The other evidence comes from Freud. Certain chains of association of the sort we find described in the *Psychopathology of Everyday Life* go through on the basis of puns and phonological resemblances; certain dreams are punning transformations of unconscious thoughts. But these puns are available only if in fact thoughts have not merely words as their components, but the same acoustical imagery spoken words themselves have. There are, of course, visual puns that operate in Freud as well. But my theory in any case is that we are representational systems, no matter whether these are systems of words or pictures or, more likely, both. My view, in brief, is an expansion of the Peircian thesis that "the man is the sum total of his language, because man is a sign." With the Freudian phenomena particularly, we are forcibly brought up against certain properties of representations beyond the representational properties themselves: it is not merely what a man represents, but is the way in which he represents it, which has to be invoked to explain the structures of his mind. This way of representing whatever he does represent is what I have in mind by style. If a man is a system of representations, his style is the style of these. The style of a man is, to use the beautiful thought of Schopenhauer, "the physiognomy of the soul." And in art particularly, it is this external physiognomy of an inner system of representation that I wish to claim style refers to. Of course we speak as well of the style of a period or a culture, but this will refer us ultimately to shared representational modes which define what it is to belong to a period. The conceptual structures of periods and persons are, I proposed above, sufficiently similar that we may speak of a period as having an inside and an outside, a kind of surface available to the historian and a kind of inwardness belonging to those who live the period in question, which is pretty much like the inward and outward aspects of the human personality. But I am restricting

myself largely to the individual case, leaving for another occasion the problem of justifying and elaborating on these analogies.

Now if anything like this concept of style has merit, we can connect it to the kind of relationships entailing the absence of a mediating knowledge or art discussed before. Once more, the analogies may be forced and the theory speculative in the extreme. But go back, even so, to the concept of belief. When a person believes that *s*, he believes that *s* is true. This would be reflected in linguistic practice through the fact that people do not ordinarily say they believe that *s*; they simply act as though *s* were true, and hence as though the world were that way. Thus we refer through our practices to the world rather than to our beliefs, and feel as though it is reality itself we are describing rather than ourselves we are confessing. In any case, there is a well-known asymmetry between the avowal and the ascription of belief that such an analysis might support. I cannot say without contradiction that I believe that *s* but *s* is false, but I can say of another person that he believes that *s* but it is false. When I refer to another man's beliefs I am referring to him, whereas he, when expressing his beliefs, is not referring to himself but to the world. The beliefs in question are transparent to the believer; he reads the world through them without reading them. But his beliefs are opaque to others: they do not read the world through those beliefs; they, as it were, read the beliefs. My beliefs in this respect are invisible to me until something makes them visible and I can see them from the outside. And this usually happens when the belief itself fails to fit the way the world is, and accident has forced me from my wont objects back onto myself. Thus the structure of my beliefs is something like the structure of consciousness itself, as viewed by the great phenomenologists, consciousness being a structure that is not an object for itself in the way in which the things of the world are objects for it. In the sense in which consciousness is of objects, it is not of itself, or is of itself in a different sense of "of"—punctuationally acknowledged by Sartre in his discussions as *conscience de soi*, in contrast with *conscience de x, x* being an object.

In other words, I do not, as a consciousness, view myself from without. I am an object for others but not for myself, and when I am an object for myself, I have already gone beyond that; when it is made visible it is no longer me, at least from within. But I should think this largely true for representations that I embody: I represent the world, not my representations of the world. Thus, reverting to Schopenhauer's use of physiognomy, my face is visible to others but not to myself, and I have no internal assurance that the face I see in the mirror is my own. It takes a major effort to rise to a kind of consciousness of my representa-

tions, and it requires a complex act of identification to accept those representations as mine. It is, I suppose, the complexity of this identification which makes psychoanalysis so complex philosophically.

Whatever the case, it seems to me that what we mean by style are those qualities of representations which are the man himself, seen from the outside, physiognomically. And the reason that there cannot be knowledge or art for style, though there can be for manner, is that the outward aspects of representations are not commonly given to the man whose representations they are: he views the world through them, but not them. The qualities of his representations are for others to see, not him, and the presence of knowledge or art exactly presupposes that externalization which is inconsistent with them being his style. Thus to be his style they have to be expressed immediately and spontaneously. And something of the same sort is true for the historical period considered as an entity. It is a period solely from the perspective of the historian, who sees it from without; for those who lived in the period it would just be the way life was lived. And asked, afterwards, what it was like to have lived then, they may answer from the outside, from the historian's perspective. From the inside there is no answer to be given; it was simply the way things were. So when the members of a period can give an answer in terms satisfactory to the historian, the period will have exposed its outward surface and in a sense be over, as a period.

What, then, is interesting and essential in art is the spontaneous ability the artist has of enabling us to see his way of seeing the world—not just the world as if the painting were like a window, but the world as given by him. In the end we do not simply see that naked woman sitting on a rock, as voyeurs stealing a glimpse through an aperture. We see her as she is seen with love by virtue of a representation magically embedded in the work. We do not see her as Rembrandt saw her, for he just saw her with love. The greatness of the work is the greatness of the representation the work makes material. If style is the man, greatness of style is greatness of person.

The structure of a style is like the structure of a personality. And learning to recognize a style is not a simple taxonomic exercise. Learning to recognize a style is like learning to recognize a person's touch or his character. In attributing a work to a person, we are doing something as complex as attributing an act to a person when we are uncertain of his authorship. We have to ask whether it would have been consistent with his character, as we have to ask whether it would have been consistent with his corpus. This concept of consistency has little to do with formal consistency. It is the consistency rather of the sort we invoke when we say that a rug does not fit with the other furnishings of the

room, or a dish does not fit with the structure of a meal, or a man does not fit with his own crowd. It is the fit of taste which is involved, and this cannot be reduced to formula. It is an activity governed by reasons, no doubt, but reasons that will be persuasive only to someone who has judgment or taste already.

The Brillo Box seems at first to enter the artworld with the same tonic incongruity the *commedia dell'arte* figures bring to Ariadne's island in Strauss's opera. It appears to make a revolutionary and ludicrous demand, not to overturn the society of artworks so much as to be enfranchised in it, claiming equality of place with sublime objects. For a dizzy moment we suppose the artworld must be debased by allowing the claim; that so base and *lumpen* an object should be enhanced by admission to the artworld seems out of the question. But then we recognize that we have confused the artwork—"Brillo Box"—with its vulgar counterpart in commercial reality. The work vindicates its claim to be art by propounding a brash metaphor: the brillo-box-as-work-of-art. And in the end this transfiguration of a commonplace object transforms nothing in the artworld. It only brings to consciousness the structures of art which, to be sure, required a certain historical development before that metaphor was possible. The moment it was possible, something like the Brillo Box was inevitable and pointless. It was inevitable because the gesture had to be made, whether with this object or some other. It was pointless because, once it could be made, there was no reason to make it.

But I am speaking as a philosopher, construing the gesture as a philosophical act. As a work of art, the Brillo Box does more than insist that it is a brillo box under surprising metaphoric attributes. It does what works of art have always done—externalizing a way of viewing the world, expressing the interior of a cultural period, offering itself as a mirror to catch the conscience of our kings.

Index

aboutness, 52, 68, 69, 79, 81, 85, 139
Abstract Expressionism, 50, 107
action theory, 4–6, 200
aesthetic predicates, 92, 95–96, 193
aesthetic properties, 153–160
aesthetic responses, 91, 94–95
aesthetic sense, 95–98, 100, 105–106, 113
ambiguity, 179
Anscombe, G.E.M., 4
appearance, 19, 21
appreciation, 91–93, 97
Arakawa, 88–89
Arbus, Diane, 22, 195
Aristotle, 13–15, 27, 69, 70, 94, 128, 129, 151, 152, 202; his *Rhetroic*, 161–178
arrayed examples, 101, 105
artistic theories, 135
artworks, and things, 1–5, 48
artworld, 5, 45, 135
Auden, W. H., 117, 118, 120
Austin, J. L., 80–81, 204

barbarian taste, 105–106
Baroque, 167
basic actions, 5, 48, 200
basic cognitions, 200
Beardsley, Monroe, 153
beauty, 105, 153–154, 157, 173
Berkeley, George Bishop, 81, 125, 151–152, 157, 160
Bonnard, Pierre, 87, 123
Borges, Jorge, 33–36, 37
Breugel, Pieter, the Elder, 115, 116–119, 120, 124
Brillo Box, 44, 208
brushstrokes, 50; Lichtenstein's treatment of, 107–111; in Chinese art, 198–199
Buddhism, 133–134
Buffon, 198

Caillebotte, Gustave, 70, 129
Canaletto, 164
Caravaggio, 120, 196
Carnap, Rudolph, 183
Carroll, Lewis, 22
Campbell's Soup Can, 142
Capote, Truman, 144
Caws, Mary Ann, 38
Cezanne, Paul, 46, 142–143, 194–196
Chagall, Marc, 39, 204
character, 202
children, who can "do that," 40, 51
Ch'ing Yuan, 134
Clark, Kenneth, 194
Cohen, Ted, 91–93, 95, 104
commercial art, 166
competence, 176, 177
content, 20–21, 49–50, 52, 139, 143–144, 148–149, 151–153, 168, 188
consciousness, 152, 205
conventions, 31–32
Copernican revolutions, 125
corners, 124
Cratylus, 71
Cubism, 143

"deductive structure," in painting, 86
definition of art, 56–57, 58, 61–62, 64, 83, 91, 113, 146–147
Degas, Edgar, 84, 115, 116, 118
De Kooning, Willem, 108
Descartes, René, 49, 54
Desnos, Robert, 38
deviance, 176–179
diagrams, 140–141, 142, 143, 147, 148
Diamond Sutra, 134
Dickens, Charles, 158
Dickie, George, 23, 91–95, 99, 104
Diderot, Dennis, 94
diegysis, 127
Dine, Jim, 39
Disraeli, Benjamin, 47

Dolci, Carlo, 167
dreams, 16–17
drips, 108–109
Duchamp, Marcel, 5, 45, 93–94, 132
Duff, John, 40

edges, 87, 123
emotions, 169, 192
empiricism, 174–175
"empty," as aesthetic predicate, 2, 51,
 52, 53
Ensor, Georges, 117
enthymemes, 169–170
Euripides, 25–28, 29
Euripidean dilemma, 26, 29–31
exemplification, 190
expression, 64–65, 148, 162, 190–197

falseness, 17–18
Fall of Icarus, 115–120
family resemblances, 58–60, 63, 65
fantasies, 15
fashion, 204
fiction, 127, 144
Fire in the Borgo, 117
forgery, 36, 44, 51
Fountain, 5, 94–95
forms of presentation, 198
Fowler, H. W., 170
Frege, Gotlob, 72, 163, 185
Freud, Sigmund, 205
Fried, Michael, 86
Fry, Roger, 196

Gainsborough, Thomas, 172
Galileo, 201
genres, 136–139
Giacometti, Alberto, 117, 194
gifts, 199–200
Giotto, 42–43, 50, 51, 162, 163
Goodman, Nelson, 21–26; on forgery,
 41–44; on representation, 73–74; on
 repleteness, 140–141; on expression,
 189–190, 192, 193
Gould, Elliot, 163–164
Guercino, 23, 24, 87

Hamlet, 9, 11
hardcore painting, 159
Hegel, Georg, 86

Heidegger, Martin, 112, 169
Hemingway, Ernest, 196, 197
Hesse, Eva, 103–104
hieroglyphics, 75–76
Hiroshige, 140
Hochberg, Julian, 74–75
Hogarth, William, 125
Hume, David, 159–160
humor, sense of, 96–97

identification, 126–127, 167
identity of artworks, 33–35
illusion, 151, 158–159
images, 77
imagination, 128–131
imitations, 13–18, 21, 23–26, 65, 68–70,
 71–74, 82–83, 149–151, 160–164
impersonation, 67, 86
impossible pictures, 87–88
Impressionism, 150
indiscernibles, 1–5, 33–39, 90–91, 100,
 120–123, 136–139, 144
Institutional Theory of Art, 5–6, 28–29,
 31, 91, 94, 99, 144
intensionality, 68–70, 179–189
intention, 130
interpretation, 113, 119–126, 131–135
Ion, 198–201

J, 2–3, 28, 29, 31, 32, 45, 51, 53, 144;
 his "Bed," 7–8, 12–13, 18, 133; his
 "La Condition Humaine," 29–31; his
 oriental counterpart, 100; his views
 on interpretation, 131–132; his con-
 test with K and his "First Law,"
 120–124, 129, 130
James, Henry, 197
Johns, Jasper, 83–86
judgment, 203

K, his rivalry with J, 120–124
Kant, Immanuel, 22, 54, 200, 202–203
Keats, John, 34
Kennick, William, 60–61, 62, 63, 64
Kierkegaard, Soren, 1
Kuriloff, Aaron, 132–133

Lamb, Charles, 125
language: and art, 155–160; and reality,
 79–83
language of thought, 205

Laundry Bag, 132–133
Leibniz, Gottfried, 35, 80
Lejeski, Gary, 40
Leonardo, 149–150, 161, 167
Lessing, Gotthold, 153
Lichtenstein, Roy: his paintings of
 brushstrokes, 107–111; his *Portrait of*
 Madame Cezanne, 142–144, 147, 148,
 164, 165, 168, 172, 193, 194
Locke, John, 128, 129
Loran, Erle, 142–143, 147, 148, 165,
 168, 172, 193

M, his literary experiments, 145–146
Macluhan, Marshall, 110
magical representation, 76–77
manner, and style, 200
Mannerism, 117–119
Mantegna, 195
Mashek, Joseph, 159
material counterparts, 101–105, 120
materialism, 160
medium, 146, 151–153, 156, 160
Meiss, Millard, 40, 50
mental attributes, 180–181, 186
metaphor, 148, 156, 167, 171–173,
 174–176, 179, 182, 187–189, 208
Michelangelo, 115–116, 198
Mill, John Stuart, 105
mimesis, 127
mirrors, as metaphors for art, 7–11
mirror images, 69, 71, 173, 206
modal contexts, 180, 184–186
models, 167–168
Monet, Claude, 143
Moore, G. E., 134–135
Morandi, Giorgio, 39, 204
Morris, Robert, 45
Munakata, Shiko, 52–53
music, 138, 152, 192

names, 71, 74
Narcissus, 9–10, 16, 69
narrativity, 137–138
neckties, 39–41
Newman, Barnett, 87
Nietzsche, Friedrich, 8, 21, 25, 28, 54,
 76–77
Nim Chimpsky, 75
nonfiction novels, 144–146

Oldenberg, Claes, 12, 40
olefactory artists, 132, 133
opacity, 188

paint, 133–135
panes, of glass, 149–151, 161, 162
Parahesios, 46
Peirce, Charles, 205
philosophical language, 134–135
philosophy: and art, 54–56, 65–66,
 77–78, 83; what it is, 79–80
Pearlstein, Phillip, 85
performance, 152
periods, 163–164, 205, 207
persons, 163–164, 205, 207
perversions, 98
Picasso, Pablo, 8, 40–47, 116, 124, 204
picturing, 73–74
Pierre Menard, 33–39, 41
Pike, Bishop James, 137
Piranesi, 129
plain man, 131–132, 134, 135
Plato, 7, 11, 15, 18, 19, 20, 23, 27, 33,
 34, 127, 151–153, 190
Pliny, 45
Polish Rider, 31–32, 42, 48
Pollack, Jackson, 108
possibility, 185–186
possible world semantics, 181
Poussin, Nicholas, 124
power, 174
Proust, Marcel, 163, 196, 197
psychic distance, 21–24

Quine, Willard, 81
quotations, 23, 137, 181, 182–184, 187

Racz, André, 155, 159
Raphael, 117
Rauschenberg, Robert, 12
realism, 24
reality, 28, 29; and art, 77, 83; as se-
 mantical concept, 80–82
recognitional skills, 61, 74–75
religious language, 134–135
Reinhardt, Ad, 204
relations, 63–64, 65–66
Rembrandt, 31, 168, 194, 195, 196, 198
repetitions, 38–39
repleteness, 141

representations, 18–21, 45, 65, 68, 69,
 71–74, 75–77, 150–155, 175, 181, 198
responses, 96–97, 153
rhetoric, 147, 148, 162, 165–172, 175
Rilke, Rainer Maria, 11
Rodin, Auguste, 36
Rondanini Pietà, 115, 116
Rosenberg, Harold, 107
Ruskin, John, 90
Russell, Bertrand, 70

Santayana, George, 97
Sartre, Jean-Paul, 10–11, 33–34, 152,
 206
Shapiro, Meyer, 24, 189, 193
Schopenhauer, Arthur, 34, 205
Schumann, Robert, 38
Segal, George, 80–81
semantic vocabulary, 79
sentential states, 187, 205
Serra, Richard, 102–103
sexual responses, 96–98
Shakespeare, William, 7, 11
similes, 180
snapshots, 48–50, 70
Socrates, 8, 9, 25–26, 67, 71, 178,
 198–201, 202
socialist realism, 167
Sophists, 170
Sparshott, Francis, 52
Steen, Jan, 196
Stefanelli, Joseph, 103
Steinberg, Leo, 104
Stella, Frank, 86–87
Stern, Josef, 179

Stoppard, Tom, 22
Strawson, Peter, 104
Strozzi Altarpiece, 50
Swift, Jonathan, 81
style, 147, 148, 160, 162, 165, 197, 207

taste, 203, 207
texts, 187–188
theater, 23, 25, 28
titles, 3, 117–118
Tractatus Logico-Philosophicus, 76–77,
 161
transfigurations, of the commonplace,
 208
translation, 188
Transparency theory, 156–164
transvestism, 67–68

Van Meegeren, Hans, 43, 51
Vasari, Giorgio, 162
Viollet-le-Duc, 90–91
Vygotsky, Alexi, 71

Warhol, Andy, 44
Weitz, Morris, 59, 62
Whitehead, Alfred, 87
wit, 44
Wittgenstein, Ludwig, 4–6, 49–50,
 57–58, 64, 76–77, 78, 82, 97, 123,
 161
Wölfflin, Heinrich, 44, 113

Yeats, William Butler, 34

Zeugganzes, 112